"Animation books often rely on simple formulas that illustrate mechanical approaches to solving specific problems or provide isolated answers and methods that lack further application. From years of filmmaking experience, Ellen has managed to distill conceptual principles that, once integrated, can build and enhance the tool kit a filmmaker uses to analyze and solve conceptual problems. Used properly, these thinking tools can lead the filmmaker to fresh and creative solutions to the challenges of communicating and entertaining with animation. Ellen's book is a concise window into her lifetime of experience and passion for the animation medium."

— Charlie Bonifacio, Animator, Starz Animation Toronto,
Walt Disney Feature Animation, Sullivan Bluth Ireland

"Ellen Besen's *Animation Unleashed* is an excellent resource for storytellers working in animation. Besen conveys her vast knowledge of the art form of animation, reflecting her much respected abilities to teach, to analyze, to illustrate key ideas with clear examples, and to reveal her unique insights into story, what makes story work — and how."

— Marilyn Cherenko, Independent Animator and Associate
Professor, Emily Carr Institute of Art and Design

"So many animation books out there get stuck on a very specific topic of the art form. *Animation Unleashed* does a beautiful job tying in so many aspects of animation that often get forgotten, yet are so important to understanding the whole process. This book is a great find for anyone trying to understand the big picture of how animation comes together."

— Mike Belzer, Animator, Walt Disney Animation Studios

"*Animation Unleashed* is more than a how-to book that covers the mechanics of creating animation and is a refreshing approach to viewing and creating animated projects. Besen digs deeper and analyses the essential concepts that underlie successful animated films. This book is destined to be a key addition to my high school program."

— Elizabeth Lewis, B.A., B.Ed., NFB and Independent
Filmmaker/Animator, Educator in First Nations schools

"Finally! A thoughtful and informed guide to the basic principles of animation and storytelling for people creating short animated films and new media. Based in visual storytelling and structure, and including principles of movement, character design, structure and animation technique, this book is a gem. An excellent textbook for beginning animation classes, *Animation Unleashed* provides a comprehensive but concise overview of storytelling tools. With many excellent illustrations and examples, this book will also help practicing animators articulate elements of structure and design that improve their work. We've been waiting a long time for a book this valuable."

— Deanna Morse, Animator and Professor,
Grand Valley State University

"For two decades Ellen Besen's presentations on animation have been among the most popular events at the Ottawa International Animation Festival. It's about time she put her wise and accessible tips on paper. *Animation Unleashed* tells us that you actually need to have an idea before you start a film! No matter how special your latest technological toy is, you ain't got nothing without a solid concept and understanding of production principles. This should be mandatory reading in animation schools and studios. In fact, all young animators should be chained to a wall and made to read *Animation Unleashed*. If they refuse, boot 'em out, 'cause animation doesn't need them."

— Chris Robinson, Artistic Director, Ottawa International
Animation Festival; Author, *Canadian Animation: Looking
for a Place to Happen* and *Ballad of a Thin Man: Sinners,
Saints and Ryan Larkin*

"This book challenges the reader to think critically about what to animate, how to do it — and why. It may even unleash the unbridled animation passion that lurks deep within the psyche of every meek and unassuming animation student."

— Janet Perlman, Animation Director/Writer,
Hulascope Studio

"Ellen Besen's *Animation Unleashed* is an invaluable resource for commercial or independent artists at any stage of animation production. I've found the principles the book covers to be extremely practical and adaptable to any kind of project I'm undertaking from the small screen to the big one and everything in between.

The format and straightforward language Besen uses makes the book accessible to anyone regardless of experience or background. At the same time it doesn't shy away from addressing the all-important 'why' to every 'what' and 'how' you need to know about animation. This book should be added to the library of anyone involved in the planning, making, or appreciation of this incredible art form."

— Mark Stanger, Animation Supervisor/Lead Animator,
Nelvana Studios

"Besen has nailed analogy as the core engine driving animation in this comprehensive and engaging manual for anyone practicing or teaching the animation arts. This is the go-to source for the principles, strategies, and techniques you need to turn ideas into compelling visualizations. Whether you are a novice or expert animator, developing character, SFX, or games, *Animation Unleashed* is the essential reference tool by a master teacher of animation."

— Janet Blatter, PhD, Educational Psychology and
Cognitive Science

"Ellen Besen is one of animation's most renowned experts on animated film theory, and it is wonderful to see her lectures turned into *Animation Unleashed*. Ellen's insight into the workings of storytelling and animation will enlighten readers and surprise filmmakers. She has this unique ability to explain clearly and thoroughly all the elements and decisions in animated storytelling that we take for granted. *Animation Unleashed* is a fascinating and intelligent approach to a fun and boundless art form."

— Linda Simensky, PBS, Head of Children's Programming

"Ellen Besen unleashes the magic and limitlessness of animation in her inspiring book. Take her challenge to think beyond the possible."

— Deborah S. Patz, Author, *Film Production Management 101*

"A very analytical compilation. An essential opus that provides the right framework and methodology for any media work."

— Madi Piller, Independent Filmmaker, Media Artist,
Programmer; President, Toronto Animated Image Society

"Having taught animation for over two decades, I found her writing interesting and thought-provoking, and found myself reminiscing about similar experiences in the classroom, wishing I'd had this text years earlier. Ms. Besen does a remarkable job of making you feel you're in conversation with her on a one-to-one basis, examining and probing story concepts and ideas. This should be required reading for all aspiring animators, young and old."

— Barry Young, Animation Program Director,
Columbia College (Chicago)

"For students of both new and classical animation alike, *Animation Unleashed* is a beautifully rendered critical analysis of what makes the format tick. "

— Scott Essman, Publisher, *Directed By*

"*Animation Unleashed* is a field guide for the creative mind — a road map that ensures safe passage to writers, illustrators, and developers who are adventurous enough to journey into the anti-reality where animals talk, people stretch out of proportion, and gravity runs on time delay. This book is a must-read for anyone who has ever considered letting their character jump off a cliff into a glass of water that's half the size of their head!"

— Catherine Clinch, Publisher, *www.MomsDigitalWorld.com*

ANIMATION UNLEASHED

100 Principles Every Animator, Comic Book Writer, Filmmaker, Video Artist, and Game Developer Should Know

ELLEN BESEN

ILLUSTRATED BY BRYCE HALLETT

Published by Michael Wiese Productions
12400 Ventura Blvd., #1111
Studio City, CA 91604
tel. 818.379.8799
fax 818.986.3408
mw@mwp.com
www.mwp.com

Text Copyright Ellen Besen 2008
Illustration Copyright Bryce Hallett 2008
Cover Art by Bryce Hallett
Additional Illustrations by Tamar Lipsey
Project Advisor: Sharon Katz
Technical Advisor: Aubry Mintz

Book Layout: Gina Mansfield Design
Editor: Paul Norlen

Mixed Sources
Product group from well-managed
forests and other controlled sources
www.fsc.org Cert no. SW-COC-002283
© 1996 Forest Stewardship Council
FSC

Printed by McNaughton & Gunn, Inc., Saline, Michigan
Manufactured in the United States of America

Library of Congress Cataloging-in-Publication Data

Besen, Ellen
 Animation unleashed : 100 principles every animator, comic book
writer, filmmaker, video artist and game developer should know / by
Ellen Besen ; illustrated by Bryce Hallett.
 p. cm.
 Includes bibliographical references and index.
 ISBN 978-1-932907-49-0
 1. Animated films--Technique. 2. Drawing--Technique. 3. Animation
(Cinematography) I. Hallett, Bryce. II. Title.
 NC1765.B46 2008
 791.43'34--dc22
 2008022847

ACKNOWLEDGMENTS

Never one for long speeches, I will keep this short but no less heartfelt.

So to all who lent their help, support and/or expertise, who cheered me on and put up with me through this long voyage, thanks to David Spek, Kate Henderson, Michael Wiese, Ken Lee, Marc Glassman, my family, my friends, and my students.

And to those who helped inspire this book, thanks to Kaj Pindal and thanks to Zach Schwartz and Derek Lamb (both still with us in spirit).

Special thanks for all of the above and more to Sharon Katz, Aubry Mintz, Bryce Hallett, Tamar Lipsey, and Steve Barr.

And to my mother, Eleanor Besen (1924~2007) I dedicate this book — I only wish you had lived to see it published.

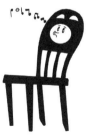

TABLE OF CONTENTS

INTRODUCTION

ALL MEDIA COMMUNICATE MOST EFFECTIVELY WHEN THEIR INHERENT PROPERTIES ARE INCORPORATED INTO THE STORYTELLING. IN THIS, ANIMATION IS NO EXCEPTION.

Sometime in the last twenty years, a few interesting things happened to me. The first was that in the course of mentoring many people through the process of creating animation, it became clear that there was a specific kind of thematic foundation which was more important than any other factor in predicating not only a coherent production process but also a successful final film.

The second was when, in the process of analyzing classic animated films, exciting stuff began to leap off the screen. These were things we had never been taught: inventive communication woven not only into performance but into camera angles, special effects and backgrounds too, adding up to a uniquely animated form of storytelling.

The third was when I realized that the first two things were coming from the same source; that both, in fact, were tapping the essence of how animation functions. And that harnessing this essence was the key to making animation which didn't just move but had something to say.

This book grows directly from these experiences and all that came after: from many workshops spent going over master-level animation with the finest toothed comb and from working one-on-one with animators as their projects take shape, using the principles which you'll find in this book as the guide.

Whether you approach this book as a beginner or seasoned professional, the principles offered here are intended as a starting place for deepening your own understanding of this medium and as a catalyst for forming new ideas about how animation can be made to communicate.

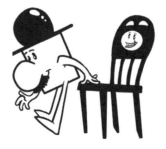
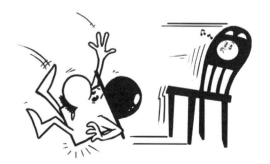

PART I | GENERAL PRINCIPLES

INTRODUCTION

WE CAN'T USE WHAT WE DON'T UNDERSTAND.

In this section we take a look at essential principles of animation based on properties which are so deeply inherent to this medium that there is no getting away from them. So since you can't avoid them, you might as well embrace them.

In fact, what we discover here is that embracing them is all for the good. Understanding what these principles are, why they are so strongly connected to animation, and how they open up animation's potential for communication lays the foundation for putting them to work in your own productions.

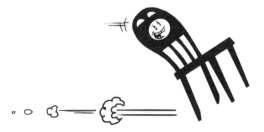

CHAPTER I: ANALOGY

ANALOGY AS FOUNDATION

ANALOGY CREATES THE BEGINNING POINT FOR STORY LOGIC.

At the heart of many great animated films you will find analogy. This essential correspondence between two things (e.g. a raucous life can be likened to a roller coaster ride) is, in fact, a foundation element on which an entire animated project can be built. Other media can, of course, make use of such relationships but here it has a special role. Why? Because animation has an especially vivid ability to make analogy literal.

From this ability a new kind of communication emerges. For example, instead of having a story about a frustrated man who feels like a puppet on a string, in animation, the character can actually be a puppet. With this beginning point we can then develop a project which is both original and has a handy, built-in guide for decision-making.

In the process of creating an animated project, countless decisions have to be made. And so we need a basis for making them. If we were making that story about a frustrated man, how would he express his frustration? And who would the villain be: a nasty teacher, a dominating partner, a ruthless dictator? At this point, any number of choices are possible, but the idea is so general that it offers no particular reason why the decisions should be made one way or the other.

With a solid analogy as our foundation, all this changes. If we make our film about the frustrated puppet, then the logical villain might be a puppeteer, and to show his rebellion, the puppet can tangle his strings. Or perhaps his tormentor is another puppet and only over time does he realize that both he and his tormentor are being manipulated by the same puppeteer and they both cut their strings and run away.

Decisions about every part of your project can be guided in this way by a solid foundation analogy, making the process of development easier while also ensuring that the final piece will have both coherence and internal logic.

Example: *Chairy Tale* — a short film which explores the frustration of being taken for granted through the eyes of a self-aware chair which naturally expresses its rebellion by refusing to be sat upon — is an excellent example of both how animation can make analogy literal and how analogy can support foundational decision-making.

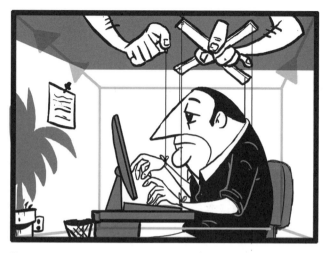

In animation,
the character
could actually
be a puppet...

Zoom out

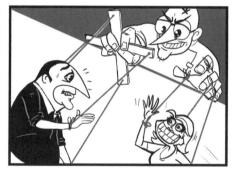

... and the
villain could
be the
puppeteer.

THE ANALOGY EQUATION

A FOUNDATION ANALOGY IS COMPOSED OF TWO PARTS: A THEME AND A VEHICLE WHICH MAKES THE THEME CONCRETE.

Analogy has the ability to function as a foundation for communication for media in general and animation in particular. To do this, though, it can't be just any "her eyes were like limpid pools" kind of equivalence. Instead it must show a specific correlation between a theme and a vehicle which gives that theme physical expression. Ideally for animation, this physical expression is not only visual but also oriented towards movement. For example, persistence (theme) could be expressed through the impossibly long migrations of butterflies (vehicle), conformity through the behavior of ants.

Notice how we have moved here not only from abstract to concrete but also from general to specific. This combination is very important: the general nature of the theme allows your work to appeal to a wide audience while the specific nature of the vehicle keeps the material fresh.

Some analogies come straight from the real world but analogies can also be invented. You can, for example, add an unusual trait to an otherwise predictable character, creating a nonconformist ant as in *Bug's Life* or, perhaps, a duck who doesn't like to swim.

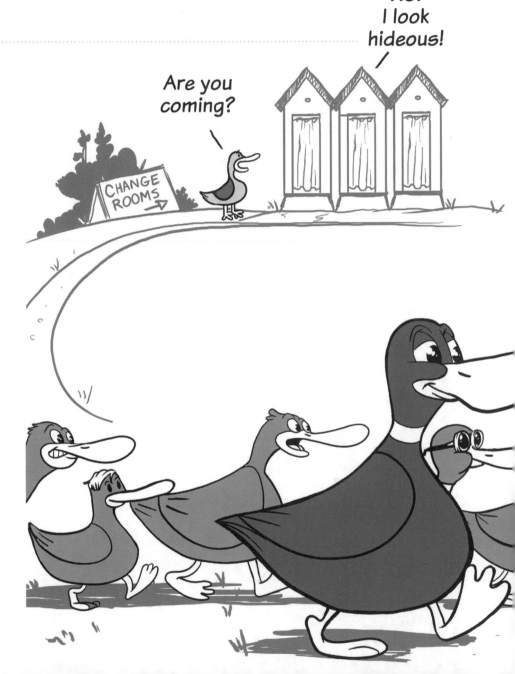

Details have a big impact on meaning. A duck who doesn't like to swim because he hates how he looks in a bathing suit is different from...

But whether discovering an analogy or creating one, be careful in your choices. The best analogies uncover an unexpected relationship between theme and vehicle rather than an obvious one or express the relationship in an unexpected way. A pencil, for instance, may not look like a strong candidate for the hero of a story about self-sacrifice until you consider that a pencil is literally consumed by the act of drawing.

Be careful also that the two parts of your analogy are a true match. A true match can guide your project from beginning to end while an inaccurate one can lead you astray. Often the difference lies in the details. A duck who doesn't like to swim because he is afraid of water is different from a duck who doesn't like to swim because he hates how he looks in a bathing suit. And a story about toys which live in a kindergarten room, played with by many children, speaks to different themes than a story about toys which are owned by just one child. Only the latter story has the built-in hierarchy peaking in the elevated but fragile status of favorite toy, which allows it to function as the foundation of *Toy Story*.

See also: *Analogy as Foundation; Animation and Movement-Based Communication; Building Distinctive Characters*

... a duck who doesn't like to swim because he's afraid of the water.

CHAPTER 2: CARICATURE
SIMPLIFY AND EXAGGERATE

TO CREATE CARICATURE, YOU NEED TO REMOVE WHAT IS EXTRANEOUS AND AMPLIFY WHAT IS ESSENTIAL. IN OTHER WORDS, YOU NEED TO SIMPLIFY AND EXAGGERATE.

Like all graphic media, animation has a natural affinity with caricature. But how exactly is caricature created?

Let's say you are making a caricature of someone's face. So you give them small, widely spaced eyes; a simple straight line nose and mouth; a huge chin and a crop of curly hair. And the end result looks just like the person. But what have you actually done here?

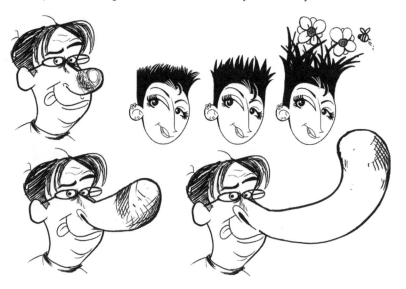

Without necessarily thinking about it, you first identified the features which define this face and those which do not. You then de-emphasized the less important features, in this case, the nose and mouth (simplification) and made the remaining essential ones more extreme (exaggeration). In other words, you followed the basic three-word formula for creating caricature: simplify and exaggerate.

Why do some features seem to define a face? Chances are this is because they are already somewhat exaggerated: the chin already larger than average, the eyes already smaller and more widely set apart. To draw more attention to these features, you take their innate exaggeration and extend it, so small eyes become tiny, a large chin becomes gigantic, thick eyebrows become bushy, and so on.

Why do other features seem unimportant? Most likely, it is because they fall clearly within an average range: not bigger, smaller, bumpier, etc. than one would expect. De-emphasizing these less memorable features helps to clarify your caricature. To accomplish this, you can render them with few details, partially render them, or leave them out altogether.

Caricature can be subtle or extreme.

The basic rule of caricature: lose the unimportant features and exaggerate the ones that remain.

The remaining essential elements can also then be simplified and exaggerated to make the end result clearer still. In fact, as long as you have identified the defining characteristics correctly, you can reduce them down to the most minimal rendering — those small eyes reduced to dots, the curly hair a simple looping line — and the subject will still read clearly. On the other hand, a more subtle approach to caricature can end up creating a heightened version of reality — one that often looks more like the subject than a more technically accurate portrait.

These same principles of simplification and exaggeration can be applied wherever caricature is required. Sometimes, though, we may need to begin with a broader process of identification.

For example, how do we know that a bird is a bird? Wings, beak and tail are the most iconic elements. As long as these are included in your caricature, you are free to also exaggerate the key traits of a specific species of bird or to take a more fanciful route. Here, you'll soon discover that over a remarkable range of variations of size, shape and style, your creations will still be easily seen as birds, provided those key characteristics are in place.

So for all kinds of caricature, as long as the correct choices are made regarding what to leave in and what to eliminate, this basic approach will give you results which read clearly no matter what the subject or final approach to style.

Examples: Though each are highly caricatured in distinctly different ways, the main characters in *Peanuts* and *The Simpsons* read clearly as humans. By comparison, the evil Queen in Disney's *Snow White* offers a good example of how a more subtle use of caricature helps make even a realistic character memorable.

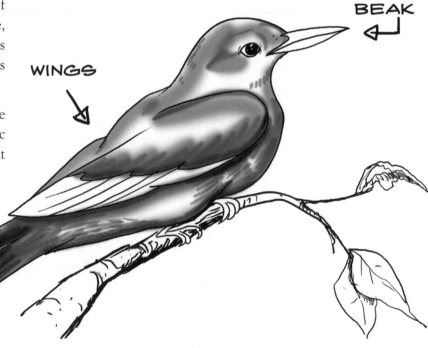

BEAK

WINGS

TAIL

Wings, beak and tail are the iconic features of most (but not all) birds.

Even with extreme exaggeration, a bird is a bird is a bird is a bird... as long as its key characteristics have been retained.

CARICATURE IN ANIMATION

**CARICATURE CAN BE APPLIED TO EVERY
ELEMENT OF AN ANIMATED FILM.**

The relationship between animation, as a graphic medium, and caricature is both natural and essential. And this relationship applies not only to the most obvious area of character design but to every aspect of production.

The classic cartoon approach found, for example, in old Warner Brother shorts, is firmly based in caricature. Here character design is streamlined, with lumps and bumps smoothed over in favor of essential curves and performance is staged to broadcast clear, unambiguous messages through every element of movement.

Animated movement in general, even very realistic 3D-CG movement, needs some degree of caricature to read properly on the screen. The graphic nature of animation distorts perception of movement, amplifying some elements and swallowing others. Non-exaggerated movement can look stiff; non-simplified movement can look overly busy. The right use of caricature corrects these tendencies, actually becoming a hidden factor that can make a performance seem more real.

Backgrounds, camera angles and sound also hold possibilities for caricature. For example, background shapes can be pushed, making mountains pointier or reducing them to a series of triangles with white peaks.

Caricature can even be built into concepts, escalating Bugs Bunny's desire to retaliate against his various tormentors into a declaration of war, perhaps, or playing with our perceptions of time. In the sequence when the puppies are being born, *101 Dalmatians* increases dramatic tension by exaggerating the way time seems to drag when we are waiting. *Why Me* exaggerates time in the opposite direction, collapsing the amount of time a terminal patient has to live to a mere five minutes, thus allowing a serious subject to be treated with a light yet still respectful hand.

Notice here that, in all its applications, the degree of caricature used can be subtle or extreme. A furry animated dog can be extra furry or just a big ball of fluff with eyes. You can add a little bounce to a character's walk to show her excitement or you can have her bouncing off the ceiling, and so on. Just be careful to match the degree of exaggeration to the overall tone of your project, as well as between one element and another. Too much exaggeration in the movement of a realistic character within a realistic piece, for example, can not only make the character look ridiculous, but can also undermine the credibility of the entire production.

See also: *Simplify and Exaggerate; Making Your Universe Real*

Every element of animation, including backgrounds, can be caricatured, whether a little...

... or a lot.

CHAPTER 3: MOVEMENT

ANIMATION AND MOVEMENT-BASED COMMUNICATION

ANIMATION IS MOST POWERFUL WHEN IT COMMUNICATES WITH MOVEMENT.

Animation has many tools for communication including design, editing and sound. It has a special strength, however, when it communicates specifically through movement.

Why is this so?

First, this is because humans are strongly geared to draw meaning from movement. This is far more fundamental to us than communication through words. In fact, if we see a contradiction between someone's words and their gestures, it is the gestures we will believe. This is a deeply inbred human attribute which happens to work particularly well with the characteristics of animation, as we shall see.

As in all film, the structural nature of animation allows it to focus attention on movement of all kinds. Compared to live theater, which is restricted in both how broad and how detailed action can be before it becomes invisible, film has no such boundaries. With a shift of camera angle, the tiniest twitch of an eyelid can be as clearly showcased as an endless military parade.

Animation, with its inherently graphic nature, takes all this even further. Not only does its graphic nature amplify what is being communicated, it also makes the movement compelling, almost hypnotic, in its own right. In other words, animated movement has a built-in ability to draw an audience's attention. This creates an obvious advantage when you have a message to broadcast through movement but also has the effect of making the movement itself a form of communication.

We are naturally delighted by graphic movement, even more so when it is also rhythmic, particularly when synched with music. Here again, animation has a special advantage with its ability to create extremely precise synchronization between movement and sound.

Animation's natural affinity for movement-based communication has also led it to keep an old tradition alive: films without words. This includes not only the fully musical approach of films such as *Fantasia* but also narrative and experimental animation filmmaking in both short and feature form.

With a shift of the camera, a tiny detail can be showcased as readily as an endless vista.

MAKING MOVEMENT MATTER

MOVEMENT SHOULD BE USED FOR ESSENTIAL COMMUNICATION.

Animation is particularly effective when it communicates with movement. But this potential can only be tapped when movement is given a meaningful role.

This means, for example, being careful not to assign all essential plot and character information to the soundtrack, particularly to dialogue. Too often this approach is the default strategy, the easy road which leaves the visuals with little to do but fill the empty screen. Characters working within this strategy may look busy* — walking, running, waving their arms, etc. — but on examination it becomes apparent that their movement is essentially expendable. Whether the audience chooses to watch this movement or ignore it makes no real difference to their understanding of what is going on. In fact, in the most extreme cases, you can turn the picture off completely and just listen to the soundtrack without missing a single plot point, character development or joke.

By contrast, consider how much more interesting it is for the audience if they have to watch as well as listen to understand what's happening. To achieve this goal, you have to spread the essential information around, deliberately assigning some parts of it to the soundtrack and other parts to the visuals.

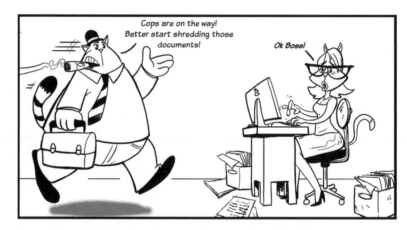

Lots of meaning in the dialogue but very little in the action versus...

In a simple division of labor, the action could focus on plot while the dialogue reveals how the characters feel about what is happening. In a more complex approach, it could be aspects of time which are divided between movement and sound with, perhaps, the action showing the present while the dialogue reveals something from the past.

A key suspect in a court drama, nervously shredding an important document as police sirens wail in the background, not only furthers the plot by destroying a piece of evidence but also reveals a personal weakness which may have future implications for the story. Here action carries both plot and characterization.

... lots of meaning in the action and sound effects plus new information in the dialogue.

Meanwhile, those approaching sirens raise the emotional stakes as they signal the character's impending doom.

Notice that, as we get more specific, meaning in movement comes from both what the character is doing and how he is doing it, as well as from the context in which the action takes place.

With this in mind, even the meaningless walking and running mentioned above can be made to matter. A businesswoman walking down the street in a nondescript manner as she phones her boss to say she is running late reveals little through her action. But have that same businesswoman limping because she has broken a heel or sauntering casually while she has that same conversation and suddenly we have a hint about who this character is and whether she is late because she is unlucky or because she is indifferent.

Then add a clock to show us it's 9:15 and a few other people hurrying into their jobs and the audience might still get the point without any dialogue at all.

With or without dialogue, use movement to communicate stuff which the audience can't afford to miss. Then present it in a manner so interesting that the audience won't want to look away.

Examples: In *The Triplets of Belleville*, the grandmother keeps up with an ocean liner all the way across the Atlantic in nothing more than a pedal boat — a simple but effective use of movement to express her devotion to her kidnapped grandson which also furthers the plot.

See also: *Animation and Movement-Based Communication; The Animated Script; Dialogue*

* If they are moving at all. Sometimes with this strategy all that is left on the screen are a series of talking heads — an equally dull result which is also resolved by introducing meaningful movement.

CHAPTER 4: FANTASY
ANIMATION HAS NO LIMITS

IN ANIMATION, ANYTHING IS POSSIBLE.

Animation and fantasy make the perfect couple. Why? Because whatever can be conceived through fantasy, can be realized with animation. In fact, one of the most fundamental characteristics of animation is that anything and everything is possible.

Live action, even at its most fanciful, at some point has to take the real world into account and that inevitably limits the way live action films are conceived and produced. But animation has no such restrictions and will in fact take us as far as our imaginations and mastery of the craft are able to go. Given the right context, pigs can fly and doorknobs can talk, if we so choose.

What else does "anything is possible" mean? The range includes not only the basics of bringing inanimate objects to life but also conceptual approaches for making the invisible, visible and abstract, concrete. So it means that the properties of real elements can be exaggerated. And new elements can be invented and invested with the properties of your choice. It means analogy can be made literal and the laws of physics can be rewritten, allowing time and space to expand or contract and gravity to be suspended.

It means you can make a film in which the hero is a lobster or a toaster or a rock. It means clouds can move to a beat, dust can spell out words and the moon can actually be made of cheese. Mythical monsters and aliens can be brought to life. Sidewalks can grow arms that cling to pedestrians or can turn to quicksand and swallow them. The cycle of the seasons can be stopped or offered in some new form and emotions can literally be worn on your sleeve.

From this we see that fantasy can be incorporated into any and every aspect of an animated project, from core ideas to character design, setting, movement and sound as well. This is especially important to keep in mind at the start of development, when you are still working with a blank slate. But an awareness that you are not bounded by the limitations of reality can open up unexpected solutions at any stage of production.

Examples: Uses of fantasy range widely. *King Size Canary* exaggerates the effects of super-grow plant food into the realm of absurdity, while *Monsters, Inc.* hinges on the idea that the monsters in our childhood closets are real. And *Ryan* uses fantasy to create a mirror world where wrecked minds produce equally wrecked bodies.

"Anything is possible" means the moon can literally be made of cheese...

Value-Added Point: The idea that anything is possible in animation may seem obvious, but putting this into effect can be trickier that you think. We spend a great deal of our education learning to put boundaries on our thinking: the sky is blue, leaves are green, things fall down and not up. But to create effective animated pieces we have to see beyond these walls and consider what else could be. In effect, we have to unlearn the world and reconceive it on our own terms.

And finally, keep in mind that while you can go anywhere you choose at the beginning of a project and you can continue to consider solutions outside the boundaries of reality even during production, at least to a certain degree, eventually you do have to place boundaries of your own choosing around your ideas, in order for them to add up to a coherent world.

See also: *Analogy as Foundation; Making Your Universe Real*

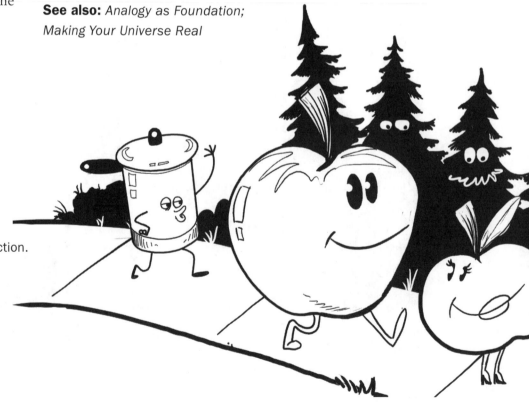

... and fantasy can be incorporated into every aspect of production.

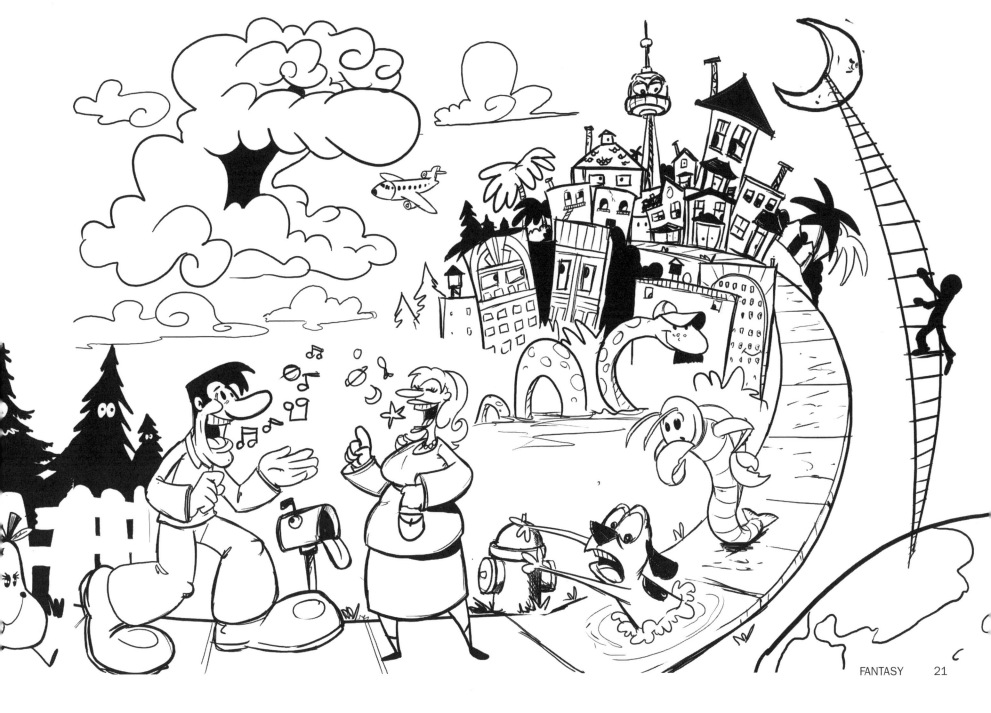

BUILDING FANTASY INTO YOUR FILM

FANTASY IS MOST EFFECTIVE WHEN USED FOR ESSENTIAL COMMUNICATION.

Animation has more impact when it does what live action can't. Here fantasy provides an essential key. Whether introduced through a character with magical powers, generated by an imaginary setting or just treated as a fact of life, fantasy can bring out the best in animation. But fantasy can only accomplish this when it is built into the fabric of your idea rather than tacked on like an ornament.

What this means is that the fantasy elements within your idea are given a real role to play and have an impact on how things progress. Notice, for example, how in *Dumbo* everything hinges on one primary fantasy element: Dumbo the Elephant's fantastically huge ears. It's because of his huge ears that Dumbo is initially rejected by the circus community, but it's also because of those ears that he can fly and so become a star of the same circus where he was once an outcast. In fact, if Dumbo didn't have big ears, there would simply be no plot.

By contrast, think of a film where a cute talking animal is cast as the sidekick for a human hero in an otherwise realistic scenario. Here you'll find that the fantasy element is an expendable frill — take it out or leave it in, it makes no essential difference. And what is a talking animal doing in such a realistic world anyway?

Such add-on devices can be good for comic business, though kind of cheap and cheesy. But too often they are added on primarily to justify the use of animation rather than because they actually benefit the story. And sometimes they do real damage. For example, in *Anastasia* an essentially historical story is skewed by fantasy cutaways which imply that the Russian Revolution was actually the result of a curse invoked from beyond the grave by the mad religious advisor Rasputin.

See also: *Animation Has No Limits*

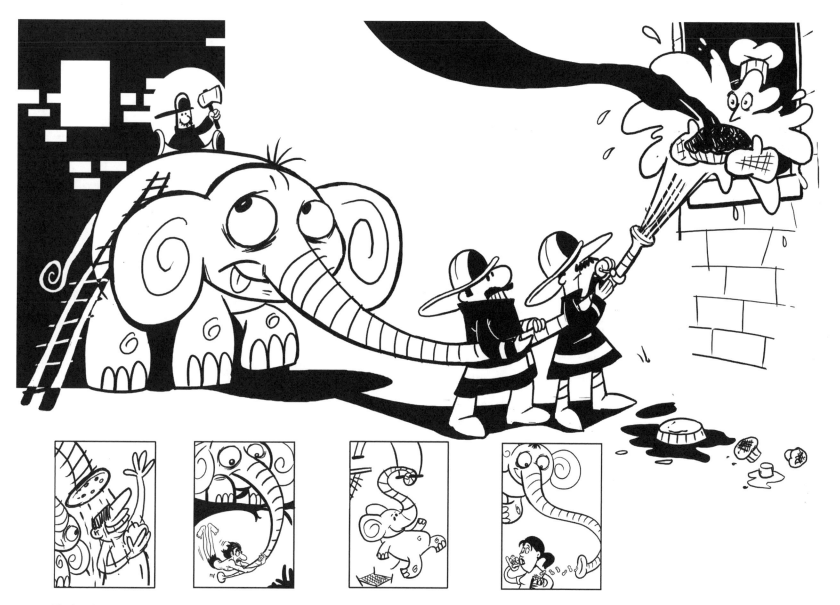

Notice how all the action here hinges on one key fantasy element: an elephant's extra long trunk.

CHAPTER 5: REALITY
CREATING A UNIVERSE

ANIMATION ALWAYS EXISTS IN AN ALTERNATIVE UNIVERSE.

Animation by its very nature exists in an alternative universe. Live action records the real world and reproduces what it has recorded. Even if the story is wildly fictional, the nature of the recording process inevitably ties the end result to the real world. In animation, however, we are not recording action and visuals, we are creating them. This remains true even when the subject matter is very realistic. Though the elements we create may reference the real world, the only world in which they exist is the one on the screen.

What difference does this make? A big one, as it turns out. Most importantly, it means that because animation exists only in an alternative universe, nothing is a given. And because nothing is a given, every element of this universe, both great and small, must be defined by you, its creator.

In live action, many real-world attributes are in play: actual cameras placed at actual angles record actual actors, etc, all working within the limitations of natural law. If a live action character must defy gravity, steps can be taken to make that appear to be so but at some point, actual gravity will have to be dealt during the process of creating the illusion.

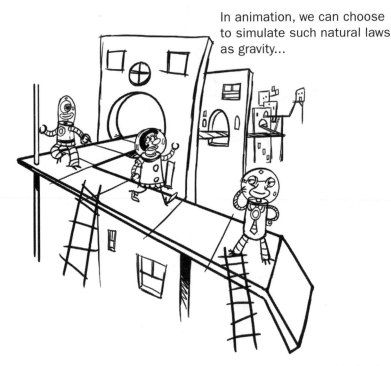

In animation, we can choose to simulate such natural laws as gravity...

And if a live action scenario calls for a mountain, quite likely this mountain will have to be chosen from among the ones that nature provides: a package deal with all the details of form, texture, color, etc. provided. A mountain which precisely meets the needs of the scenario may exist but more likely, the action will have to be adapted to the limitations real mountains present.

In animation, this situation is reversed. We do not have to account for natural law, though we may choose to do so. And while we can choose to simulate reality, it is only one of many options. But in

... or create a world which runs on laws of its own.

return for this freedom comes the necessity of building everything from scratch. And remember that this involves not just how things look but also how they function and in what specific context. In this we have no choice, it is simply the nature of the medium.

The advantage of this is that the worlds we create are entirely pliable. We can shift and change their attributes both inside and outside the boundaries of reality. This not only opens doors for innovative storytelling, it also gives us a handy tool for problem solving. So if gravity is getting in the way of our storytelling, we can do away with it, and rather than bending our plan of action to the limitations of that mountain, we can custom build a mountain to suit our needs.

A live action director might ask a location scout, "How big is the mountain?" and then adapt the shooting plan accordingly. But for the animator, there should only be one answer to that question: as big as it needs to be.

Value-Added Points: It's worth noting that projected movement, whether recorded or created, is itself an illusion; the only place the movement actually exists is in the viewer's mind.

Also note that while our worlds are entirely pliable at the outset, we must eventually lock into our chosen attributes in order to create a coherent, believable production.

See also: *Making Your Universe Real*

MAKING YOUR UNIVERSE REAL

ANIMATED WORLDS NEED LOGIC, CONSISTENCY AND BOUNDARIES.

The universes we create in the process of making an animation are, of course, not real but to fully engage an audience, they need to feel real.

This can be accomplished in a number ways, all of which begin by recognizing that there is one place where even the most abstract or fantastical animation makes contact with reality: in the audience's mind. Audiences automatically take whatever you present on the screen and compare it with their experience of the real world. In fact, without this constant point of reference, comprehension would be impossible. Keep in mind here that this refers not only to physical reality but to emotional reality as well.

So first, this means that if you are aiming for very realistic structure, design and movement in your characters, you need to be aware that this approach will be most closely compared to real structure, design and movement, and therefore most easily found wanting. It also means that even when you are working with very unrealistic characters, the audience may be forgiving of their movement but will still scan their behavior in search of emotional believability.

Another key element in creating a sense of reality is consistency. In creating a world, we have to make decisions about every element in great detail. This can mean everything from the color of the sky, to whether animals will be able to speak, to whether a particular character's hat will be made of wool or straw. But once these details are decided, we can't then decide to change them on a whim. Instead, we need to treat them as if they are indeed real and no more inclined to arbitrarily shift traits than things in the real world do.

Finally, we need to give our worlds internal logic. Whether grounded in reality or fantasy, logic means that elements within your world will develop with a believable sense of cause and effect, a process which opens up new possibilities while simultaneously closing off others. Logic, then, combines with consistency to mean that not only will your elements maintain the traits you have assigned them but they will also act within the boundaries predicted by those traits, unless you introduce a believable new element to account for the change.

See also: *Creating a Universe*

Two ways to define a talking cat:

Cat A– Talks like a human and thinks like a human.

Cat B– Talks like a human and thinks like a cat.

I THOUGHT HIS LAST FILM WAS RATHER PEDANTIC. DIDN'T YOU?

...AND NOW LETS MOVE INTO DOWNWARD DOG

CATS INVENTED YOGA, YOU KNOW.

MMM– THIS IS EXCELLENT

DON'T INSULT ME

SEEK THE POWER WITHIN, TIFFANY!

SO I SAYS TO HIM I SAYS JOE. I SAYS, JOE YOU HAVE TO WATCH YOUR CHOLESTEROL. WELL HE JUST GIVES ME A LOOK, AND I SWEAR....

DID I MENTION I'M HUNGRY?

YOU GONNA EAT THAT?

YOU CALL THIS FOOD?!

LOVE YOU

WAKE UP! HUNGRY! WAKE UP!

OOOUUUUUUUT!

INNNNN

To create logic and consistency, you have to choose your details and then stick with them. Here this means that Cat A would be as unlikely to chase a mouse as Cat B would be to spout Shakespeare.

CHAPTER 6: CONTROL
THE FRAME AS THE SMALLEST UNIT OF ANIMATION

EVERY ELEMENT IN AN ANIMATED FILM CAN BE CONTROLLED DOWN TO THE FRAME.

Animation shares many attributes with live action but when it comes to control there is an important difference, one that begins in structure but has wider implications. In live action, the smallest element of structure is a subsection of a scene called a beat. In animation, the smallest element of structure is the smallest element of film itself: the frame.

So while animators can range freely during the development phase, when it comes to production they must literally build their work one frame at a time, an approach which demands a great deal of control. Working frame by frame is the very essence of animation, so exercising an extreme level of control over our productions is a deeply inherent property.

But in order to work at the level of the frame, we have to think at the level of the frame. This means that we have to be aware of the component parts of every frame, knowing what each element is and why it's there. We also have to be aware of where each element is coming from and where it is going to. And this means that we

need to be aware not only of how all these tiny parts serve the final whole but also of the specific relationships created from frame to frame.

This final point has special importance because it is in the flow from one frame to the next that animated performance is created. If you focus on the elements within each frame in isolation as you animate, rather than focusing on the flow, you will be able to create movement but you won't be able to create movement which communicates.

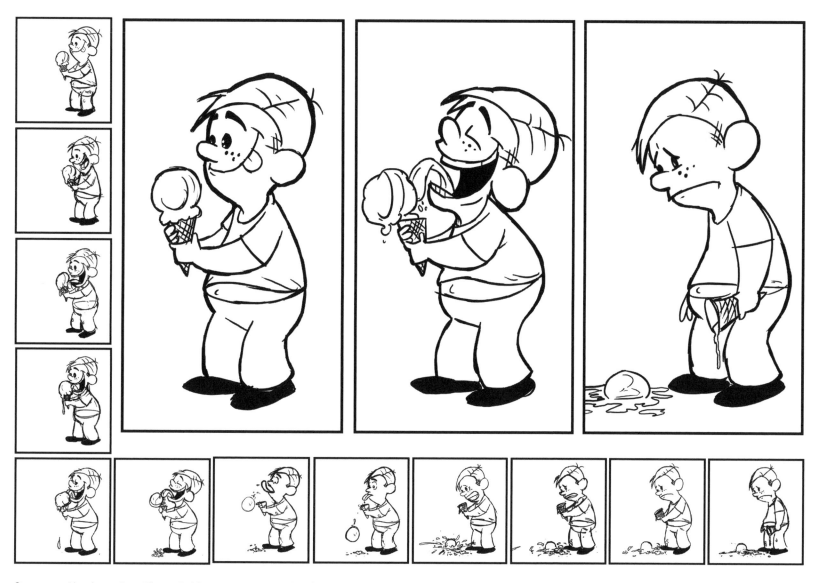

Compare the broad outline of this movement to its frame-by-frame breakdown and notice how many details have to be controlled both within each frame and from one frame to the next.

MAKING EVERY ELEMENT COUNT

EVERY ELEMENT IN ANIMATION CAN BE USED FOR COMMUNICATION.

Because every element in animation can be controlled down to the frame, every element can be harnessed not just for visual effect but also for communication. In fact, not only every element but every detail of every element can be controlled and therefore harnessed in this way, from the twitch of a finger, to the shape and color of a cloud, to the placement of the camera to the finest degree.

This property opens up all kinds of possibilities. But to take advantage of its potential, we need to extend our thinking about the nature of communication, performance and character. Animation often features traditional characters using the traditional tools of performance such as dialogue and gesture. Here, the ability to control even tiny details can have the effect of heightening performance. If, for example, you were creating a sequence featuring a Rockettes' style of kick line, this special level of control would allow for machine-like precision in the synchronized movements. Even the dancers' blinks could be in perfect synch.

But this property also allows us to take things which would otherwise be window dressing and make them active players in performance. Elements such as special effects can be bent towards serving a particular story point or thoroughly recast as full-blown characters.

The end effect is that the line between character and backdrop is sometimes blurred or even reversed.

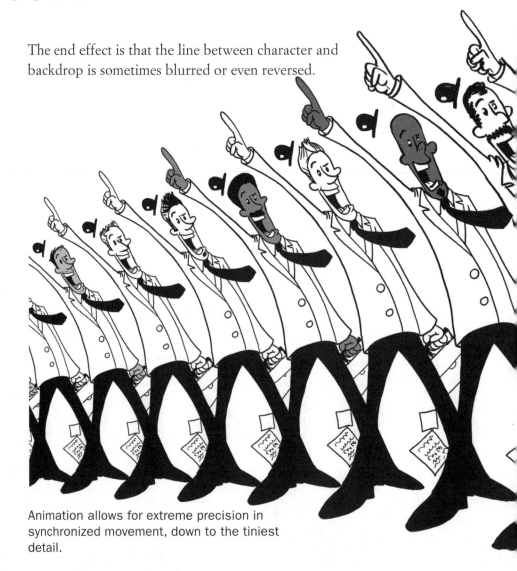

Animation allows for extreme precision in synchronized movement, down to the tiniest detail.

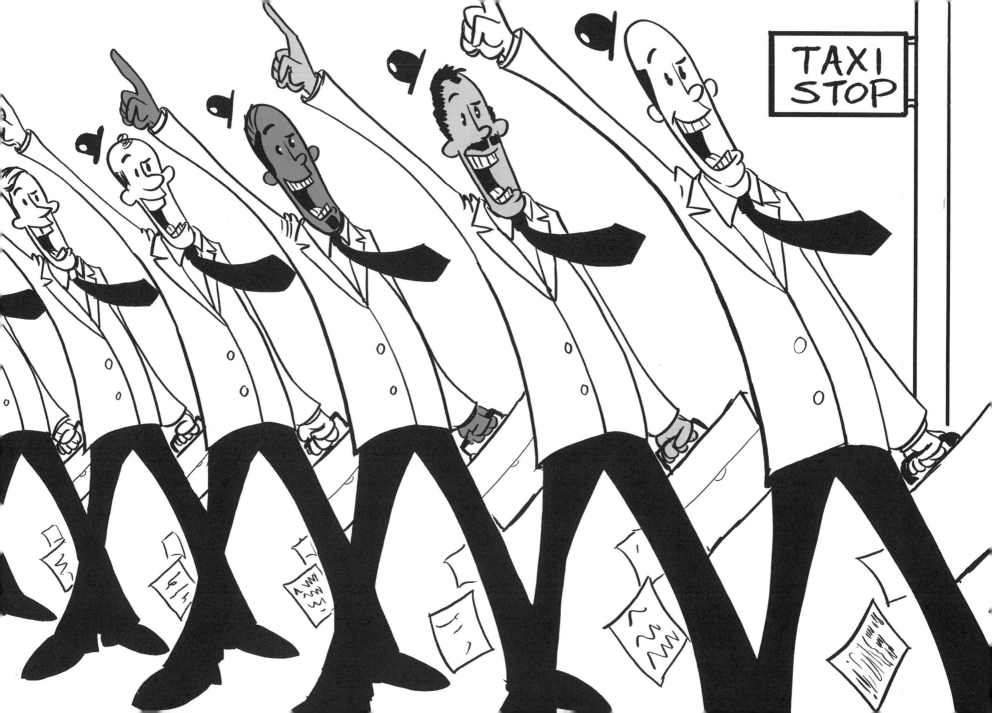

So if you were trying to establish the supremacy of a particularly powerful ruler, you could give this character a big voice and ultra-strong gestures. And you could support his performance with the exaggeratedly submissive behavior of his subjects. But you could also give him power over the forces of nature, letting him wilt crops, set off tidal waves or resurrect the dead to defend his interests. The sun could just shine brighter when he passed but it could also bow down and cover its face with a passing cloud in a show of absolute deference.

Notice here how the extreme control granted by the frame-by-frame process complements animation's inherent pliability and capacity for fantasy. These last two traits give us free rein to imagine new ways to communicate but it is the frame-by-frame process which allows us to fully realize even the wildest ideas.

Examples: In *Lady and the Tramp*, the musical number "We Are Siamese" shows how not only every detail can be controlled for communication but even the details of the details. For example, in the main action of the fishbowl sequence, Lady tries to prevent the cats from knocking the bowl off its table. But watch for the value-added entertainment: a charmingly choreographed mini-drama playing out inside the bowl as the resident goldfish tries to cope with impending disaster.

See also: *Animation Has No Limits; The Frame as the Smallest Unit of Animation*

With the extreme control created by the frame-by-frame process, even the trees can bow down to their king.

PART II PRINCIPLES FOR PRODUCTION

INTRODUCTION

COMMUNICATION IN ANIMATION INVOLVES EVERY PART OF PRODUCTION.

Part I outlines the general principles of animation; Part II shows these principles in action for every major stage of production, along with other related principles which come up along the way. Here we examine how, with the support of these principles, every aspect of your animation can be made not just to communicate but to communicate accurately and effectively.

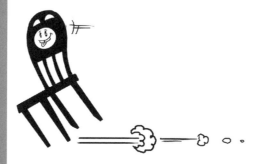

CHAPTER I: IDEAS, SCRIPTS, AND STORYBOARDS

INTRODUCTION

The first phase of creating an animation is exciting but a little scary: so many possibilities leading to so many decisions with so few markers to guide the way. Where does that first idea come from and what do we do with it once it's been found? What's the purpose of an animation script? And what goes into a storyboard? This section examines such questions and in so doing, uncovers key points to help you on your journey from raw idea to animation-ready storyboard.

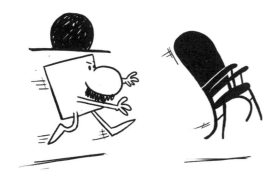

UNCOVERING CORE IDEAS

LOOK FOR IDEAS WHICH INCORPORATE ANIMATION'S STRENGTHS.

BASIC

Ideas which take advantage of animation's strengths (as shown in Part I: General Principles) can be found all around you, literally right under your feet or lurking in your kitchen cupboard. These are the ideas which can be found in the hidden worlds of insects, animals, small appliances, etc. The discovery of an overlooked world is the beginning point of such films as *Bug's Life* and *Finding Nemo*.

Hidden worlds have several built-in advantages. They automatically encourage fantasy by focusing on non-human characters. They allow us to see our own world from a new point of view. They often come with built-in analogies. And they inspire fanciful, unexpected action. For example, *Finding Nemo* explores the hidden world of fish, a world where open water equals danger; a fish tank is like a prisoner of war camp and a strong ocean current is as much an excuse for a joy ride as a way to travel from A to B.

ADVANCED

Acute observation can uncover even more obscure worlds: life in a drop of water, for example, or at the bottom of a handbag. You can also look for hidden facets of established fantasy worlds, such as the private lives of well-known characters like the Easter Bunny or Dracula.

Sometimes the characters you uncover in a hidden world work better when placed in an alien environment. This "fish out of water" approach could give us an old-fashioned porcelain doll fighting for attention in the modern world of Bratz and Barbie or literally a fish out of water, left stranded on the kitchen floor. Notice how these sorts of combinations easily generate interesting action by creating unexpected problems for the characters to solve.

The hidden world approach is just one of many for kick-starting ideas, of course. Other sources include fairy tales and fables; mythology and stories from the daily news; art, literature, science and science fiction; poetry, dreams and your own observations of the world around you.

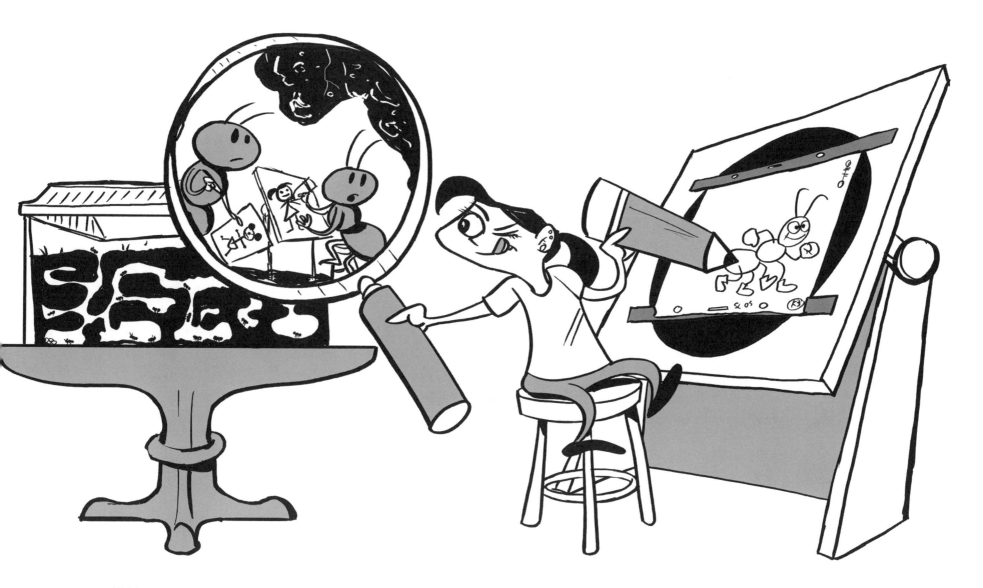

Hidden worlds encourage fantasy and allow us to see our world from a new point of view.

The trick is to twist and turn basic ideas from such approaches or mix and match from various sources until a working combination of elements is discovered. The particular strength of the hidden world, though, is that ideas which begin grounded in fantasy tend to stay grounded in fantasy and that, in the long run, makes for a better animated production.

Examples: *Toy Story's* discovery that living in subjugation to a child's whims is actually a tough job refreshes the idea of bringing toys to life.

The Great Toy Robbery begins with the idea of unexpectedly dropping Santa into the old Wild West.

See also: *Part I: General Principles*

Notice how stranding our fish in the desert rather than on the kitchen floor produces a whole different set of problems.

DEVELOPING CORE IDEAS

IN ANIMATION, IDEA DEVELOPMENT MUST INCLUDE VISUAL EXPLORATION.

BASIC

Visual exploration is an essential step in taking your animated ideas from general concept to concrete, specific, detailed form, a step that helps you avoid some common pitfalls.

It can, for example, help you avoid the trap of generic thinking. Generic thinking is grounded in an unquestioned, generalized view of the world, one where skies are always blue, little girls always have pigtails, and so on. In other words, it is grounded in stereotypes. Stereotypes do have their uses in animation but too often from such generalized thinking flow only generalized, predictable ideas which weaken our projects instead of supporting them. Yet just as often, this is where our minds automatically go when we first try to make our core concepts concrete.

Generic thinking can happen for various reasons. It may simply be that we haven't exercised our ability to dig deeper. The good news here is that this ability is like a muscle: the more you exercise it, the stronger it gets.

Another cause may be a lack of visual vocabulary. The belief that ideas should come to us out of thin air is one of the biggest pitfalls in development. Far from working in a vacuum, we actually tend to generate ideas by drawing on material to which we have already been exposed. So if all we have ever seen is, for example, standardized mainstream animation, this may be all we come up with for the details (both visual and otherwise) of our own work. To overcome this, you need to widen your frame of reference. Study from real life and feed your imagination with pertinent work from many sources including but not exclusive to animation. Then use these new resources to challenge your own stereotypical thinking and generate a more original, and therefore stronger, vision.

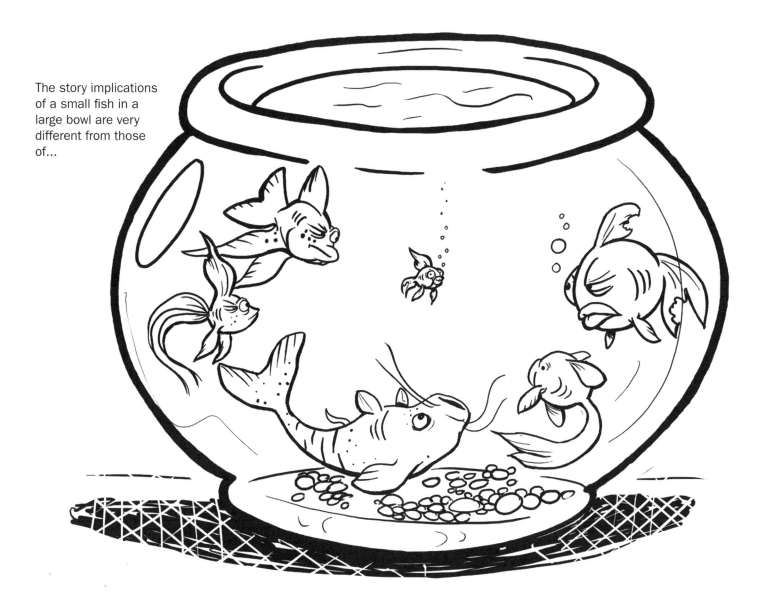

The story implications of a small fish in a large bowl are very different from those of...

Rule Breaker: Stereotypes and clichés do have the advantage of instant audience recognition but need to be used deliberately instead of as an automatic default. Consider using them when time is short, for example, or when there is room to build on the generic element and make it your own

ADVANCED

The details we finally settle on for developing our projects need not only originality but also accuracy. This is because details have a surprisingly big impact on communication, especially in combination with each other. Here again, visual exploration is the key.

Let's say you have an idea which involves a fish in an aquarium. How big exactly is the fish? And how big exactly is the aquarium? Remember here that animation is a visual medium. So unlike, for example, writing where description may be optional, you are going to have to show the audience a specific fish in a specific aquarium, and the combination of characteristics you choose will dramatically affect the message you are sending. A big fish in a small fish bowl has connotations around such issues as complacency, while a small fish in a great big tank implies something quite different.

This relationship between detail and message affects every part of your production. Because of this, it's essential to approach your visual explorations from many angles. Actively consider different ways of handling your visuals, keeping in mind that even tiny details matter. Then experiment with different combinations of elements to discover the best match with your idea.

See also: *Making Every Element Count; Building Distinctive Characters*

... a large fish in a small bowl.

THE ANIMATED SCRIPT

AN ANIMATED SCRIPT SHOULD CREATE A PLATFORM FOR A PERFORMANCE. TO ACHIEVE THIS, WRITE FOR ACTION FIRST.

You've come up with a great core idea and taken the time to explore its potential. Now you're ready to organize it into a script. So where do you begin?

Your first impulse may be to start with dialogue but, actually, dialogue is the last thing which should be added to an animated script. Instead, concentrate first on what your characters are going to do and only then start thinking about what they are going to say.

When we start with dialogue, words become the controlling element. We tend, with this approach, to wrap the action around the words, limiting the amount of action and adjusting its pace so that it doesn't interfere with what is being said. At its extreme, action virtually disappears, leaving little else on the screen but endless shots of talking heads.

By comparison, when we begin with action in mind, pace becomes flexible and dynamic. Without words to lean on, we are stimulated to think of new ways to communicate with movement alone. And more varied use of movement opens doors for better, more varied use of settings, camera angles and even dialogue.

Let's say your idea concerns a married couple who are getting on each other's nerves. How are you going to demonstrate their mutual irritation? The most obvious starting place would be an argument. In this version, there could be vitriolic words from each about the other's faults, punctuated, perhaps, by hitting, scratching, throwing of dishes, etc.

But what if we take away the words? Now we can't have the characters just talking about what bothers them. Instead, perhaps we can show the actions which create the irritation in the first place. Maybe one character's extreme tidiness drives the other into childish messiness, setting up an ever more frenzied chain of action and reaction around increasingly picayune issues. Or maybe they each have hard-to-overlook quirks: his insistence

If you aren't gonna finish yours, can I have it?

Oh you can have it all right, you pig!

Here we go again– another boring speech from Mrs. Etiquette...

Maybe I wouldn't have to give boring speeches about etiquette if you'd get some manners of your own!

When words come first, options for actions become limited.

on practicing extreme yo-yo tricks next to the china cabinet versus her compulsion to stack (and re-stack) their furniture in piles, for example.

Notice here how the action has shifted from a supporting role to a starring one. Notice, as well, how the audience, instead of receiving information about the couple's unhappiness second-hand, now witness for themselves what goes on between these two, adding new levels of meaning to the dialogue when the inevitable accusations and denials come.

And be aware that we are not talking about writing action so much as writing *for* action. The script's job is to set up the where, the why and, in broad strokes only, the what of a sequence of action, leaving room for the animator to work spontaneously within a well-thought-out structure — the optimum circumstances for creating performance.

Examples: *The Big Snit* uses a couple's insanely irritating habits to build an action-based film about the ups and downs of marriage.

See also: *Animation and Movement-Based Communication; The Storyboard as Blueprint; Dialogue*

MUNCH, CRUNCH

Aah

SLLLUUURRR-

Mmmmmmm

SIGH

Great meal, hon!

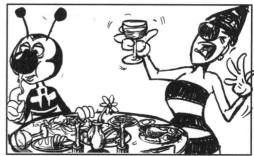

EEEeeeeeeeeeeeeeeeeeeeeeeeeeaaaaaaaaaaaaaAAAAA

¡PLASH!

Nice table manners, "Mrs. Etiquette"!

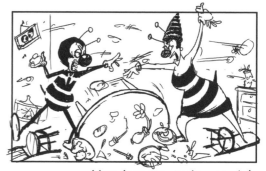

You drove me to it, you pig!

Writing for action first opens up options for both performance and film structure.

THE STORYBOARD AS BLUEPRINT

THE STORYBOARD IS A BLUEPRINT FOR YOUR FILM IN WHICH ALL KEY STRUCTURAL ELEMENTS ARE SHOWN.

Much like an architectural blueprint, an animation storyboard lays out the entire structure of a project from beginning to end. This is not just a proposed structure used as a shooting guide for some sequences as might happen in live action, but the actual structure of the final piece.

Theoretically, an animation storyboard will reflect the final structure with 100% accuracy but in practice this doesn't always happen. Animated features, for example, are often revised as they go along. But even here a significant portion of what ultimately ends up on the screen will already have been fully planned out in the boards.

In effect, an animated project can be pre-edited at the storyboard stage with every shot, every camera move, every transition, every main action and every key sound element accounted for before production begins. Even timing can be added by shooting an expanded version of the storyboard to the precise length of the final piece, creating what is called a story reel or animatic.

This detailed approach has many advantages. It allows you to fill in gaps in your thinking about plot or structure. It also allows you to rough out your settings and the broad strokes of your action. In offering such a clear diagram of the final project, it is an excellent tool for communicating with both backers and your production team.

Again in contrast to live action which typically shoots generous amounts of footage, most of which is then discarded in editing, the animation storyboard process gives you greater control over your production, significantly reducing the ratio of footage shot to footage used in the final piece. To get the full benefit of this, though, you need to truly treat storyboarding as a period of editing. This means trying out different combinations of camera angles, moves, edits and ways of fleshing out the action before making your final choices.

Remember here that it is the animation itself which takes the most time in an animated production. So, far better to correct key problems at this early and relatively easy stage than to spend time animating sequences, only to discover after the fact that they don't work.

Rule Breaker: In commercial situations, the structured approach to storyboarding is an invaluable tool for maintaining control of schedule and budget but the independent artist has more flexibility. Here you may find some independents using storyboards as a springboard only, leaving significant room for the visuals to evolve as the project progresses.

See also: *Timing and Rhythm Structure*

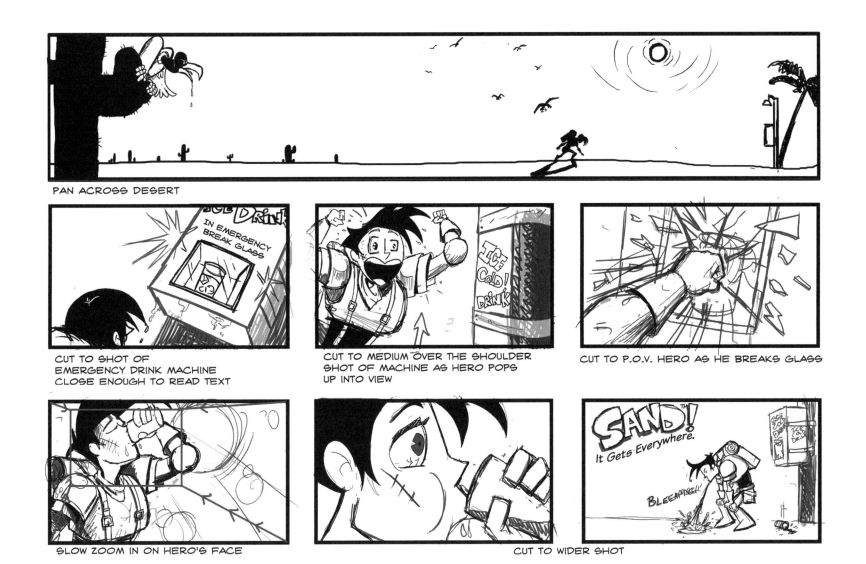

PAN ACROSS DESERT

CUT TO SHOT OF
EMERGENCY DRINK MACHINE
CLOSE ENOUGH TO READ TEXT

CUT TO MEDIUM OVER THE SHOULDER
SHOT OF MACHINE AS HERO POPS
UP INTO VIEW

CUT TO P.O.V. HERO AS HE BREAKS GLASS

SLOW ZOOM IN ON HERO'S FACE

CUT TO WIDER SHOT

An animation storyboard lays out the entire structure of a project, including camera angles and moves as well as editing, sound, and the main action.

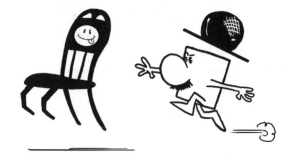

CHAPTER 2: CHARACTER

INTRODUCTION

Before you lock down your characters for a given production, remember that character creation is a pivotal activity, one which has a wider effect on your production than you might think. Here we will look at not only how we can develop a character's design and personality but also at how design affects performance and how personality affects plot. And we'll consider the broad range of possibilities in animated characters, both human and beyond, and how your choices here have a special impact of their own.

ANYTHING CAN BE A CHARACTER

IN ANIMATION, ANY CONCEIVABLE ELEMENT, REAL OR IMAGINARY, CAN BE MADE INTO A CHARACTER.

BASIC

A plucked, stuffed Thanksgiving turkey which escapes from the roasting pan, a pair of rocks which philosophically observe the entire rise and fall of human civilization, a human hand which rules a world of puppets with an iron fist: this ability to invest any conceivable thing not only with life but with personality is one of animation's greatest strengths.

The range of character possibilities in animation is virtually endless including mythological creatures, germs, aliens, robots, plants, toys, cutlery, vehicles, kitchen appliances, and so on. Even such unlikely things as fast food snacks can become characters as in the TV series, *Aqua Teen Hungerforce*, not to mention less concrete elements such as fate, time or one's ego.

In spite of all this potential, our first impulse is often to create projects centered on realistic human characters leading to plots so thoroughly grounded in reality they might as well be done in live action. But animation is often more effective when it moves beyond the boundaries of reality. Working with an unexpected character, whether in a starring or supporting role, not only adds originality to your project but also automatically takes your work beyond those boundaries

Examples: As described above, the films *Thanksgiving*, *Rocks* and *The Hand* make imaginative use of unexpected characters. Other films which do the same include *Chairy Tale* which focuses on the frustrations of a ordinary wooden chair, *Luxo Jr.* which brings a pair of office lamps to life and, of course, Disney's *Beauty and the Beast* which translates the quiet solitude of a castle tended by invisible servants, found in the original story, into the more dynamic approach of having the servants turned into living household objects.

When we say anything can be a character in animation, we literally mean anything.

ADVANCED

Besides opening up content to fantasy, working with imaginative characters also offers special advantages, among them license to handle potentially sensitive material.

Consider, for example, how difficult it would be to make a family feature about a depressed father whose only child is kidnapped and placed in captivity. While this doesn't sound like a kid-friendly romp, it is, in fact, the basic plot of *Finding Nemo*, a film which works well even for very young children. Told with live action, such a film might be overwhelmingly real for a younger audience. But seeing it through the eyes of a fish grants the material a critical degree of psychological distance, allowing its issues (ones which are frightening yet compelling for children) to be safely explored and even experienced as an entertaining adventure.

See also: *Analogy as Foundation*

Imaginary characters can give even very dark subject matter a lighter touch.

BUILDING DISTINCTIVE CHARACTERS

STRONG, DISTINCTIVE CHARACTERS CAN BE BUILT BY CUSTOMIZING AN ESTABLISHED TYPE.

Animated characters are often built on character types. Character types have the advantage of being instantly recognizable so we don't need to waste precious screen time explaining who they are. But they also carry the risk of being too predictable.

This can be overcome by taking a character type and customizing it. For example, try giving a type a contradiction, such as the reversal of a core characteristic. This approach can produce characters which are less predictable yet still have a reference point for internal logic. So Bugs Bunny looks like a rabbit and eats carrots like a rabbit but his street smart, cool under pressure attitude — even when he's looking down the barrel of a gun — is the antithesis of all things rabbit.

Bugs Bunny's combination of timid type with unexpected inner strength works to his advantage, giving him an element of surprise over his adversaries. But contradictions combined with type can also create conflicted characters, dramatically useful creatures who are often the driving force of story. This could be a sheep who is unable to conform, a contradiction which pits the character not only against her own nature but also against the expectations of the herd. Or it could be a god who harbors self doubt.

This last example reverses the combination which makes Bugs Bunny work. Here the type is associated with power and inner weakness is the twist, a volatile combination which can produce corruption. Lacking the internal strength to resist using his very real powers towards the wrong ends, this god character is in a position to wreak significant havoc.

Notice here that character types offer more than just easy recognition; they also set up predictable expectations from other players in the scenario, from the audience and even from the stereotyped characters themselves. Adding a twist then creates a gap between expectation and delivery, one which stirs up emotions and often sets things in motion.

Value-Added Point: A great character doesn't need an endless number of characteristics, just the right ones. Explore and develop as many as you want, but in the end you often only need the strongest two or three.

See also: *Analogy as Foundation; The Analogy Equation*

Reversing a core characteristic can produce characters
with inner conflict or unexpected strength.

EXPRESSING PERSONALITY

IN ANIMATION, THE EXPRESSION OF PERSONALITY IS NOT CONFINED BY REALISM.

BASIC

How are your characters going to express their personalities? Giving them flexible facial features and articulating hands lets them tap the vocabulary of realistic human expression but this is not your only option.

In fact, animation offers all kinds of stylized ways to express personality (and by extension, emotion) which go beyond the limits of reality, a potential which can be released simply by giving your characters the right physical characteristics.

For example, you can draw from the world of literary expression to give your conceited character a literally swollen head. And analogy might inspire you to portray a character who is good at multitasking as an octopus, or at least to give him some key octopus characteristics such as multiple limbs. You can also exaggerate realistic forms of expression to help reveal personality, for example, giving a confident character the world's biggest smile.

Be aware though that, in general, such fanciful traits tend to enhance more realistic forms of expression rather than simply replace them. They also dictate how a character will move.

And be careful to reserve stylized treatments for essential traits only. Taking this approach with every passing emotion would be overwhelming. In fact, one or two of these special traits is usually enough for any given character.

Example: The waiter in *The Triplets of Belleville* is so flexible that he can literally bend over backwards to please his customers.

ADVANCED

Nonrealistic forms of expression are often used in a highly targeted manner to enhance the performance of one particular character. But sometimes a strategy has potential for wider application. For example, an overarching strategy can be applied to multiple characters within a production towards various outcomes. In *Ryan*, we enter a mirror world where everyone's emotional, internal damage is expressed in external, physical ways: one character is as deflated as a fallen soufflé, another sports a false halo and some have ravaged bodies with missing chunks, as if life has taken great bites out of them. Here, the overall concept creates coherency while also making each character unique.

Ryan also demonstrates how even extremely realistic expression can co-exist with extremely distorted and symbolic expression within the same performance. In this case, the end result is decidedly surreal.

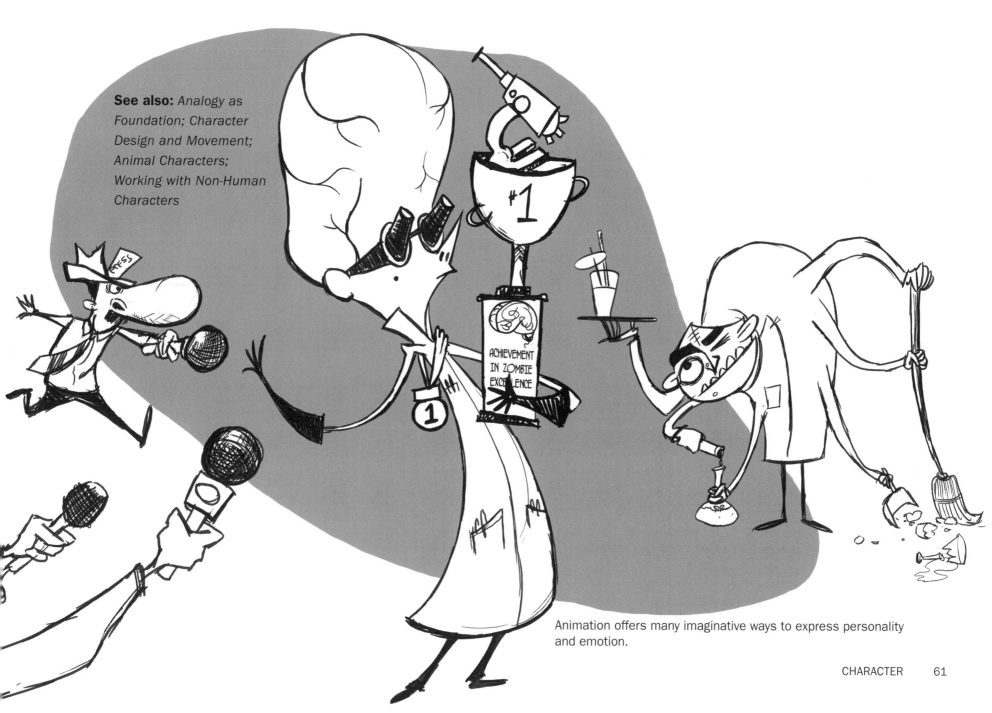

See also: *Analogy as Foundation; Character Design and Movement; Animal Characters; Working with Non-Human Characters*

ACHIEVEMENT IN ZOMBIE EXCELLENCE

Animation offers many imaginative ways to express personality and emotion.

CHARACTER DESIGN AND STYLE

THERE ARE NO BOUNDARIES ON HOW CHARACTERS CAN BE DESIGNED. HOWEVER, CHARACTERS WITHIN A GIVEN PROJECT MUST LOOK AS IF THEY BELONG IN THE SAME WORLD.

BASIC

Though every era has its dominant approach to design, animated characters can actually be created in an infinite number of styles. In broad terms, they can be realistic, cartoony, abstracted, etc. And within each broad category there are multiple variations. The realism of a Disney feature is different from the realism of *King of the Hill*, for example.

Every style has its own special characteristics. Traditional cartoony characters, for example, tend to be rubbery and have caricatured features with noticeably distorted proportions, while realistic characters have relatively realistic proportions and bodies which function much like our own. Keep in mind that regardless of the style you choose to work in, it is essential to identify the dominant characteristics and use them consistently to make your characters feel as if they belong in the same world.

Examples: *101 Dalmatians* and *Ryan* showcase two different approaches to realistic design. And Bugs Bunny shorts feature traditional 2D cartoon design as opposed to the contemporary 2D cartoon style seen in such TV series as *The Fairly Odd Parents*.

Value-Added Point: When designing characters, remember that the key conveyers of expression are the eyes, mouth and hands, so keep these elements clear, readable and easy for the audience to find.

Full head rotation vs Front and side view only

Jointed knees and elbows

VS

Arms and legs like rubber hoses

Lots of stretch and squash
VS
Minimal stretch and squash

Less exaggeration VS More exaggeration

Every style has its own set of distinctive characteristics.

ADVANCED

Animation often has to deal with a variety of characters within one production, including not only different kinds of people but also anthropomorphized animals, objects, creatures, etc. Even with such variety, characters can easily feel as if they belong in the same world when only one approach to character design is used. But what happens when two or more styles are required in the same production?

Think of Disney's *Snow White*, for example, which combines a realistic heroine with cartoony dwarves and animals. Why do we accept this combination?

If we imagine the most extreme versions of these two styles at opposite ends of a continuum, we can see that, though essentially realistic, Snow White has actually been handled with a fair degree of caricature and the dwarves' cartooniness has been modified towards the realistic. So by placing characters of different styles towards the center of the continuum, we give them enough common ground to co-exist believably.

Rule Breaker: Wildly different styles can co-exist within one production but only when this works with the underlying concept of the piece. The overall absurdity of a show such as *Harvey Birdman* is strengthened by the deliberate use of many styles. But in the context of a more traditional narrative, say a Pixar feature, this approach would undermine the sense of coherence. Even in a show like *Harvey Birdman*, however, you will find linking elements within the design of the various characters. In this case, for example, there is an overriding flatness to all of the design and an integrated use of color.

See also: *Human Characters*

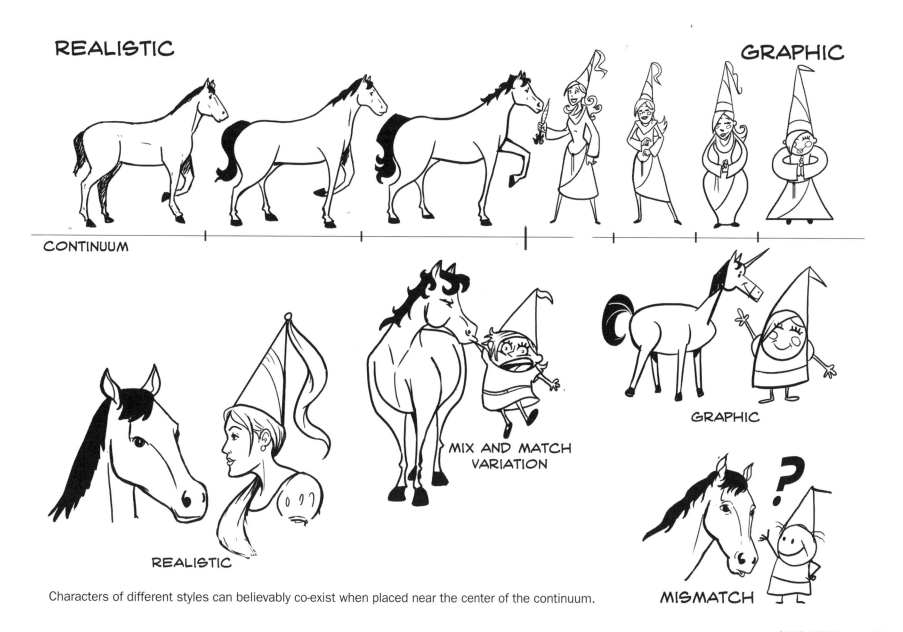

REALISTIC

GRAPHIC

CONTINUUM

REALISTIC

MIX AND MATCH VARIATION

GRAPHIC

MISMATCH

Characters of different styles can believably co-exist when placed near the center of the continuum.

CHARACTER DESIGN AND MOVEMENT

A CHARACTER'S ABILITY TO MOVE IS AFFECTED BY HOW IT IS DESIGNED.

BASIC

Design has a direct impact on how characters move, limiting some movements and allowing others. For example, cartoony action depends on cartoony design. In other words, you can't make just any kind of character do a big Tex Avery–style take, like the wolf in *Red Hot Riding Hood*. You have to build in the necessary overall stretchiness to make such extreme distortion possible.

Some stylized designs have very particular restrictions, such as the original 2D characters from *Peanuts* who can only be drawn in profile and full face. And within a style, individual characters can have specialized design needs: a realistic animal which is going to talk (e.g. Pongo from *101 Dalmatians*) needs a modified mouth and muzzle to make this look natural. And a character who is going to literally tie herself up in knots needs extra long limbs in order to get the job done.

ADVANCED

Design not only defines how characters can move, it also implies how they should move. In general terms, this means that when

Design affects both how characters can move and how they should move, so consider letting your flexible character stretch over that fence or limbo under it...

we see realistic design, we expect realistic movement. And when we see cartoony design, we expect cartoony movement, and so on.

This also affects our expectations of individual characters. A short, round character implies a different kind of movement than a tall, flexible one, and your end result will be more satisfying and have greater internal logic if you follow through on those implications.

... and while your round character can try to climb the fence, it might be easier and more fun to just let him bounce over it.

If that round character looks like he should be as bouncy as a rubber ball, the audience wants to see you deliver on that promise. And the performance of the tall character will be stronger if you incorporate his flexibility into his movement than if you treat him as a one-piece cutout which is dragged across the screen.

Example: Goofy is a character whose movement is highly related to his gangly, extra springy design.

Rule Breaker: This rule can be broken if you do so with a purpose. For example, making the tall, flexible-looking character unexpectedly rigid in his movements could imply something about his state of mind. And making realistic characters move in impossible ways could add to the already absurd tone of a particular piece, as in *How to Kiss*.

See also: *Lip Synch*

HUMAN CHARACTERS

REALISTIC HUMAN CHARACTERS NEED A DEGREE OF CARICATURE.

Of all possible animated characters, realistic human characters are the most challenging. This is because of the high degree of subtlety and complexity involved in real human expression. And also because the closer you come to real world elements, the more the audience automatically begins to compare what they see on the screen to what they intuitively know and live everyday. So while you are tackling the most demanding kind of animation, you are also being watched and judged more closely than with any other kind of animated performance.

One solution for this issue is to simply stay away from realistic design, unless it plays a real purpose in your piece. After all, humans, like all animated characters, can be created in any number of styles.

If you are committed to realism, then the answer lies in using at least some caricature in your designs. Even a small degree of caricature creates distance between your characters and reality, placing them more clearly in their own world. This helps the audience accept your characters on their own terms instead of automatically holding them up for direct comparison to the real thing.

Caricature also allows for more exaggerated movement, which tends to read more clearly in the graphic arena than directly referenced realistic movement. Literally realistic movement gets swallowed by the graphic nature of animation, making characters seem stiff, while a subtle use of exaggeration actually makes performance seem more natural. Compare the relatively realistic Prince from Disney's *Cinderella* to the extra long and lanky Roger in *101 Dalmatians* to see the difference a bit of caricature can make. Though clearly the more caricatured of the two, Roger still reads as real. But his looser design leaves room for a more natural and spirited performance compared to the wooden Prince.

This principle even holds true for the high realism found in CG. The main characters in *Ryan* appear almost photorealistic, but even here a critical degree of subtle exaggeration is used to keep the characters looking alive.

The key here is to think of what you are doing as an interpretation rather than a recreation of reality, even if you are aiming for the appearance of extreme realism. And don't become too dependent on technology here. Whether rotoscope, motion capture or performance capture, technology can only be an aid in the process of creating realistic human character and performance.

Overly realistic human characters can seem wooden...

... while a subtle use of caricature can make realistic performance more natural and lively.

Value-Added Point: Of course, technology which "captures" live performance does have an important role to play in the creation of realistic animation, with the captured material serving as a foundational first draft of the animation. *Snow White* demonstrates that long before live performance could be captured digitally, when rotoscoping required frame by frame tracing of live action footage, such technology greatly increased the range of animated human performance.

ANIMAL CHARACTERS

STRONG ANIMAL CHARACTERS BEGIN WITH REAL ANIMAL DESIGN.

Standing animal characters up on their hind legs and outfitting them with eyebrows and opposable thumbs on their front paws are well-established ways to increase their capacity for emotional expression and performance. But in the rush to humanize these characters, the potential of their natural physical traits shouldn't be overlooked.

Keep in mind here that the range of physical characteristics found in real animals is wider than we might think. Chickens, for example, come in a great variety of shapes and sizes, many with fanciful top combs and crazy tail feathers. Such characteristics can be applied "as is" into your designs, making them instantly distinctive, or used as inspiration for variations of your own.

More importantly, these characteristics often increase vocabulary for performance, whether by enhancing a cartoon cat's expression of fear with the natural raw energy of bared claws and puffed fur or undermining the authority of an overbearing rooster with a fanciful supersized comb which is forever flopping into his eyes.

In fact, the simple exaggeration of a well-known characteristic can have many unexpected applications for performance. For example, a giraffe with an extra long neck suddenly becomes a window washer's ideal helper.

Rule Breaker: As useful as real animal traits are, there are times when it's better to make an animal character as little like the real thing as possible. Sometimes this can be used to expand the animal's symbolic connection to the story's theme. Other times it's because realism doesn't work. For example, Jiminy Cricket might be harder to take seriously as a moral voice if designed as a realistic cricket. And sometimes, it's just because it's funnier, as with SpongeBob SquarePants whose design owes more to a manufactured kitchen sponge than to the actual sea creature.

See also: *Expressing Personality; Working with Non-Human Characters*

Real characteristics can create visual variety and inspire fanciful variations.

OBJECT CHARACTERS

OBJECT CHARACTERS NEED A BODY MAP.

BASIC

Where do you put the face on a pair of talking panty hose? Or on a bowling pin? Or on a kitchen chair? This is the kind of problem which arises when we attempt to bring inanimate objects to life. Humanoid objects such as dolls have key elements of expression like faces and hands built in, but for most objects this is not the case. So where, in such cases, do we begin?

Start by looking for a body map: elements in the structure of an object which resemble the bodies of living creatures. This is the first frame of reference your audience is going to turn to when dealing with object characters, so using it as the foundation for your decisions will automatically make your characters feel more real.

For example, the upper end of a bowling pin looks like a head sitting on top of a neck and shoulders. And the bottom resembles a simplified torso and legs. So if you wanted to give your bowling pin a face and arms, it's easy to see where they would logically go.

Finding a body map in a kitchen chair is a bit trickier. But if you try looking at it from various angles, you'll find that it has at least two potential maps. Keep in mind that you want the audience to

A chair has the potential for at least two body maps.

believe that this is a chair which has come to life, as opposed to a new creature made from a chair (a different kind of challenge which requires its own solutions), so make sure you use a map which allows the object itself to read clearly.

Object characters can be given arms and legs but there are also other options.

Example: Look for a good variety of object characters with well thought out body maps in Disney's *Beauty and the Beast*.

Value-Added Point: Can't find a body map? It may just be that the object, such as the pair of panty hose, isn't suited for the job.

ADVANCED

How completely does an object need to follow the body map of a living creature in order to read as a believable character? For example, does every object character actually need arms or legs? The answer depends on such factors as style and what the character will be required to do. In fact, there is plenty of room for variation here with some approaches relying heavily on elements drawn from living creatures and others more on mix and match from a number of sources.

Let's say your character is a pencil. In the classic cartoon approach, you might give your pencil a face, arms, hands, legs and feet, with the tip acting as a kind of tail. With a pencil's simple body map, this would be easy to do. But if the pencil isn't actually going to use hands, arms or biped legs in its performance, you could just give it a face and let the pencil tip fill in as a new type of foot. Now you have, in effect, a uniped character which could get around by jumping. Or you could use one of a pencil's real traits here and have your character glide around on his tip, perhaps drawing as he goes.

Sometimes even a face isn't necessary, if the body map reads clearly enough. The chair in *Chairy Tale* demonstrates this very clearly.

IMAGINARY CHARACTERS

IMAGINARY CHARACTERS NEED THEIR OWN HISTORY.

How can a character be conjured out of thin air?

This is the special challenge we face when creating imaginary characters. And it's not only how such characters look that needs to be conjured but also how they think, act and sound.

Characters which are grounded in the real world, such as humans and animals (and even objects, to a certain extent), can be compared to their real counterparts for inspiration. In fact, drawing on the natural traits of these counterparts helps give such characters essential underlying logic. But how can this be accomplished with monsters, aliens or other characters which only exist inside your head?

One key lies in understanding the cause and effect relationship which should exist between an imaginary creature and its history, just as it does for creatures which are real. And not just the imaginary creature's individual history needs to be considered, but also the story of its ancestors and, in fact, its entire race. This means you need to ask yourself such questions as where do these creatures come from? And under what conditions did they evolve?

For example, if you are creating aliens from another planet which travel to Earth on a spaceship, think about the physical conditions on their home planet. Just as creatures which live in

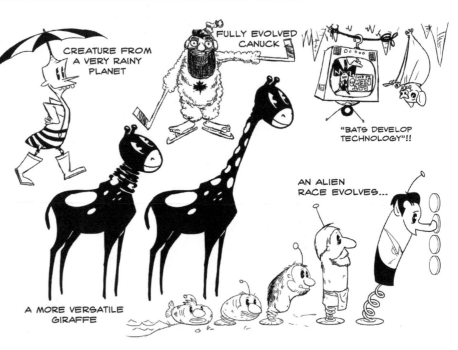

Beings adapt to fit their environments and then adapt their environments to fit their own needs.

total darkness under the sea do not necessarily develop eyes, so you can consider how creatures which come from a planet with very strong gravity or constant extremes of hot and cold might logically develop in order to survive.

Along the same lines, you can think about the cultural background of your aliens and how this interacts with their design. Have they developed written language or music? If so, what physical attributes have they developed in order to perform these feats?

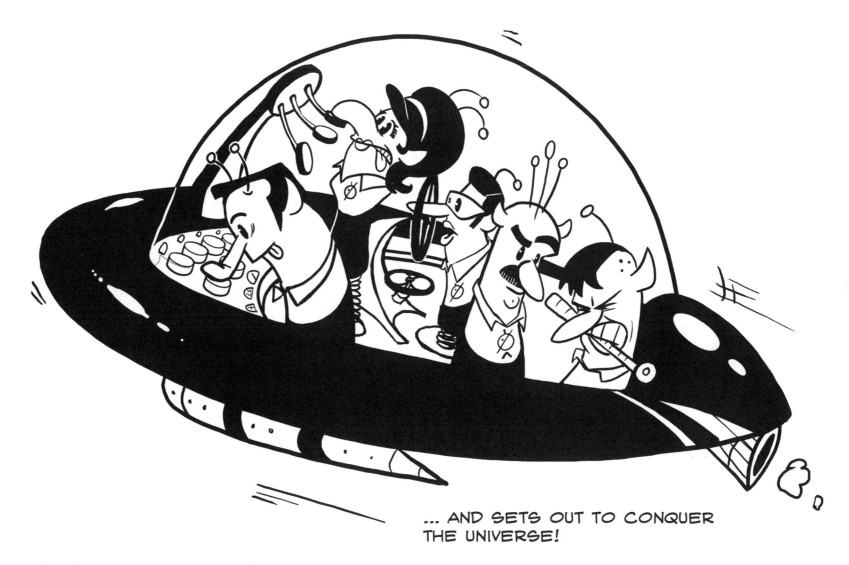

... AND SETS OUT TO CONQUER
THE UNIVERSE!

And on the technology side, be aware that if, upon landing, their spaceship opens and a set of stairs appears, you are implying that your creatures have two feet attached to jointed legs just as we do rather than, for example, gelatinous sliders or wheels which would benefit from a different means of exiting the ship.

Example: Look at the work of Ray Harryhausen for examples of creatures which are strongly grounded in logic. Harryhausen was a pioneer of this kind of thinking, which becomes especially important when animation is mixed with live action.

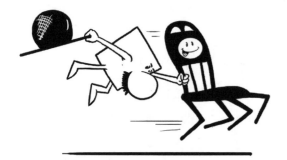

CHAPTER 3: ANIMATION FILM STRUCTURE
INTRODUCTION

Once we have a clear idea about content (concept, plot, character, visual strategies, etc.), we can begin to think about structure. Camera angles, camera moves, editing and transitional devices: these are the basic building blocks of all film structure. But when it comes to animation there is a special twist: while animation can make use of these basic structures, it also has other options.

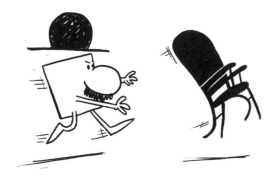

STRUCTURE AND MEANING

EVERY ELEMENT OF STRUCTURE HAS MEANING IN ITS OWN RIGHT.

BASIC

The elements of structure — camera angles, camera moves and editing — are more than just framing devices for your content. In fact, they all have meaning of their own. For example, a close up could mean look at this detail and a fade out could mean the absolute end of a thought.

Be aware here that each element has potential for more than one meaning. Its precise meaning in a given context actually depends on how it interacts with the content. So in one context, a zoom out from a close angle to a wide one could mean that something new is about to enter the scene and we need to make room for it. But in another context the same move could mean that this part of the story is over and we are exiting the situation.

This means that, as you make your structural decisions, you must ensure that the interaction between content and structure is adding up to the message you intend. As part of this, be aware that a poorly chosen structural element can actually change the meaning of a given shot.

ADVANCED

Digging a little deeper, we find that structure has other potential layers of meaning. For example, a close up can be used to simply showcase a detail but can also be used to enter a character's personal space. In other words, a close up can create intimacy.

Of course, the effect of this intimacy will be different if you are taking the audience closer to a scary monster rather than to a gorgeous heartthrob. In either case, part of the impact comes from the fact that the audience has been brought here beyond their control. With the monster, you are, through the camera, "forcing" the audience to look closely at something which may make them feel uncomfortable. Or allowing them otherwise impossible access to that good-looking star.

This, of course, is true of all structure — that the audience goes wherever you choose to take them. This use of structure opens up a new relationship between you and your audience, one that can be used to make audiences feel powerful or helpless; to create tension or to release it; to titillate, frustrate, comfort, scare or thrill.

EXAMPLE 1

HERE A ZOOM OUT MEANS SOMETHING
NEW IS ABOUT TO ENTER THE SCREEN
AND WE NEED TO MAKE ROOM FOR IT...

1 BEGIN ZOOM OUT 2 CONTINUE ZOOM OUT 3 CONTINUE ZOOM OUT 4 END ZOOM

EXAMPLE 2

...WHILE HERE A ZOOM OUT MEANS
THE STORY IS OVER AND WE ARE
EXITING THE SITUATION

1 BEGIN ZOOM OUT 2 CONTINUE ZOOM OUT 3 CONTINUE ZOOM OUT 4 CONTINUE ZOOM OUT
AND FADE TO BLACK

Every element of structure has potential for more than one meaning.

FRAMING

CAMERA ANGLES SHOULDN'T CALL ATTENTION TO THEMSELVES FOR THEIR OWN SAKE.

BASIC

Never use a fancy angle when a simple one will do.

Camera angles should always be chosen because they serve the needs of content. This is especially important to remember when you are considering using a showy angle just for the look of it. A fancy angle chosen for the wrong reasons can distract the audience by calling attention to itself rather than the content and can even change the meaning of the shot.

Also keep in mind that fancy angles create more work because everything within the shot has to be created with the same, difficult perspective. This is only worth the effort if the angle adds real value.

ADVANCED

Camera angles, like other elements of structure, should generally not be noticeable to the audience. Instead, they should direct the audience's attention to the images on the screen. But sometimes you want the audience to be aware of the camera. This can be a general awareness intended to jar the audience out of complacency, teasing us into overlooking the impossibility of animated documentary footage, for example.

It can also be a more focused awareness as in the short animated film, *The Fly*. In this film, we essentially don't see the titular hero; instead, the piece is shot from the fly's crazed point of view. This way the camera effectively becomes the character. And maintaining awareness of the camera angle becomes the equivalent of tracking the movements of a character who is actually on the screen.

The camera can take other roles, as well. In *Duck Amuck*, Daffy Duck is at war with his director, represented during most of the film as an off-screen force, visible only through how he manipulates not just the camera angles but the entire structure of the film.

See also: *Structure and Meaning; Off-Screen Sound*

EXAMPLE 1

HERE, THESE SHOWY ANGLES CREATE EXTRA WORK WITHOUT ADDING VALUE...

EXAMPLE 2

WHILE HERE, THEY SERVE TO INCREASE THE SENSE OF DANGER.

Framing needs to support communication.

CAMERA MOVES

CAMERA MOVES TAKE US FROM ONE ANGLE TO ANOTHER WITHIN THE SAME SHOT AND IN SO DOING CREATE MEANING NOT ONLY BY THE SHIFT IN ANGLE BUT ALSO BY THE MOVEMENT ITSELF.

BASIC

The key to understanding camera moves lies not only in what they do but also in how they do it.

Like a cut, a move shifts the camera from one angle to another. But unlike a cut, a move takes us along for the ride and that means we get to see not only the beginning and end angles but also everything in between. And that opens up a new world of possibilities.

For example, by showing us everything, a move can keep the audience completely oriented in time and space, often a critical factor in communication. Let's say your film starts on a wide shot of a row of houses with identical front doors and then shifts to a close up of one of those doors which then opens to reveal your hero. If you make this shift with a cut rather than a zoom in, how will your audience know exactly which house this is? This kind of orientation is generally important for the audience, if only for their comfort. However, it becomes critically important if, for example, your plot hinges on the hero accidentally walking into the wrong house later in the script.

VERSION ONE 1 2

LONG SHOT OF STREET CUT CLOSE UP OF DOOR

Here we cut to a close up of a door but which door is it?

vs

VERSION TWO 1 2

CONTINUOUS ZOOM IN FROM LONG SHOT TO CLOSE UP OF DOOR...... END ZOOM IN

Here, by using a zoom in, we know exactly which door this is, no matter how close we get.

Camera moves keep the audience oriented in time and space.

Example: Watch in *Feed the Kitty* how a camera move which pans along with Anthony the Bulldog, as he is literally swept across the kitchen by his irritated mistress, not only draws us into Anthony's humiliation and helplessness but also offers us the location and proximity of all the key elements in the sequence which follows.

PAN/ZOOM OUT FROM POSITION A TO B.
PAN RIGHT AND ZOOM IN TO POSITION C AND PAN UP FROM C TO D

Distortions, such as forced perspective, can add value to a camera move, when used judiciously.

ADVANCED

Because animation is a created reality rather than a recorded one, we have the option to draw even more meaning from camera movement by adding distortion to its usual properties.

For example, in *King Size Canary*, a space which has been established as being quite small suddenly stretches during a pan, becoming as long as a football field to exaggerate the impact of a gag before reverting to its original size. Be careful, though, before you start bending space, that this approach fits the overall approach of your project. Overt distortions work best in stylized productions. When the approach is closer to reality, distortions are still possible but generally need to be handled with more subtlety.

See also: *Creating a Universe*

EDITING

ANIMATION STRETCHES THE VOCABULARY OF EDITING.

BASIC

The basic language of editing — cuts, dissolves, wipes, etc. used to string scenes together — can be applied to animation in much the same way it is used in live action. But this basic language can also be supplemented with techniques which are more specifically tied to animation. One such technique is the animated transition.

Animated transitions can take many forms and are often customized to work with the overall imagery of the project. For example, in *Sea Dream*, which focuses on a child's underwater fantasy, a simple transition is created with dense schools of fish which fill the screen at the end of one scene. As they pass off screen, we see that behind them, a new scene has begun.

ADVANCED

At its most basic, specialized animated editing takes standard editing techniques, such as wipes, and dresses them up in fancy new gear. But animated editing can go much farther, opening up potential for dramatic transitions, for example, which carry extra layers of meaning and challenge the essential nature of editing.

Yellow Submarine is structured around a submarine voyage which passes through various fantastic worlds. One noteworthy transition from world to world (or sequence to sequence) is created by a vacuum monster which literally sucks up everything in sight: first, all the other sea creatures, then the submarine with everyone on board and then the entire setting. Finally it sucks up itself, releasing the submarine into the blank white space which makes up the next world. This transition is not only visually amusing, but through its seamless coherency also reflects the gentle questioning of reality (both actual world and filmic) which underpins the entire production.

Here, a basic animated transition takes us from one setting to another.

ALTERNATIVE STRUCTURE

ANIMATION CAN BE CREATED WITH A STRUCTURAL LANGUAGE ALL ITS OWN.

Though animation can and often does adopt the structure of live action with its use of camera angles, camera moves and editing techniques, it's important to remember that animation is, in fact, distinctly different from live action. For example, in live action, angle changes are created by physically moving the camera from one position to another. By contrast, in some animation techniques, such as CG, what we call "camera" is entirely a digital simulation of what a live action camera does. In other techniques, there is an actual camera but it has limited movement and much of what are perceived as "angle changes" are, in fact, created with artwork.

Of course, a digital simulation doesn't have the physical restrictions of an actual camera and neither does artwork which can be rendered in the most extreme perspectives imaginable. In other words, we may be using these techniques to simulate a live action camera, but we have other options.

For example, we can choose to set up a totally fluid environment in which every shift between vantage points is created with animated movements or metamorphosis. Elements can slide on and off the screen, animate into full detailed focus and then animate back into soft focus background mush. Characters can stay static while the environment around them transforms; background elements can evolve into characters and visa versa.

The Street offers an excellent example of this fluid approach to animation structure.

Value-Added Point: Look to such areas as gaming and the web for other evolving animation structural languages. Here animation is combining with new media oriented towards new kinds of storytelling and communication, resulting in a distinctly different use of structure.

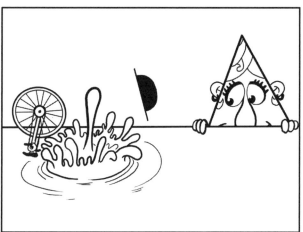
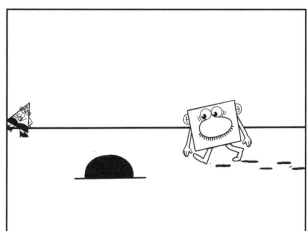

Animation can choose to simulate live action or create structures all its own.

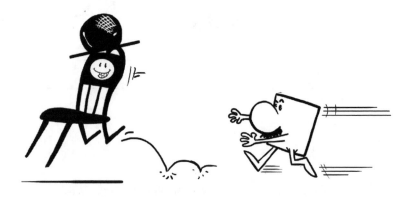

CHAPTER 4: SOUND
INTRODUCTION

Though animation is predominantly a visual medium, the role of sound shouldn't be underestimated. In fact, animation is more often a complex interaction of visual and sound, an interaction which creates a new range of communication possibilities.

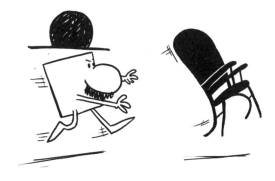

SYNCHED SOUND

IT'S EASIER TO SYNCHRONIZE MOVEMENT TO SOUND THAN VICE VERSA. THEREFORE IN ANIMATION, WHEN EXTENDED SYNCHRONIZATION IS REQUIRED, THE SOUND IS RECORDED FIRST.

BASIC

Imagine a dance performance where the orchestra has been instructed to follow the rhythm of the dancers instead of the other way around. The result would likely be a loose relationship between music and movement at best, with synchronization achieved around only the broadest elements of musical phrasing and beat.

But animation often requires precise synchronization, for example, in lip synch or in production numbers such as *The Sorcerer's Apprentice* in *Fantasia*, where even such details as water splashes are tightly timed to the music.

The key to creating this level of precision, particularly when extended synchronization is required (as in dance numbers or conversation versus a single explosion), is to first record the sound and then create the animation, using the sound as a guide.

Once sound is recorded it can be broken down into its component parts such as musical beats, beginnings and ends of phrases (both verbal and musical) and key elements of speech. With this information in hand, the synchronization between sound and animation can then be planned very precisely, right down to the frame.

ADVANCED

There are other options for handling sound in animation. For example, where synchronization is looser (as in background music) or more contained (as in isolated sound effects such as that single explosion), sound can be added once the animation is completed. Where extensive synchronization is required but the sound isn't available before production begins, a click track which provides a precise foundation beat can be used for planning the timing of both the animation and the sound. When both elements are planned to the same beat structure in this way, a good level of synchronization can be achieved.

And though usually we focus on maintaining control here, a bit of improvisation sometimes creates an unexpected synchronization which then generates new ideas for how sound and visual can work together. Sounds can be shifted forward or back and experimental elements can added in just to see what happens. For example, try adding marching music to a sequence of characters walking around. You might be surprised to discover that most of the walks synch nicely with the music, suddenly transforming your walking sequence into a parade.

See also: *Lip Synch*

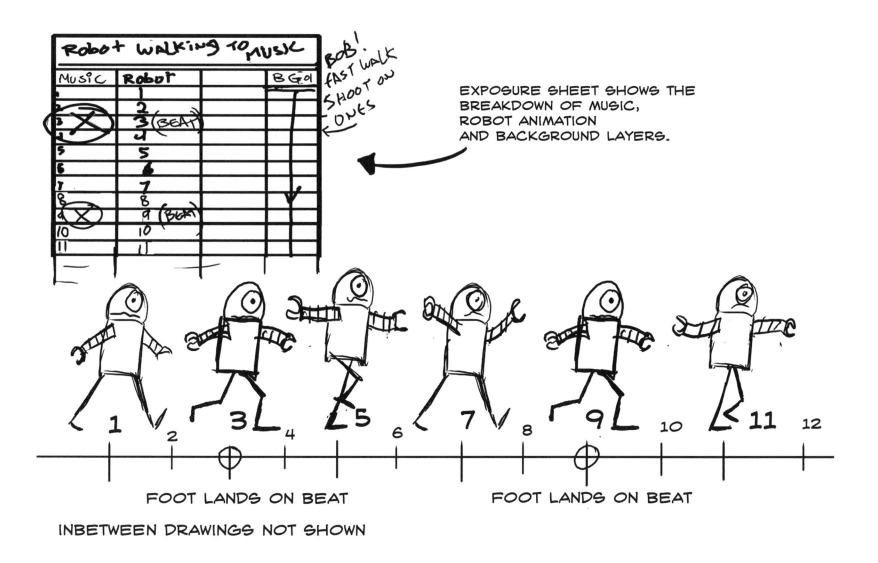

EXPOSURE SHEET SHOWS THE
BREAKDOWN OF MUSIC,
ROBOT ANIMATION
AND BACKGROUND LAYERS.

FOOT LANDS ON BEAT FOOT LANDS ON BEAT

INBETWEEN DRAWINGS NOT SHOWN

Animation can be planned precisely to a broken down soundtrack, here allowing a character to walk exactly on the beat.

DIALOGUE

DIALOGUE IS MOST EFFECTIVE WHEN USED SPARINGLY.

BASIC

When planning dialogue, try to see how few words can be used to get your point across. The key to achieving this lies in remembering that the words themselves are only one part of a larger system of communication. In fact, the way the words are said also creates meaning, as do the accompanying facial expressions, gestures, reactions of other characters and even camera angles, timing and editing.

So instead of having your character say, "Oh no! Our worst fears have come true; it is a flying saucer!", you can just have her say in an aghast tone, "Look!" as she points off screen. Then have the other characters turn and look where she is pointing and suddenly freeze with fear. Finally, you can cut to let the audience see what the characters are seeing — a giant alien space ship which has just hovered into view.

Notice how this approach amplifies meaning and emotion: we not only hear the spoken words, we also hear the character's fear in her tone of voice. And we see even more fear in the reactions of the other characters. To cap it off, we have to wait to find out what everybody is so upset about, making us impatient and tense and therefore more emotionally reactive when the big ship finally appears on the screen.

Rule Breaker: *Rabbit Seasoning,* a cartoon comedy of manners, appears to be nothing but dialogue. However, the real content of the film — the rivalry between Bugs Bunny and Daffy Duck — is actually played out as much by contrasts in their body language and manner of speaking as in the words themselves.

EXAMPLE 1

In animation, words are only one part of a larger system of communication.

ADVANCED

Taking the idea of using fewer words to its extreme, how about dialogue with no words at all? There are many examples in animation where words are replaced with gibberish, giving us a universal language of emotional sounds.

These sounds can be created in a variety of ways, using voice, musical instruments, sound effects, etc. *Every Child* offers an excellent example of gibberish dialogue created with voice effects.

All the characters in the film are assigned their own distinctive sounding language such as the melodramatically operatic sounds given to a highly emotional romantic couple.

Used in conjunction with other elements such as gesture, gibberish can convey a surprising amount of information, not only emotional but even thematic. In *Gerald McBoing Boing*, the main character's inability to speak in anything other than sound effects becomes both an emblem for difference and the crux of the story as the "normal" adults around him struggle to accept him as he is.

GIBBERISH CREATES A UNIVERSAL LANGUAGE

Value-Added Point: Whether your characters are quoting Shakespeare or literally spouting gibberish, how the words (yes, even gibberish "words") are said is critical to accurate communication. So to make sure you get exactly the right reading of your dialogue, go through the script before going into recording and mark such things as essential pauses, key words which need special emphasis and what emotional quality you want specific words and phrases to convey through intonation.

See also: *Making Movement Matter; The Animated Script*

ELEMENTS SUCH AS EMPHASIS, TIMING AND INTONATION CAN CHANGE THE MEANING OF DIALOGUE.

Is that a **PINEAPPLE?!**

Is THAT.... a pineapple?

IS.... that a pineapple?

NARRATION

NARRATION SHOULD COMPLEMENT ACTION RATHER THAN REPEAT IT.

BASIC

Be careful when you use narration that the soundtrack does more than simply repeat the same information being shown in the action. If the audience can see that your hero is climbing down into the cave to confront the dragon, you don't have to tell them as well.

Instead, use the narration to complement the visual. This can take many forms. For example, the narration can offer general ideas which the visual makes specific. So the narrator might simply tell us that the hero is off to fight the dragon (general information) while the visual shows specifically how this actually happens: we see the hero climbing into his armor and riding across the plain to the mountain where the dragon lives and so on.

Examples: *Sea Dream* and *Special Delivery* both use narration to offer general information while the visuals show the details. For example, the narration in *Sea Dream* tells us that the heroine has tea with her octopus friend while the animation shows us exactly how an octopus can use her many arms to pour a cup of tea and simultaneously offer both cream and sugar.

Rule Breaker: Narration can closely match action if done deliberately, as in *The Scarlet Pumpernickel*. Here the mirroring of action and narration heightens the overwrought staginess of the story while simultaneously making fun of that same trait, a joke we are let in on when the characters themselves begin to comment on the hoariness of the device.

It was a dark and stormy night. Suddenly a shot was fired... and then the maid screamed.

I'll never forget the night... our cosy life came to a sudden end.

Narration should complement the visuals rather than repeating what is being shown.

ADVANCED

There are other kinds of relationships which can be set up between narration and visual. For example, you can contrast an authoritative narration with absurd visuals thus parodying old style educational films. The narration of *How to Kiss* offers apparently serious advice on the art of kissing only to undermine that tone with visuals in which two lovers find it hard to press lips without doing each other serious damage.

Or you can use narration to carry the plot and therefore the continuity, freeing the visuals to respond to the narration in a much looser way, for example as a series of blackout skits.

Value-Added Point: Keep in mind that there are also many types of narrators, each of which affects overall communication in a different way. So even though your narrator never appears on the screen and seems to be outside the content looking in, he or she is actually a kind of character in your piece whose nature and purpose needs to be precisely defined.

So is your authoritative narrator a voice of God giving us urgent information or a concerned parent reassuring us that everything is going to be all right? Of course, a narrator could also be a child commenting on an adult situation or an object commenting on a human situation. And don't forget that, in the right context, a narrator can actually become an active player in your piece, engaging with the other characters in a manner ranging from friendly banter to open hostility.

Here's our happy doofus now..

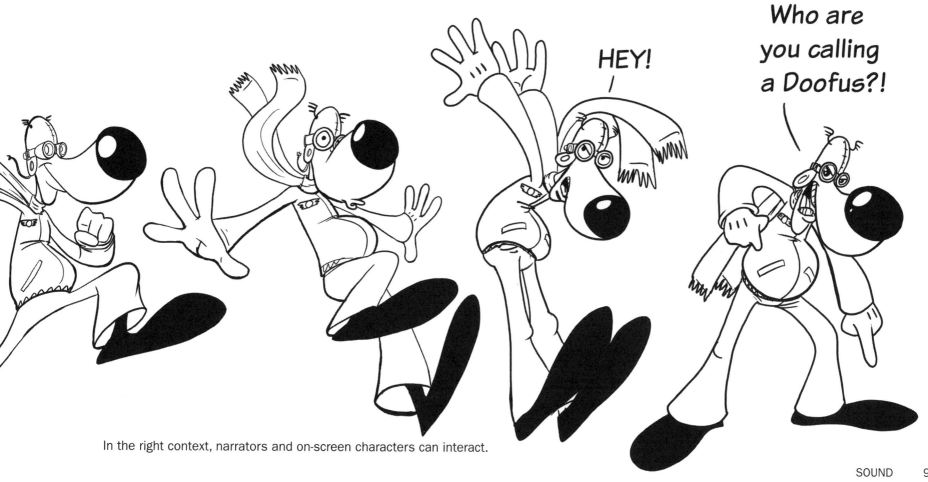

HEY!

Who are you calling a Doofus?!

In the right context, narrators and on-screen characters can interact.

CHARACTER VOICES

VOICE AND CHARACTER CAN BE MARRIED THROUGH RELATED TRAITS.

BASIC

Voice plays an important role in bringing animated characters to life. A well-chosen voice will suit both a character's design and its personality. But how do you make such a match, especially when the characters you are dealing with aren't necessarily human?

One way is by looking for key elements connected to your characters which can be translated into vocal terms. On the broad scale, since all animated characters tend to have a degree of caricature, it makes sense to give their voices some caricature too. This can be achieved by taking the distinctive qualities of natural voices and exaggerating them, pushing a high-pitched voice into squeakiness or a clipped delivery into a machine gun staccato.

Customize this use of caricature by looking for specific traits within your character which can be expressed through voice. These can be personality traits. For example, Bugs Bunny's tough Bronx-Brooklyn accent was inspired by his cool, street-smart attitude.

Or they can be physical traits. A motorcycle might also have a tough voice but this one characterized by a deep-throated rumble reflecting the power of its engine.

Value-Added Point: Unless it's intentional, voices need to be intelligible. So don't let caricature override meaning.

ADVANCED

You can also create strategies which match voice quality to the properties of an entire production. The amateurish voices of the kids in *South Park* are a logical match with the deliberately amateurish quality of the design and animation. The overall effect of this also reinforces an implied underlying premise of this show, that it is not only about kids but made by kids, presumably without adult censorship and therefore able to be brutally honest.

See also: *Caricature in Animation; Human Characters*

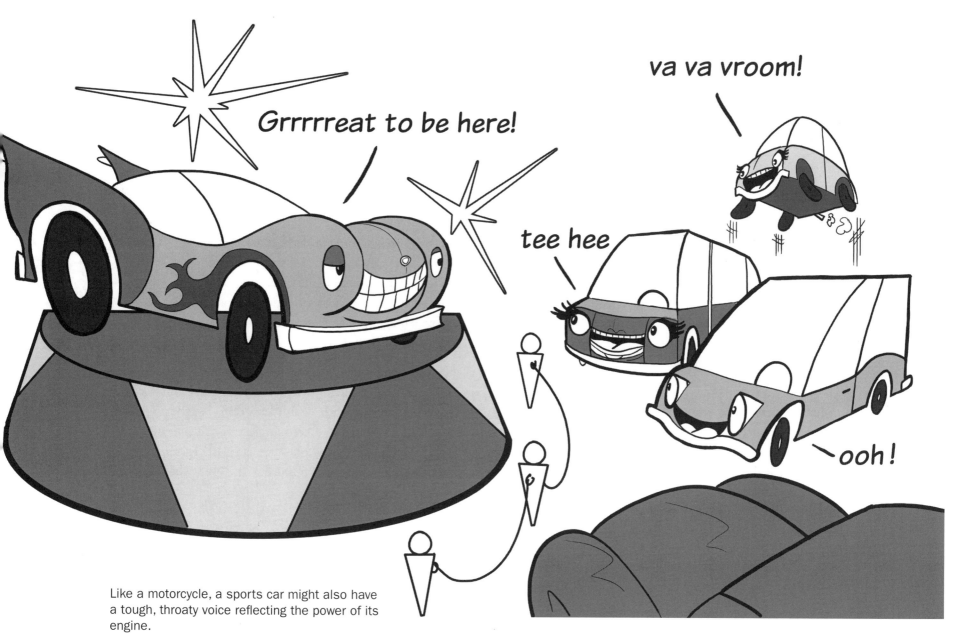

Like a motorcycle, a sports car might also have a tough, throaty voice reflecting the power of its engine.

SOUND EFFECTS: REALISTIC VS. STYLIZED

ANIMATION CAN USE BOTH REALISTIC AND STYLIZED SOUND EFFECTS.

BASIC

Sound effects in animation can range from realistic to stylized but the impact of each approach is distinctly different.

In a sword fight, for example, the realistic sound of metal on metal makes the swords feel more real, regardless of how they are visually rendered. Visuals alone won't convince us that these are actually dangerous weapons with weight and strength, but, interestingly, realistic sound effects will. And along with this conviction comes a raised level of attention and concern as we are drawn into the belief that someone could get seriously hurt here.

But watch what happens when you replace those realistic effects with stylized ones. Loud swooshes as the swords swing through the air followed by exaggerated, echoing clangs can make the action feel more theatrical than real, reminding the audience that no one here is at any real risk of dying. Removing this most serious concern can have a number of effects. For example, it may significantly lighten the mood, even shifting the tone from drama to all-out comedy.

ADVANCED

Another approach to stylization involves musical sound effects. These can be used in place of many realistic effects such as doors slams, blinks, footsteps, etc.

Beyond adding weight and emphasis to movement in much the same way as more realistic effects, musical effects have special qualities of their own. They can, for example, add an element of emotion, giving us footsteps which are not just slow or fast, heavy or soft, but also happy, sneaky, or sad.

And they can communicate other information which might not show up in realistic sound. For example, the musical effect for climbing up and down stairs used in Warner Brother shorts doesn't just tell us that characters are getting closer or farther away. Instead, with its rising and falling tones, we can actually hear whether characters are going up or down those stairs, even when they are completely off screen.

See also: *Off-Screen Sound*

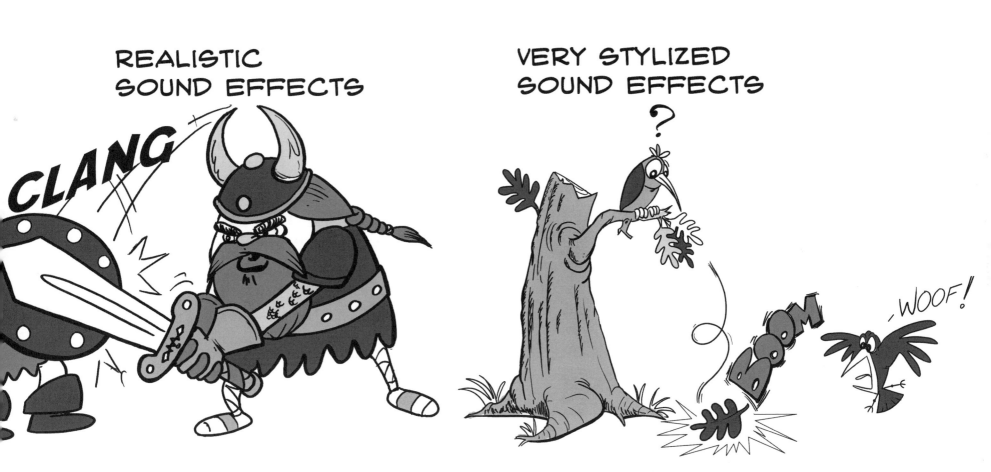

Realistic sound effects make these swords feel more real while stylized effects support fantasy or absurdity.

THE ROLE OF MUSIC

MUSIC CAN BE USED AS AN EXTENSION OF CHARACTER.

BASIC

Beyond the important role of setting mood, music in animation can be used in a highly controlled manner which ties it closely to the feelings of specific characters. In *101 Dalmatians*, for example, making Roger a songwriter allows the music to shift seamlessly from background sound to wordless voice of a character. The sequence which introduces Cruella begins with Roger composing a song which becomes background music as he retreats to his upstairs studio, leaving Anita to fend with Cruella on her own. Once up there, Roger adds his own instrumental voice to the background mix, banging on the piano and blasting a trombone, directly above Cruella's head, in a clear (if somewhat cowardly) statement of protest about her presence in his home.

Value-Added Point: While not its only purpose, music and mood do go hand in hand, so much so that if there is a gap between the mood of the music and that of the rest of the content, the music's mood will almost certainly prevail. So be careful when you marry music and visual that they are a good match. On a basic level this can simply mean, for example, that happy visuals need happy music. In a more complex approach, differing moods in music and visual can work together in a meaningful way, for example, pairing violent visuals with classical music to create a sense of emotional detachment.

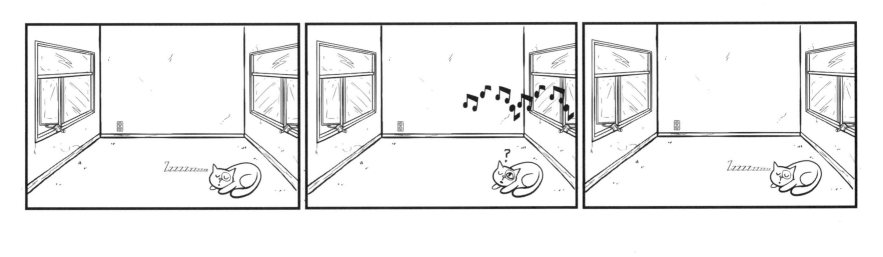

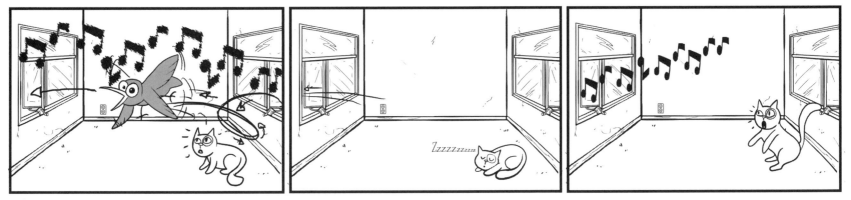

Here, music becomes an extension of this crazy bird both on and off screen.

ADVANCED

The intertwining of music and character can also be reflected in the structure of the music. In the "We Are Siamese" sequence from *Lady and the Tramp*, the music reinforces the key point that Lady is being displaced in the household by the newly arrived Siamese cats. This is accomplished not only by the obvious fact that the song is sung by the cats in praise of their own wondrous selves but also by the relationship of the music's structure to the cats' performance.

The main action of the sequence involves the cats systematically wreaking havoc in the parlor while Lady tries fruitlessly to stop them. Throughout the sequence, the cats are highly synchronized to the music's strong, persistent rhythmic motif, which lends their destructive actions an air of authority. Moreover, neither the rhythm structure nor the equally emphatic melody vary much throughout the piece, broadcasting and reinforcing the cats' unwaveringly confident state of mind.

By contrast, Lady's melodic and rhythmic relationship with the music is so underplayed as to appear almost nonexistent. With increasing frustration, she seems to scramble to stay with the music, refusing to concede that she is fighting a losing battle.

Her changed position is made even clearer by the fact that, in the previous sequence, the music belongs entirely to her, reflecting every nuance of her shifting emotional state from happy and secure to uncertain: a perfect prelude to the arrival of the cats.

See also: *Off-Screen Sound; Timing and Rhythm Structure*

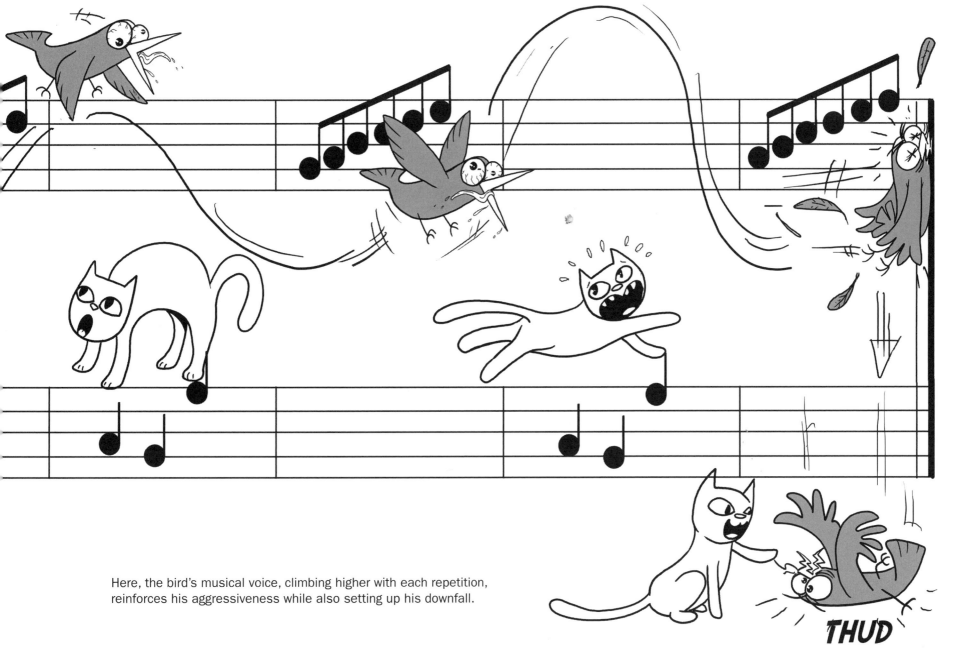

Here, the bird's musical voice, climbing higher with each repetition, reinforces his aggressiveness while also setting up his downfall.

THUD

OFF-SCREEN SOUND

IMPLYING ACTION THROUGH SOUND IS SOMETIMES MORE EFFECTIVE THAN SHOWING THE ACTION ITSELF.

BASIC

Picture and sound can work together in many ways. Sometimes, for example, the camera can be looking at one thing while the sound comes from a source which can't be seen. This is what is called off-screen sound, a versatile tool which can be used in many ways.

Among other things, it can be used to generate tension or surprise. Think here of the potential for scary off-screen bangs and bumps to trigger our imaginations, playing on our tendency, in the face of the unknown, to assume the worst: yes, those noises probably are just the cat but they might also be chainsaw-toting zombies.

There are other situations where hearing can be more effective than seeing. Some actions, for example, are difficult to animate effectively. In such cases, implying the action with off-screen sound may be the better approach. In *Dumbo*, the sequence where Timothy becomes inebriated proved difficult to animate effectively. So instead of directly showing this action, Timothy is shown falling into a bucket of whisky. Then we hear his voice grow drunker and drunker till finally he surfaces, thoroughly hammered.

Off screen sound implies off screen action.

ADVANCED

Off-screen sound implies not only off-screen action but also off-screen space. The sound of an unseen infant crying brings to mind the nursery as well as the baby herself.

The effect of implied space can be used in conjunction with implied action, allowing for more elaborate off-screen scenarios. Perhaps you could have a character attempting to relax in the den of his mansion, who repeatedly has to go off screen to answer the door. Each time the doorbell rings, he has to take an endless trip through the many unseen rooms of the house, conjured only by the various sounds we hear emanating from them, as the hero encounters a series of increasingly familiar obstacles. Each trip is capped by some new and unexpected result upon his return to the den.

And imagine the possibilities for tension building for a nervous character stuck in that same den, listening first to the front door unexpectedly opening and then to the endless approach of some invisible and therefore unknowable danger (maybe this time not just the cat).

Example: *Charade* uses off-screen sound to establish not only an off-screen space but an off-screen audience to fill it as well. We see the charade contestants as they attempt to act out various movie titles, etc. but we only hear the audience shouting out their guesses from off screen. We presume that these unseen characters are facing the on-screen contestants, which means that they are sitting behind or beside us, a neat trick which makes us part of the game.

Off screen sound also implies off screen space.

SILENCE

SILENCE, OR NEAR SILENCE, IS SOMETIMES MORE EFFECTIVE THAN SOUND.

Don't be afraid of a little silence in your soundtrack. It's quite common to load on the sound with layers of dialogue, sound effects and background music. But dropping the density of your sound, even to the point of no sound, can be as refreshing to the ear as a change of pace in movement is to the eye.

For example, wall to wall background music isn't always necessary. Taking away the constant music leaves room for smaller sounds which, in silence, can draw an audience's hungry ear.

Silence, or near silence, can also create contrast which gives loud sound more impact. So over quiet classroom sounds of pens on paper, the sudden screech of nails on a blackboard reaches us unimpeded, with nothing to soften its assault on our ears.

Even within music, a little silence can be useful. Extending a pause in a musical piece for an unexpected extra beat can reinforce the sensation of holding our breath, waiting for something to happen, extending tension which is released when the music finally resumes.

Examples: A good example of less sound can be found in *101 Dalmatians*, when Roger and Pongo are awaiting the birth of the puppies. Here the comforting structure of background music which fills in all available emotional space is replaced with the repetitious ticking of a clock. The tense, empty desolation of this sound is broken up by bursts of music whenever there is a bit of news. After the long stretch of deprivation, the return of music (implying a return to order and emotion and an end to waiting) has a heightened impact on the audience, helping us to really feel the characters' joy and relief.

Value-Added Point: Keep in mind that going to the extreme of no sound (handled, in reality, with some degree of background sound called white noise) is another expression of exaggeration within animation.

See also: *Caricature in Animation; Varying the Pace*

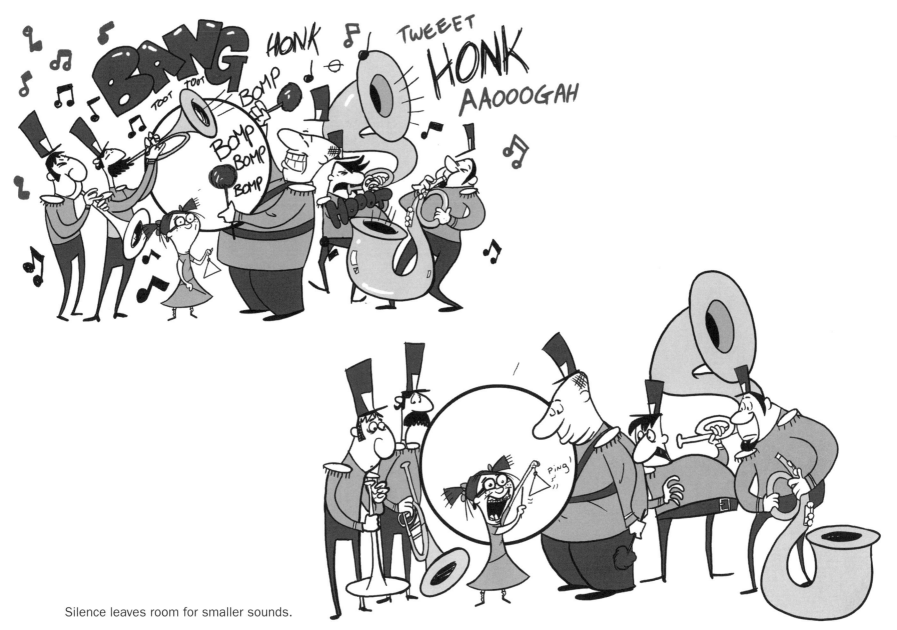

Silence leaves room for smaller sounds.

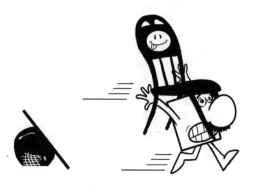

CHAPTER 5: ANIMATION TECHNIQUE
INTRODUCTION

From pencil drawings to computer graphics to sand on glass, animation can be created with a wide variety of techniques, each of which has its own specific characteristics. Animation also has many outlets ranging from the most personal expression to big budget CG features, including industrial applications, animation for the web and the ever-growing field of video games.

Here, though, we will look less at the specific details of animation for individual techniques or outlets and more at principles which can be universally applied, adapted and even inverted towards creating more effective, more meaningful movement.

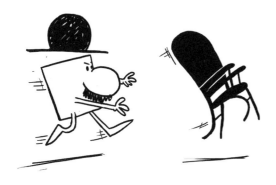

REALISTIC ANIMATION VS. STYLIZED

ANIMATED MOVEMENT CAN RANGE FROM HIGHLY REALISTIC TO HIGHLY STYLIZED.

BASIC

There isn't any one correct way to animate. Instead, there are many ways, each with different advantages. These can be divided into two broad categories: realistic and stylized.

Realistic approaches, such as classical animation, are based on how things work in the real world. So it is assumed that the laws of physics, such as gravity, are in effect. And that things have consistent mass. And that human and animal characters have bodies with muscles, bones and joints. And that, just as in the real world, all of this affects how things move. This doesn't exclude fantasy, caricature, or even the bending of some of these rules. But it does, for the most part, put natural boundaries on the movement. So you can't just spin a character's head 360 degrees for no good reason or have a wingless character suddenly be able to fly.

Stylized animation, by comparison, plants itself clearly in an invented world and so assumes that the rules of movement are up for grabs. Stylized approaches still need boundaries for consistency, but they are boundaries defined by the animator rather than by nature. So a character might be conceived as being made of rubber or cotton baton and be animated accordingly, or be able to fly with or without wings.

One advantage of realistic animation is that it can make movement more nuanced and less mechanical while also giving characters greater substance. This makes characters feel more real and extends their capacity for performance. On the other hand, with stylized animation there are no limits on the use of imagination. And in moving away from real world references, stylized animation is given license to explore territory which could be too sensitive or weird for realism to touch.

Examples: Look for realistic animation in *101 Dalmatians,* more stylized animation in Warner Bros. shorts and highly stylized animation in such UP shorts as *Gerald McBoing Boing*.

REALISTIC MOVEMENT / EMOTION

JOY

ANGER

FEAR/SURPRISE

NEUTRALITY

SADNESS

ADVANCED

The ability to express emotion is a key issue in animation. Realistic and stylized approaches both address this issue but in distinctly different ways.

In realistic animation, the broad and fine movements used by living creatures to express emotion are analyzed and recreated. This process requires a deep understanding of such things as how muscles work: their anchor points, how they show tension, how movement is triggered and how all this contributes to the expression of a specific emotion. This ability to recreate a literal expression of emotion is one of realistic animation's great strengths, the very one which opens up possibilities for performance which is both subtle and sustainable.

By contrast, stylized animation relies more on caricatured emotional expressiveness and gains additional strength from its ability to show emotion through analogy, with characters who can actually spin out of control or explode with joy. Instead of capturing how we look when expressing emotion, stylized animation can capture how we feel when experiencing emotion.

Examples: In *101 Dalmatians*, the sequence in which the puppies are born offers a sustained classical performance, tempered with a just a little cartooniness. Here we see varied action and emotions which range from sadness and fearful impatience to unadulterated joy.

In *Red Hot Riding Hood,* the wolf's extreme reaction to RH demonstrates how far from reality animated emotional expression can go and still make its point.

See also: *Making Your Universe Real*

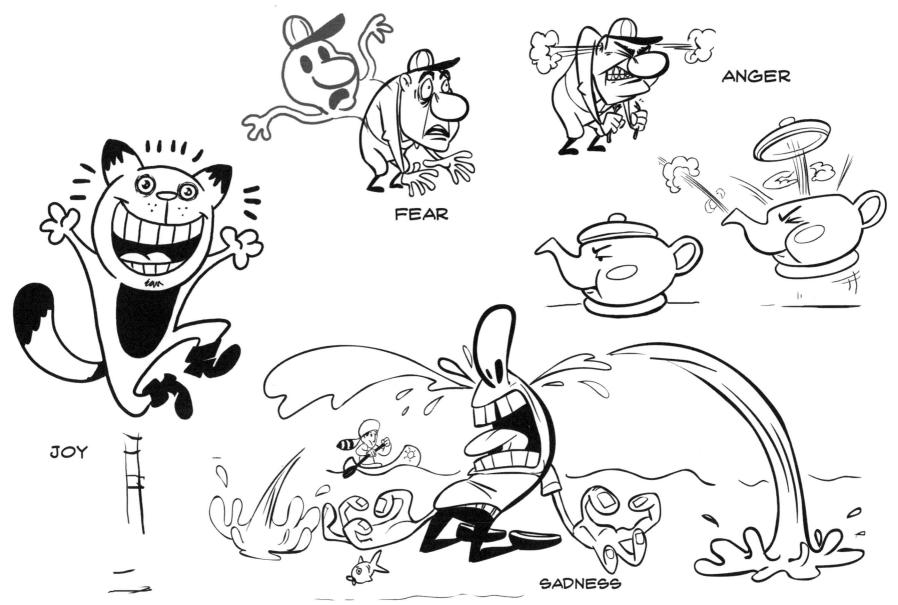

FEAR

ANGER

JOY

SADNESS

FULL ANIMATION VS. LIMITED

ANIMATED MOVEMENT CAN RANGE FROM EXTREMELY FLUID TO ALMOST STATIC.

BASIC

Within most techniques, animation can be full or limited. Full animation refers to the fluid motion typically found in Disney features. The stiffer motion of limited animation is commonly found in TV series and, in an even more limited approach, in web animation.

But what creates this difference in fluidity? Keeping in mind that animation involves breaking action down into a series of positions, one key to fluidity lies in the number of positions created for every second of movement.* The more positions used, the more fluid the movement becomes. Limited animation typically ranges from 3 to 8 positions per second while full animation averages around 12 positions per second.

This means that in full animation, each position is held on the screen for 2 frames or less. In limited animation, each position is held longer, typically for 3 to 8 frames. Based on this, animators will describe full animation as being "shot on twos" and limited animation as being (for example) "shot on threes" or "shot on eights."

Keep in mind that the nature of the poses you create for your animation also affects fluidity. And be aware that in the more extreme uses of limited animation, only some body parts move while others stay perfectly still.

Full animation is generally associated with realistic movement and limited animation with stylized movement used for economy's sake. But full animation can also be used to create fluid, stylized movement, such as in the "Toccata and Fugue" section of *Fantasia*. And the exaggerated timing of the limited approach is sometimes used in realistic animation to give the movement more snap.

There is also a tradition of producing realistically designed super-hero series with limited animation. The effect of this combination ranges from dramatic at best (the Fleischers' *Superman*) to ridiculous at worst (*Rocket Robin Hood*), the latter paving the way for the tongue-in-cheek version seen in such shows as *Harvey Birdman*.

* Based on the traditional projection standard of 24 frames per second.

FULL ANIMATION

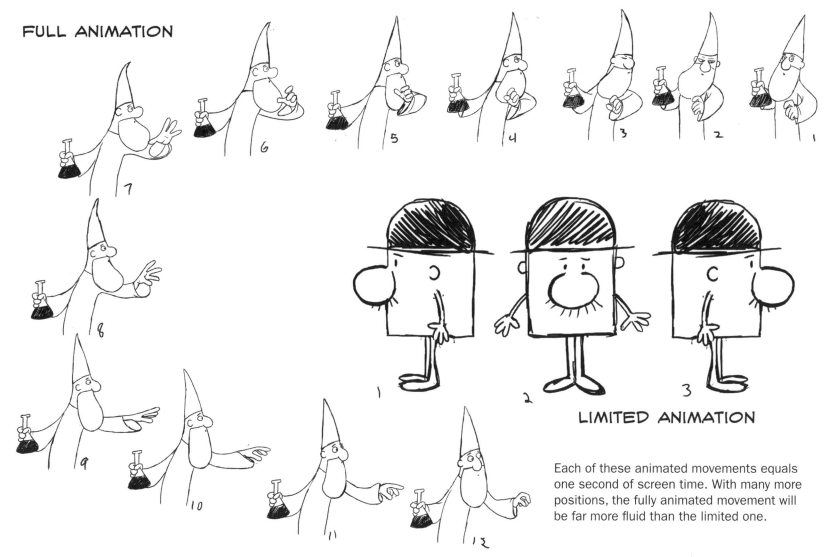

NOTICE HAT AND BEARD KEEP MOVING AFTER HEAD HAS TURNED

LIMITED ANIMATION

Each of these animated movements equals one second of screen time. With many more positions, the fully animated movement will be far more fluid than the limited one.

ADVANCED

Deciding how fluid your movement should be goes beyond a simple decision of realism versus the bottom line.

Limited animation, with many fewer positions to create, is often associated with economy over quality. But TV shows such as *Rocky and Bullwinkle* make a virtue of deliberately crude limited movement, creating humour by contrasting it against sophisticated dialogue and narration.

Limited animation can also be used to keep an audience aware that what they are looking at is art and not a simulation of reality. This opens the door to other interesting applications. For example, limited approaches can create staccato rhythms, an effect which can even be combined with full animation within the same production. This creates visual interest but also can be used as a visual strategy to show us something about the differences between two characters, a smooth salesman and a jumpy customer, perhaps, or a character with limited abilities versus one who is more fully developed.

Full and limited movement can also be combined in one character with some body parts kept limited and other parts moving fluidly, as seen in such films as *Gerald McBoing Boing*. Again this has multiple applications: it can be used as a focusing technique, drawing attention to the fully animated parts while the limited parts shift into the background. Or it can tell us something about the character, as a way to show ambiguity, for example, with a stiff upper body and wildly moving legs demonstrating a futile attempt to maintain physical control in the face of exciting news.

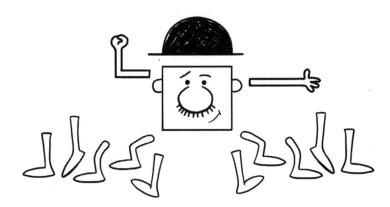

Here are all the pieces needed to make this character jump.

MORE ABOUT LIMITED ANIMATION

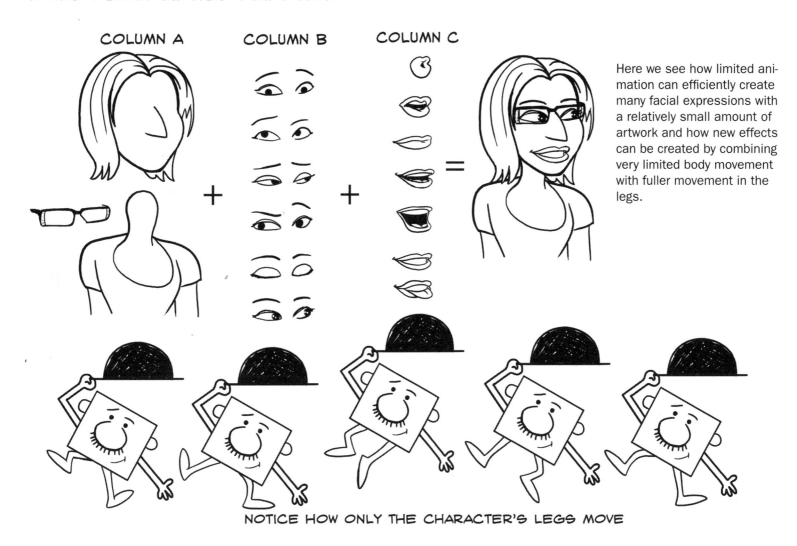

COLUMN A COLUMN B COLUMN C

Here we see how limited animation can efficiently create many facial expressions with a relatively small amount of artwork and how new effects can be created by combining very limited body movement with fuller movement in the legs.

NOTICE HOW ONLY THE CHARACTER'S LEGS MOVE

STRAIGHT-AHEAD ANIMATION VS. POSE TO POSE

THE TWO MAIN APPROACHES TO ANIMATION ARE POSE TO POSE AND STRAIGHT-AHEAD ANIMATION.

BASIC

Animation can be created either by blocking out the main positions (called keys and breakdowns) of an action and then filling in the in-between positions or by starting at the beginning of the action and working straight through to the end. The first approach is called pose to pose and the second is called straight-ahead animation. Each has its own advantages.

Pose to pose animation offers a great deal of control. Scenes can be initially blocked out in keys and breakdowns with precision. Then the grunt work of inbetweening, which plays an important role in defining timing, can be done with complete assurance that the action will hit all its marks, beginning, middle, and end.

Straight-ahead animation creates a more spontaneous effect, as the creation of a free flow of movement is achieved in relatively speedy fashion. This combination of speed and spontaneity allows the animator to create something closer to a performance in real time.

Examples: Look for strong examples of cartoon-style pose to pose animation, marked by its use of broad clear poses, in any classic Warner Brothers short. *Creature Comforts* offers a demonstration of straight-ahead animation.

Value-Added Point: Note that breakdowns are essential poses which help define the arc of a movement. Most natural movement creates arcs. In animation, the use of arcs helps prevent stiff and mechanical movement.

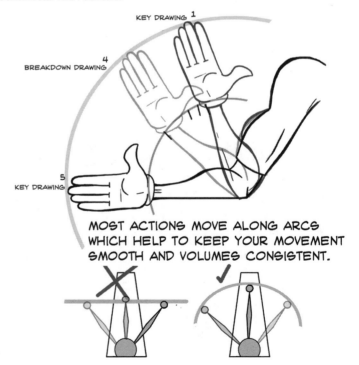

KEY DRAWING 1
BREAKDOWN DRAWING 4
KEY DRAWING 5

MOST ACTIONS MOVE ALONG ARCS WHICH HELP TO KEEP YOUR MOVEMENT SMOOTH AND VOLUMES CONSISTENT.

POSE TO POSE ANIMATION

FIRST BLOCK OUT THE KEYS

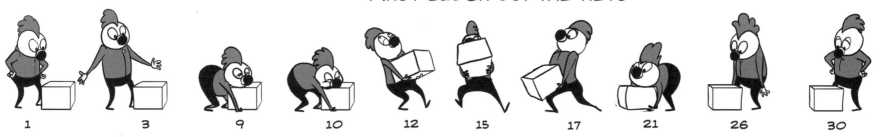

1 3 9 10 12 15 17 21 26 30

THEN ADD THE INBETWEENS

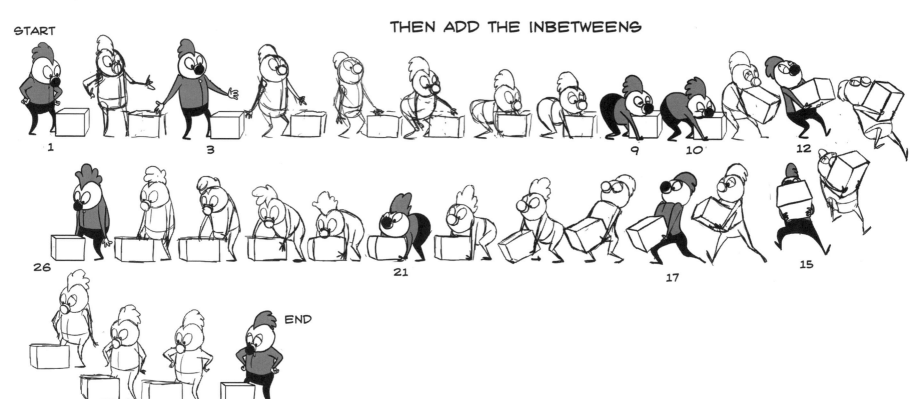

START

1 3 9 10 12

26 21 17 15

30 END

ADVANCED

Both pose to pose and straight-ahead animation have specialized applications.

Pose to pose is particularly useful when extreme precision in timing and placement is required. In a complex dance number, for example, with multiple characters and an intricate beat, pose to pose allows you to block out the path of action of each dancer in advance while also pre-planning a detailed relationship between the movement of the dancers and the structure of the music.

Straight-ahead can contribute to a more subtle narrative performance and works well in situations which benefit from and can afford a higher degree of improvisation, such as in *The Street*.

There are also ways in which these two approaches can be combined. For example, within a given sequence, a character's main action can be blocked out pose to pose. Then the secondary action, such as the movement of hair or clothing which can be difficult to block out, can be handled with the straight-ahead approach.

STRAIGHT-AHEAD ANIMATION

START WITH DRAWING ONE AND WORK STRAIGHT THOUGH TO THE END

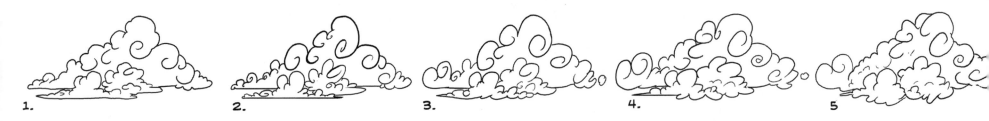

1. 2. 3. 4. 5

In another mixed approach, the overall action can be worked out in advance, with a series of thumbnail poses. Working with the thumbnails as an outline, the actual animation can then be created with a straight-ahead approach. This "best of both worlds" approach allows you to foresee potential problems with the pose to pose thumbnails while still achieving the freshness of straight-ahead in the final animation.

See also: *Timing and Rhythm Structure*

STRETCH AND SQUASH

DISTORTION (KNOWN AS STRETCH AND SQUASH) MAKES ANIMATION MORE ENGAGING. HOWEVER, SHAPES CAN ONLY BE DISTORTED AS LONG AS THEY MAINTAIN VOLUME.

BASIC

Animation without distortion tends to look stiff. Action seems less exciting; emotions seem duller and less engaging. Does this apply even to realistic characters? Here you might think that animating without distortion would create more convincing action. Take a look at some live action footage, however, such as a boxer taking a punch, and you will discover that in real movement a surprising amount of distortion actually takes place.

When we animate, even realistically, we often choose to exaggerate the amount of distortion in the movement to make it read more clearly. But whether we distort a little or a lot, the volume or mass of the elements being animated must never change in order for the movement to be believable. To get a picture of this, think of what happens when you stretch a balloon or press down on it: when the ends bulge out, the middle gets thinner; when the ends are pushed in, the middle gets fatter, and so on.

ADVANCED

Stretch and squash can be applied in many different ways. Realistic characters need to live inside the rules of physics to maintain their credibility, so here you have to be very strict about maintaining volume and keep a limit on how much distortion you use. In cartoony forms, such as rubberhose animation, the characters can be highly elastic, with arms and legs like flexible hoses. This opens the door for extreme stretch and squash which can be used for comic or surreal effects.

And of course, when characters are highly stylized, the rules get looser. Here you can choose to maintain volume or compress a large character into a tiny ball if it makes sense with your design and concept.

Example: The wolf in *Cinderella Swing Shift* offers an example of extreme stretch and squash.

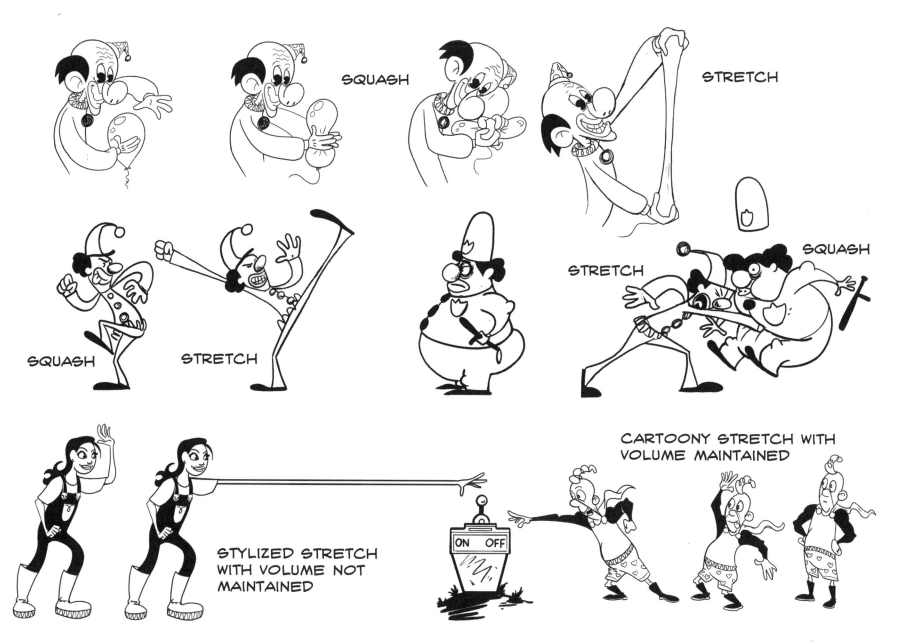

SQUASH

STRETCH

SQUASH

STRETCH

STRETCH

SQUASH

CARTOONY STRETCH WITH
VOLUME MAINTAINED

STYLIZED STRETCH
WITH VOLUME NOT
MAINTAINED

ON OFF

ANTICIPATION

A MAIN ACTION ALWAYS BEGINS WITH A COUNTER-MOVE IN THE OPPOSITE DIRECTION. THIS PREPARATORY MOVEMENT IS CALLED ANTICIPATION.

BASIC

A cartoon judge's big backswing before he brings the gavel down or the extreme scrunching of his face before his bug-eyed, big-mouthed, exasperated call for order: these are examples of the preparatory movements called anticipation. Though they may seem like corny conventions, these countermoves actually have real purpose which is applicable to most kinds of animation.

Like the compression of a spring, anticipation stores energy for release into the main movement while also creating more space for the main movement. Whether you are animating a realistic golfer winding up for a swing or that cartoon judge preparing to lay down the law, both of these anticipations add punch to the final performance.

Anticipation also helps get movement started. Think here about the simple act of walking: in order to take a step, you have to lift one foot and to do that, you have to first shift all your weight from that foot onto the other. It's this critical weight shift which is yet another form of anticipation.

Value-Added Point: The size of an anticipation is proportional to the size of the main movement, so, for example, the bigger the movement, the bigger the anticipation.

ADVANCED

Another important function of anticipation lies in helping the audience follow action. So if a character is about to put her hand into her pocket and pull out a gun, the hand may first go up in anticipation of the main downward movement. This kind of anticipation draws the audience's attention to the hand which is the "star" of the main action and also signals the direction of the main movement to come. In total, this prepares the audience to track the movement of the hand in and out of the pocket and so ensures that later there will be no confusion about where the gun came from.

Of course, if you want to deliberately confuse the audience, you can, like a magician, use a false anticipation to distract the audience from the essential action, leaving them wondering about that gun even though it has actually appeared in plain sight.

Rule Breaker: In some forms of stylized animation, anticipation can be deliberately left out to increase the sense of unreality.

See also: *Realistic Animation vs. Stylized*

THIS ANTICIPATION ADDS PUNCH TO THE MAIN MOVEMENT...

AND THIS ANTICIPATION HELPS THE AUDIENCE FOLLOW THE ACTION

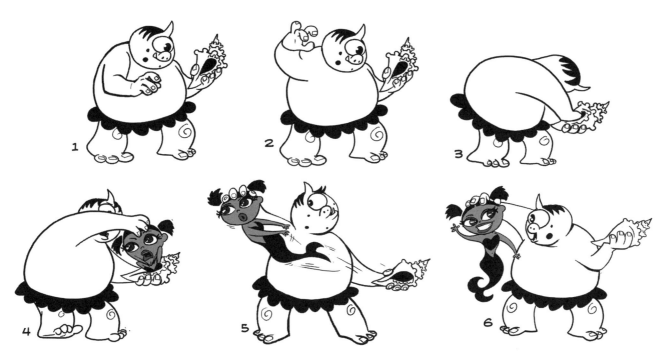

OVERLAPPING ACTION AND FOLLOW THROUGH

WHEN A BODY IS IN MOTION, ITS VARIOUS PARTS DO NOT MOVE IN LOCKSTEP. RATHER, EACH PART STARTS AND STOPS AT ITS OWN TIME AND IN ITS OWN WAY.

What happens when you turn around to look at something behind you — does every part of your body from head to toe turn at exactly the same time, like a spinning top pivoting on its point? Of course, such a move would be virtually impossible. Notice, instead, how the overall movement is actually accomplished in parts, with the head leading the way followed by the shoulders,

waist, hips, knees, and finally the feet. Notice also how each action in succession begins before the previous one ends, creating a cascade of motions which are literally overlapping.

A little observation soon reveals that any moving element more complex than a block of wood also has overlapping action: the branches of a swaying tree trail behind the main movement of the trunk; the tail and mane of a galloping horse do the same; even your clothing has a schedule of its own, as you jump, walk, or twirl.

WATCH EARS AND KILT FOR OVERLAPPING ACTION...

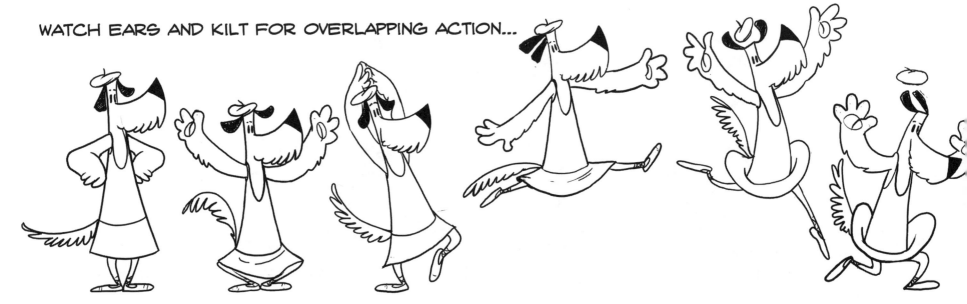

The end of a movement creates an additional element of overlap: after the main body in question has come to a stop, the looser bits, such as a dog's floppy ears, keep going, moving beyond the stopping point of the main body and sometimes even swinging back and forth before settling into repose. This overlapping action is called follow through.

Value-Added Point: Note that factors such as the speed and direction of all overlapped action will always be in relationship to the qualities of the main action.

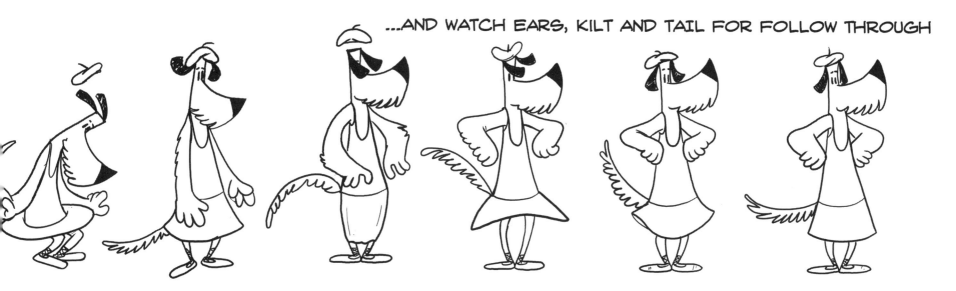

...AND WATCH EARS, KILT AND TAIL FOR FOLLOW THROUGH

SPEED LINES

VERY FAST ACTION REQUIRES THE USE OF BLURRING.

BASIC

Try waving your hand in front of your face as fast as you can. You'll notice that once you get up to speed, the image begins to blur. This is the effect we have to reproduce in order to give animation the appearance of great speed. In fact, if you try to move a character quickly across the screen without this blurring effect, the action tends to stutter or pop rather than zip.

To make this effect read clearly, the leading edge of the moving object or character is kept in focus while the back end softens into a blur. Often called speed lines (also known as blur or smear drawings), this blurring effect can be composed of actual lines. But more typically, the various parts of the moving element bleed off into streaks or a trailing smudge.

Examples: An early example of speed lines can be found in Disney's *The Tortoise and the Hare*. Watch in particular for a tour de force use of extreme speed when the hare shows off by playing tennis with himself.

In *Zoom and Bored*, the contrast between Wily Coyote's slow, clumsy running and the Roadrunner's lightning pace is exaggerated by giving the Roadrunner speed lines.

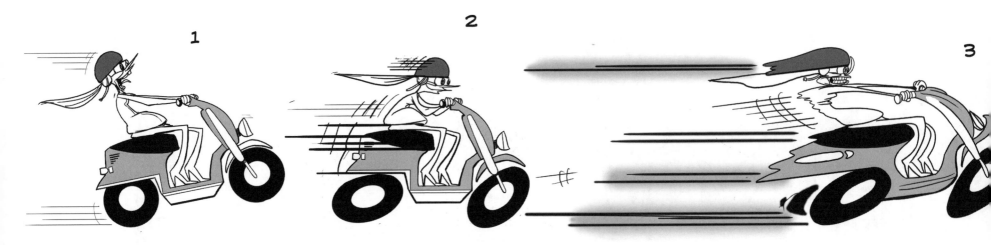

VARIATIONS ON SPEEDLINES

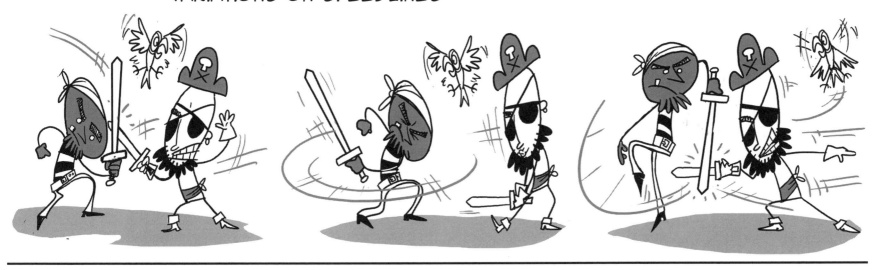

In very fast movement forward, the leading edge stays in focus while the back end becomes blurred.

ADVANCED

Speed lines and multiple images show up in lots of unexpected places. Any quick-moving element, such as a hummingbird's wings or a swinging baseball bat, needs them. Vibrations need them too. To create a vibrating effect, the speed lines and multiple images move outward from a central image. Interestingly, multiple imagery is also used to enhance other kinds of very quick movement — try freeze framing a fast moving animated sequence and look for the hidden extra arms, eyes, etc.

Even the traditional cartoon fight consisting of a big rolling ball of dust studded with visible multiple images of flying fists and other random body parts is essentially a variation on the speed line principle: all those fast-moving limbs are blurring together but, in the process of fighting, so much dust is kicked up that most of the blurred action is obscured.

However, unlike straightforward blurring which we can generate with a fast-moving hand and readily capture with live action footage, this stylized approach to fighting has a looser relationship with reality (best described, perhaps, as an exaggeration of the swirling dust which gathers around a tornado), and may be more accurately understood as an effective convention that expresses the energy and confusion of a fight without actually confusing the audience.

See also: *Wind and Tornadoes*

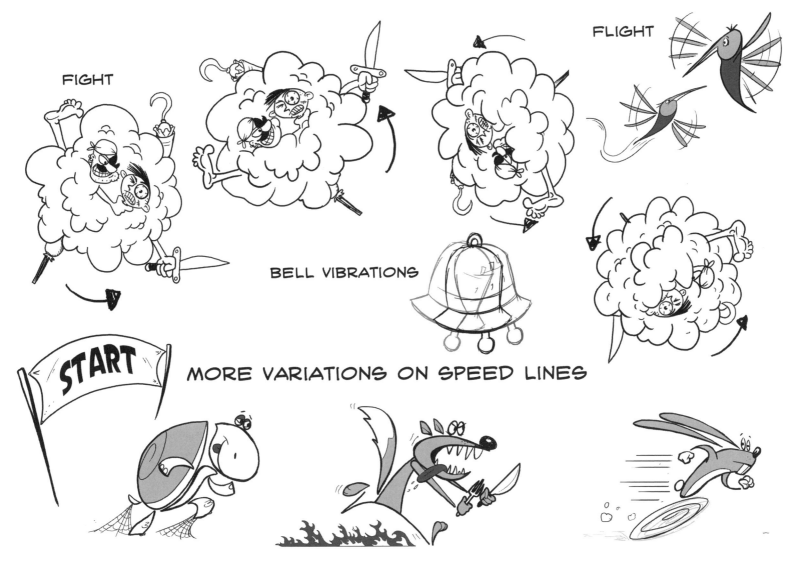

FIGHT

FLIGHT

BELL VIBRATIONS

START

MORE VARIATIONS ON SPEED LINES

LIP SYNCH

IT IS BETTER TO UNDERPLAY LIP SYNCH THAN TO OVEREMPHASIZE IT.

BASIC

Lip synch can be as simple as a mouth flap with two positions: open and closed. At the other extreme, it can create the appearance of fully articulated speech. One way or the other, success tends to lie in doing less rather than more. For example, even with the most realistic lip synch it isn't necessary to animate every consonant.

So unless you are dealing with an exceptional situation, it's generally enough to highlight the vowels, hit the main accents accurately, pay attention to the key consonants — b, f, m, l — and underplay the rest.

Examples: Disney features offer strong examples of full articulation while a stylized approach to lip synch can be seen in such TV shows as *South Park*.

Value-Added Point: Keep in mind that a major factor in creating the appearance of dialogue-action synchronization isn't the mouth movement so much as the accurately timed body English which accompanies it. This is so important that, when done well, you can sometimes get away with no mouth movement at all. So try animating the gestures first and adding the mouths after.

ADVANCED

Remember that mouth positions may be different for different characters, influenced by the shape of their mouths and how they are inclined to speak. Think, for example, about the same words being spoken by a character with a small, tight mouth and a character with a wide, loose-lipped mouth.

We also have to think about how to approach lip synch in highly stylized human characters and non-human characters, too. Here we might be dealing with a mouth structure never intended for human speech. For example, how can a bird talk with its long beak?

The solution for beaks, muzzles, even the immature jaws and mouth structures of human babies is to adapt them to make speech believable. This stylization doesn't have to be obvious. In fact, it can be so subtle that we hardly notice it, as in the animals in *101 Dalmatians*.

With objects, mechanical characters, and fantasy characters, the approach to lip synch can be more creative. For example, in place of a mouth, *Futurama's* Bender has a screen which generates "electronic" patterns that synch with the dialogue.

See also: *Gesture and Dialogue*

NORMAL

HE E LL O O

EXAGGERATED

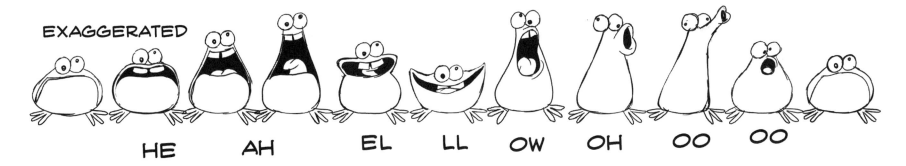

HE AH EL LL OW OH OO OO

EXTREMELY BASIC

STYLIZED

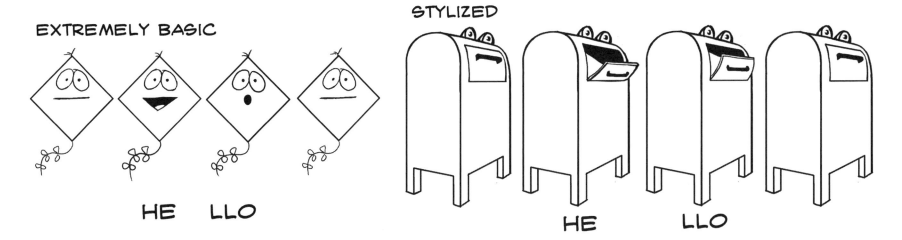

HE LLO HE LLO

ANIMATED THOUGHT

IN ANIMATION, THE THINKING PROCESS NEEDS TO SHOWN.

Animated characters seem more alive when their actions appear to be motivated by thought. To achieve this, the thinking process generally has to be shown as a clear and separate step between seeing/experiencing something and reacting to it. Otherwise, the reaction may appear to be merely mechanical.

This thinking moment can be expressed in many ways: through a change of facial expression, for example, from happy to quizzical before the reactive emotion is expressed; through a shift of eye focus upward or inward away from the action; through a change in movement as when a character who is walking slows down as a thought kicks in or even by a simple pause in the action with a few eye blinks.

And of course, you can always fall back on one of the oldest of cartoon traditions: having a character pause and then snap his fingers or turning on a light bulb over his head.

A THINKING MOMENT CAN BE EXPRESSED THROUGH...

A CHANGE IN MOVEMENT...

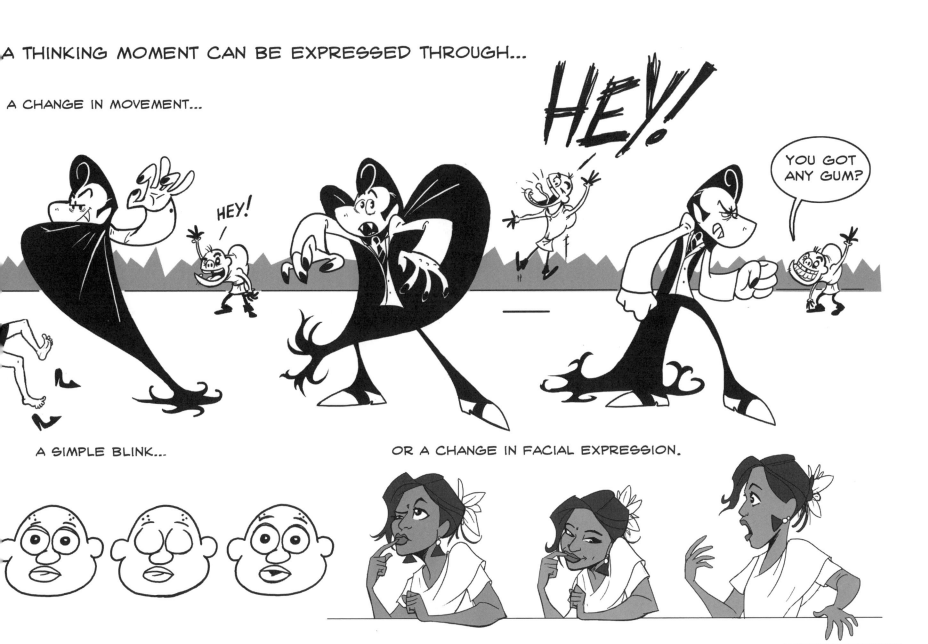

A SIMPLE BLINK...

OR A CHANGE IN FACIAL EXPRESSION.

CHAPTER 6: PERFORMANCE
INTRODUCTION

Good animated performance enlightens while it entertains; it reads easily and clearly on the screen (a key part of what we call staging) and can involve action with dialogue or action alone. But good animated performance also requires the ability to tackle scenes which can take place in the oddest of places, with the oddest combinations of characters, any of which may at any time be required to do the oddest of things....

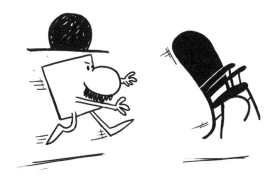

SILHOUETTES

ACTION SHOULD READ CLEARLY EVEN WHEN IN SILHOUETTE.

BASIC

Action doesn't communicate unless it can be seen. So how can we be sure that our action is staged in a manner which is going to read clearly? One key lies in the silhouette.

To understand this, try taking the main poses from one of your own animated sequences and turning them into silhouettes. Do the poses still read even without any detail? If the answer is yes, you have created strong silhouettes which ensure that your audience will see the key action clearly. If the answer is no, you may have planned your action so that it sits over your character's body, which means it risks getting lost on the screen. If this is the case, try shifting the character's position or restaging the movement so that it clears the mass of the body and therefore reads without interference.

If the problematic action involves a character taking a watch out of his pocket, for example, try shifting the action to the other hand or putting the watch in a different pocket. Or rethink the main purpose of the action. If all the character really needs to do is check the time (as opposed to, say, showing off the pocket watch), then this could be accomplished in another way. So perhaps the

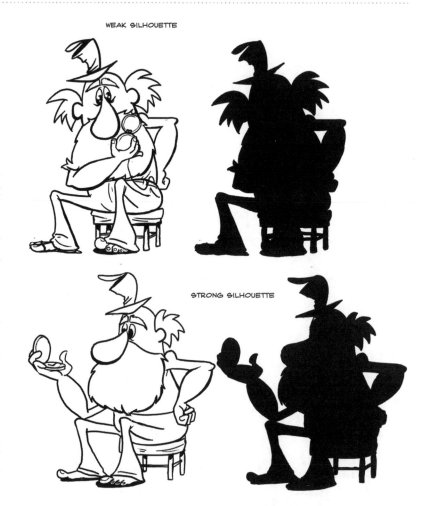

WEAK SILHOUETTE

STRONG SILHOUETTE

If your action doesn't read clearly in silhouette, try restaging the action or making a change which creates a new action.

character could be given a wrist watch instead of a pocket watch, allowing for staging which is not only potentially clearer but less work to accomplish as well.

Example: Try freeze framing a sequence from virtually any Disney feature and watch how the poses are planned to read clearly in silhouette.

Value-Added Point: Remember, there is always more than one way to stage an action. So look for one that produces the clearest silhouettes.

ADVANCED

Maintaining a clear silhouette is as useful for 3D styles of animation as it is for 2D. Even the greater depth perception that 3D techniques achieve (a factor that helps action which sits over the body read more clearly) can't fully overcome the fact that the final image is presented on a flat screen. However, at the top end of CG, in such films as *Ryan* for example, there is enough compensation for this factor to allow for a cautious loosening of this rule.

OTHER WAYS TO SOLVE THE PROBLEM

BREAKING OUT OF THE BOUNDARIES OF REALISTIC PERFORMANCE

ANIMATED CHARACTERS DO NOT HAVE TO PERFORM REALISTICALLY.

Let's say you find yourself stuck on an impossibly tricky bit of animation. What do you do? The problem may be that you are handling the action too realistically. So the solution may be to try rethinking the performance outside the boundaries of reality. Can't get that acrobat to climb off her elephant? Maybe she could jump off and use her open umbrella to parachute safely to the ground. Forgot to give your action hero a rope and now he's standing at the edge of an abyss with no way to cross? Let a friendly spider throw him a line which he can use to swing across. Or maybe he can push his side of the abyss a little closer to the other, allowing him to hop over the gap.

This kind of thinking can be used to bypass a technical problem or simply because it appeals to you. In fact, some of the most appealing moments in animation come from the use of such creative solutions. Be aware, though, that there are some limits to how far you can move away from reality in your action, depending on such things as the technique or design approach you are using. For example, more realistic design gives you less room for creative solutions, while less realistic design gives you more.

Also remember that if you are going to break the boundaries of realistic performance, you have to establish this early in the project. Suddenly introducing boundary breakers halfway through an otherwise realistic production only undermines the credibility of the world you have already established.

Value-Added Point: Boundary-breaking solutions sometimes act as a shortcut as well, reducing the amount of work needed to create the animation while also offering a clearer, more original way to communicate your point.

See also: *Making Your Universe Real; Character Design and Movement*

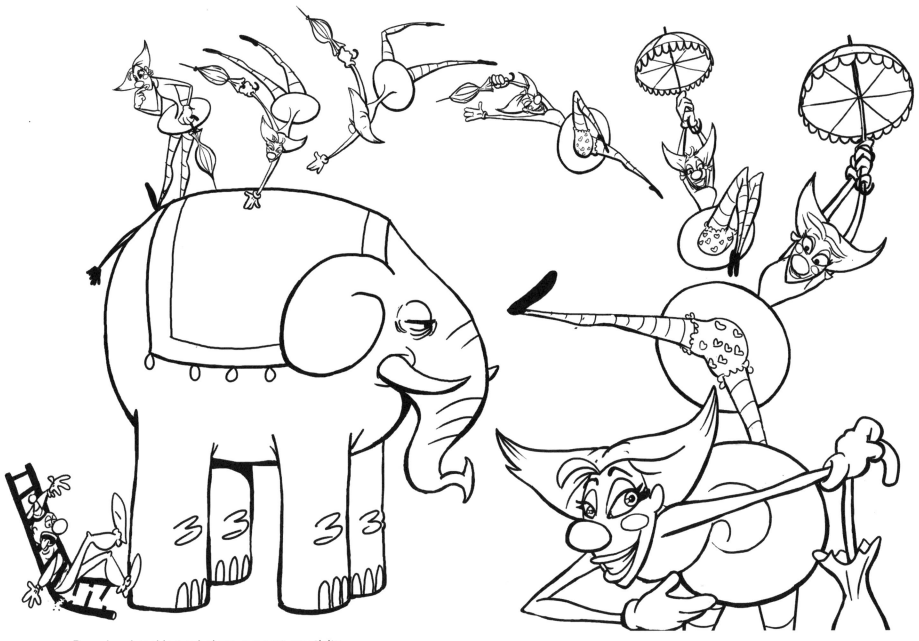

Boundary breaking solutions support creativity.

GESTURE AND DIALOGUE

GESTURE SHOULD SUPPORT DIALOGUE BUT CAN ALSO ENHANCE IT.

BASIC

Whether a victorious thumbs up or a dismissive shrug, gesture can convey a great deal of information all on its own. But what happens when gesture is combined with dialogue? At first glance, this kind of gesture often looks like little more than rhythmic hand flapping. But in reality, gesture used in this context is an important part of the overall communication and involves not only hands but any expressive body part.

The primary role of gesture here is to support the dialogue. In their most straightforward form, supporting gestures are rhythmic, abstract movements which help to clarify dialogue by emphasizing its structure. Heads bob, fingers jab, all to draw attention to key words, beginnings of phrases, etc. Gestures in this context can also become more directly involved in storytelling, reinforcing the emotional meaning of dialogue, for example, while still helping to clarify its structure. Here, hands curl into fists to emphasize anger; fingers rub temples in a worried manner, and so on.

Value-Added Point: Be aware that while a moderate use of gesture supports communication, too much can distract the audience and so interfere with their ability to follow the dialogue.

ADVANCED

Sometimes gestures can support communication by contradicting dialogue. Think here of a character who insists that he feels calm while nervously drumming his fingers on the table. The words say "calm" but the gestures say "nervous." Taken together, words and gestures add up to a potential new message. Perhaps this character is applying for a new job and is trying unsuccessfully to hide his nervousness from the hiring committee or maybe he is very detached from his emotions and isn't even aware of what his fingers are expressing.

At its best, this contradictory use of gesture helps put the audience inside your character's head. But when using this approach, be sure the contradiction between words and gestures adds up to a clear message. If the contradictory elements cancel each other out or convey only vagueness, the audience will be left with a sense of confusion.

Example: In *101 Dalmatians*, when Roger confronts Cruella over the sale of the puppies, his words sound brave but his nervous gestures and delivery give away his true feelings.

See also: *Lip Synch*

GESTURES CAN...

... SUPPORT CONVERSATIONAL STRUCTURE

YOU'RE GOING OUT THERE A NOBODY...

...BUT YOU'RE COMING BACK

..A STAR!

...REINFORCE EMOTIONAL DIALOGUE

WE WON!

YES!

YIPPEE!

I'M NOT ANGRY

NEITHER AM I

I LIVE TO SERVE!

...AND CONTRADICT THE MEANING OF DIALOGUE

USE OF PROPS

EFFECTIVE PERFORMANCE CAN BE BUILT ON ONE PERFECT PROP USED IN MULTIPLE WAYS.

Handing a character the right prop can be the key to a great performance. A good prop has two essential characteristics: a logical connection to its character and the potential to be used in a variety of ways.

A logical link between character and prop can be as obvious as giving Bugs Bunny a carrot. But more typically, you are looking for props which express something about a character's personality. For example, in *Pinocchio*, Stromboli's sharp, oversized knife hints at the dark side of his character even before he wields it.

In choosing a prop, consider not only what *you* want this object to express about your character but also what the *character* thinks the prop expresses about himself. In *101 Dalmatians*, Cruella's cigarette, in its extra-long holder, gives this kind of double message, broadcasting how she aspires to sophistication while only achieving pretentiousness.

The performances of both Cruella and Stromboli also demonstrate how one prop can be used in a variety of ways. Cruella's cigarette extends the reach of her already long arms, helping her to dominate the screen by literally filling it up. And what better prop to demonstrate her selfish disregard for others than a cigarette, messy even in the hands of a more considerate soul? The abandon with which Cruella sprinkles ashes in a proffered cup of tea, blows acrid smoke and crushes the butt into a cupcake doesn't just tell us how rude she is. It also proves her dominance, as if she were using the detritus produced by the cigarette to mark territory.

Stromboli's performance with the knife communicates its own message of dominance and danger. In an extended sequence, he uses the knife in two distinctly different ways, alternating between carefully controlled movements such as when he uses it to count his money or delicately spear morsels of food, and wildly aggressive moves which bring the blade perilously close to Pinocchio. This performance highlights Stromboli's dangerously unstable personality while also making it perfectly clear what he values (food and cash) and what he doesn't (Pinocchio's well-being).

A good prop has a logical connection to its character and potential to be used in multiple ways.

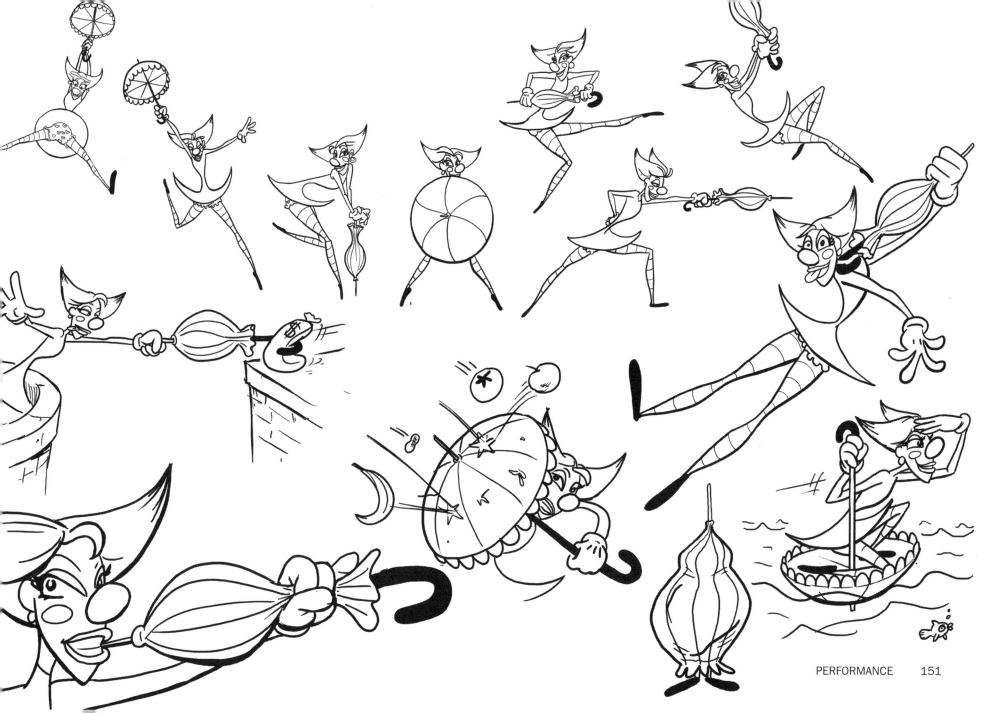

Value-Added Point: The connection between prop and character can also be visual. For example, Cruella's cigarette and holder reflect her long thin silhouette as well as her over the top fashion sense.

Rule Breaker: Sometimes the best prop is a contradictory one: for example, assigning the biggest sword to the smallest soldier may release an unexpectedly bloodthirsty side of this character.

See also: *How Special Effects and Characters Interact*

A contradictory prop
can sometimes release
an unexpected side of
a character.

WORKING WITH NON-HUMAN CHARACTERS

NON-HUMAN CHARACTERS NEED CUSTOM-BUILT EMOTIONAL VOCABULARIES.

Unlike human characters, non-human characters don't necessarily come with built-in emotional vocabulary. So to create performance with such characters, you first have to create a custom-built vocabulary. This can be accomplished in a number of ways.

With animal characters, for example, watch for real animal behaviors which bear a resemblance to human behavior. These give you license to expand the performance range of even very realistic animal characters with full credibility. A baby bear, waiting for its mother at the edge of a stream, for example, will pick at its toes, play with the water, etc., very much like a bored child. Applied to an animated bear cub, such crossover gestures can be exaggerated towards the human, creating more room for emotional performance without sacrificing the sense that this character is truly a bear given greater consciousness, rather than a human in a bear suit.

Along the same lines, object characters may have built-in movement possibilities which reference either humans or other sentient beings. A garden hose can borrow freely from the behavior of a snake. And the movable appendages of some corkscrews connect them to the gestures of a preacher about to give a benediction.

Crossover behaviors can also be combined with unique behaviors which specifically reference the animal or object world. These behavioral traits can be exaggerated in a different direction, towards the comic or absurd, adding new dimensions to your characters' performances while also tying them more closely to their deepest nature. A cornered cat's tendency to spit, hiss and arch its back can be taken to a demonic level. And a boiling mad pressure cooker can literally blow its lid.

Of course, all of these strategies can also be combined with straightforward anthropomorphization — that direct imposition of human attributes onto a non-human character which in its full blown form produces a Mickey Mouse.

Examples: Animated bears with crossover behaviors can be found in both Disney's *Jungle Book* and the TV series, *Little Bear*.

In *Toy Story*, Mr. Potato Head's removable features add unique elements to his performance, allowing him, for example, to see over obstacles by holding up his eyes over his head.

See also: *Expressing Personality; Animal Characters; Object Characters*

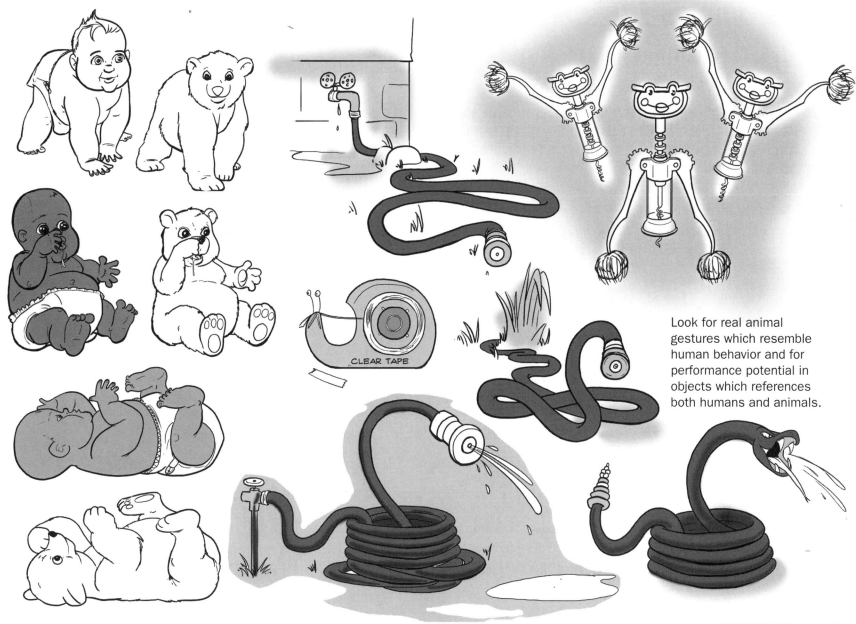

Look for real animal gestures which resemble human behavior and for performance potential in objects which references both humans and animals.

CLEAR TAPE

CHARACTER INTERACTION

IN ANIMATION, CHARACTER INTERACTION CAN MEAN HUMAN TO HUMAN BUT IT CAN ALSO MEAN HUMAN TO ANIMAL, HUMAN TO OBJECT, OBJECT TO OBJECT, AND SO ON.

Odd combinations of characters which vary wildly in structure, size, species, etc. are a fact of life in animation. This can make the staging of animated action a special challenge.

For example, how can interaction between an elephant and an ant be handled? Here a primary issue is the vast difference in size, creating a host of interesting problems. How can these characters make eye contact? How can we even show them both on the screen at the same time? If we go close enough in to see the ant, the elephant disappears. If we go far enough back to see the elephant, the ant disappears.

One solution for these problems is to only show the larger character in parts. In a friendly exchange, the elephant could use her trunk to bring the ant up to her own eye level. What we might see on the screen here is the full figure of the ant but only the face of the elephant. In a less friendly exchange, where, perhaps, the elephant might rather stomp on the ant than look him in the eye, we could go down to ground level. Here once again we see the full figure of the ant but all we see of the elephant is her gigantic foot.

Example: With characters ranging in size from tiny Jiminy Cricket to enormous Monstro the Whale, *Pinocchio* offers many examples of large-small character interactions, both friendly and not so friendly.

Value-Added Point: Sometimes a great difference in size can be gotten around by modestly enlarging the smaller character and/or reducing the bigger one in the shots where they both appear. Of course, there are limits to how far you can go with this cheat before the audience starts to wonder why your characters keep changing size.

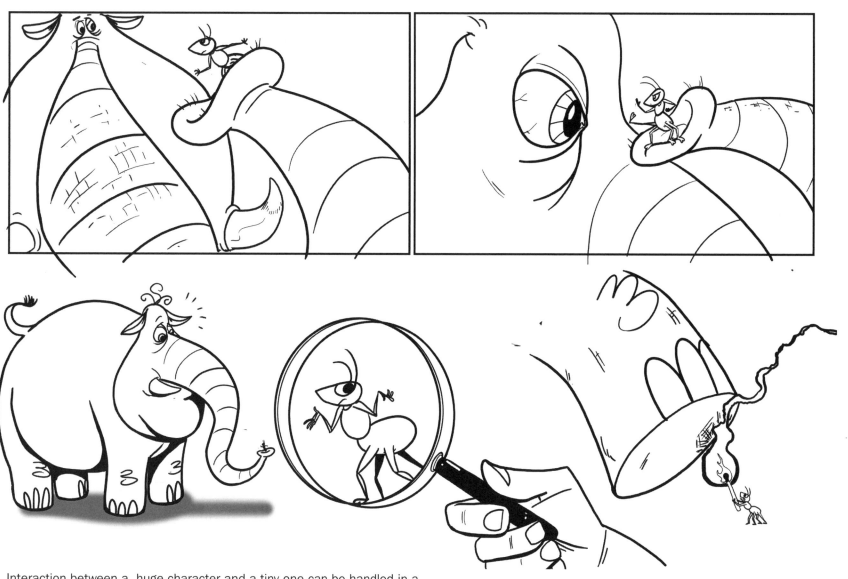

Interaction between a huge character and a tiny one can be handled in a variety of ways.

CHAPTER 7: TIMING
INTRODUCTION

The length of a scene, the speed of an action — timing doesn't sound like much but it is, in fact, one of our most powerful tools for communication. As you will see, even small changes in timing can make a big difference.

Note that for simplicity's sake, the terms "timing" and "pacing" will be used interchangeably.

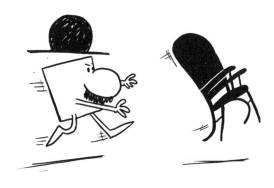

TIMING AND ACTION

CHANGES IN TIMING ALTER THE MEANING OF ACTION.

A surprising amount of what we perceive as meaning in action is created by timing. Used accurately, timing can invest even very mundane actions with meaning.

Imagine, for example, a character doing something as basic as getting up out of a chair. If she does this very slowly, we might think that she is depressed or in pain. But if she jumps out of the chair, we might think that she is excited or perhaps, alarmed. A character dropping his jaw quickly could be expressing amazement; at mid speed, he might be opening wide for the dentist. And if he does this action very slowly, he could just be showing his boredom with a great big yawn. A slow eye roll indicates exasperation but a fast eye roll could be the onset of a seizure, the beginning of a faint, or a sign of insanity.

Even very small changes in timing can alter the meaning of an action. In fact, every frame makes a difference. Think, for example, of one character poking another in the arm. A very quick poke will look like a hard, painful jab; slow it down by adding 8 frames and now the first character is poking the second to get his attention; add 20 frames instead of just 8 and this could be a doctor gently feeling the arm to test for a sore spot. So with the addition of a mere 20 frames — less than a second of screen time — we've gone from hurting to helping, a complete reversal of meaning.

Value-Added Point: A stopwatch is an animator's best friend (or one of them anyway). Get in the habit of using a stopwatch to time your action while you act it out. With experience, you'll learn how to feel the difference even a frame or two makes.

THE SCREAM

THE YAWN

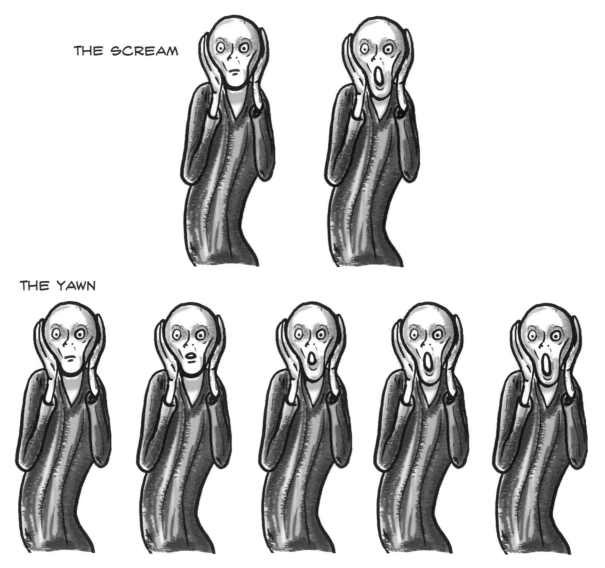

Even small changes in timing can alter meaning.

VARYING THE PACE

VARYING THE PACE WITHIN A SEQUENCE OF ACTION HELPS MAINTAIN AUDIENCE INTEREST.

Varying the pace within a sequence of action automatically makes your work more engaging. So instead of setting a steady pace for a sequence, whether slow plod or brisk gallop, you could, for example, begin very slowly and then explode into a flurry of movement or vice versa.

Of course, such variations can't be used for the sake of entertainment alone. Pacing (or timing) affects meaning, so you have to be sure that your shifts fully support the message of the sequence as well. In fact, with well-planned, varied pacing, your performances will not only be more entertaining, they'll actually communicate more clearly.

For example, in the sequence where Roger and Pongo are waiting for the puppies to be born in *101 Dalmatians*, the pace of performance shifts back and forth from fast to slow. This shift corresponds with the changing moods of these two characters, slowing down to augment the tension during periods of waiting and suddenly speeding up to express their release from anxiety into joy each time they receive a bit of good news.

Value-Added Point: Keep in mind that because this is animation, you can exaggerate these changes of pace, jumping from frenzy to total stillness for dramatic or comic effect.

Rule Breaker: There are, of course, situations where a steady pace can be very effective. If you were doing a version of *The Grasshopper and the Ant*, for example, the ant's constant pace as he gathers food and brings it home would be a simple and clear way to communicate his steadfast nature in comparison with the grasshopper's flightiness.

See also: *Timing and Action*

Here, meaning is created by contrasting the grasshopper's frivolous behavior against the ants' ultra steady pace.

EFFECTIVE PAUSES

PAUSES CREATE TENSION, CLARITY AND EMPHASIS WITHIN PERFORMANCE.

BASIC

Pauses are the periods and commas of performance. In other words, in much the same way punctuation works with the written word, pauses help make action and dialogue more comprehensible by, for example, indicating the end of one thought and the beginning of the next.

But this is not all pauses can do. Consider the attention-getting pause in the action just before a high diver makes her leap or the pregnant pause in conversation at the local family restaurant when the Goth couple in full regalia make their entrance. These key moments are an essential means for creating tension, both dramatic and comic. Done well, they hold the audience in suspense, toying with their interest in knowing what comes next and helping to produce a heightened emotional response — fear, humour or relief — when all is revealed. And because this is animation, you can even exaggerate such pauses to build more tension, leading to an even bigger response.

Value-Added Point: Animated characters cannot come to a full pause for very long without losing the sense of being alive. This can be overcome in a variety of ways, depending upon technique and style of animation. The solution can be as simple as a couple of eye blinks. Or you can create a "moving hold," a technique originated in drawn animation, by making several deliberately not quite perfect copies (called tracebacks) of the held pose which are then alternated with the original throughout the pause.

ADVANCED

In highly stylized animation, you can exaggerate not only the length of a pause in the action but also the nature of the held pose, even to the point of defying gravity. Watch for the moment in *Gerald McBoing Boing* where Gerald's father is suspended in mid air, in an entirely unnatural way. This exaggerated pause emphasizes how off balance, helpless and literally "up in the air" the father feels about Gerald's inability to communicate with anything but sound effects.

Rule Breaker: As part of its high stylization, this same moment in *Gerald McBoing Boing* also does away with the moving hold, adding a note of catatonia to the father's distress.

See also: *Silence*

Pauses can build tension and heighten emotion.

TIMING AND MOOD

MOOD CAN BE ALTERED BY CHANGES IN TIMING.

BASIC

Timing is the hidden factor for creating mood in animation. Factors such as color and lighting easily come to mind when we consider mood because we think of animation as a visual medium. But animation is also a medium which moves through time. And that means that, just as in dance or music, mood is affected by the speed at which things move.

In a dramatic piece, slower movement adds to an overall feeling of tranquility or despondency while the mood associated with faster movement might be lighter, more excited or even agitated. Think here of the slow, somber performance of the dwarves in *Snow White* when they think the young princess is dead compared to their sprightly performance when she first moves in.

In comedy, greatly speeding up the action often makes things funnier. Less typically, so does slowing the action way down, particularly in circumstances where we expect the action to move along at a fair clip.

Value-Added Point: Be bold when you experiment with the timing of action. For example, many actions read clearly at much faster speeds than you may think, creating more room for comedic or dramatic effect.

ADVANCED

The relationship between timing and mood affects not only action but also structure. This includes such things as the lengths of scenes and the speed of camera movements. Here, longer scenes and slower camera moves contribute to calmer or, perhaps, darker moods, while shorter scenes with faster moves raise the level of excitement.

Typically, the tempo of structure should reflect the tempo of the action. Structuring fast action, for example, with long scenes and slow camera moves tends to dull the excitement of the performance, creating a flat effect. The audience will be able see the excitement but they won't be able to feel it. By comparison, combining fast action with shorter scenes and quicker camera moves heightens the sense of excitement and draws the audience into the mood.

Of course, you can intentionally mismatch the tempo of structure and action towards creating a different kind of mood. For example, you could "trap" a fast-moving character in a slow-moving structure, or make a slow-moving character seem out of step with a structure that whizzes by.

Given the right context, ultra slow timing can create humour.

TIMING AND RHYTHM STRUCTURE

LIKE MUSIC, ANIMATION NEEDS A RHYTHM STRUCTURE.

BASIC

Animation created without an overall rhythm structure can seem ragged and hard to follow. So treat animation like you are writing a piece of music and try timing such elements as camera moves, editing, sound and movement to an underlying beat.

When working with action, for example, whether fast paced or slow, using a beat allows your movement to flow along naturally, taking the audience with it. At the same time, working with a beat allows audiences to follow the action more easily. This not only reduces audience confusion but also opens the door for the use of more complexity and speed.

To accomplish this, try acting out your action to the beat of a metronome. Based on the traditional projection standard of 24 frames per second, 12 frame beats (equaling 2 beats per second) and 8 frame beats (equaling 3 beats per second) are the most widely used tempos. To give you an idea of how they feel, remember that, in general, people walk with a 12 frame beat (also the tempo for marching) and run with an 8 frame beat.

Examples: To see the beat-animation relationship in action, try watching an animated musical number, such as *What's Opera Doc* or *Dance of the Hours* from *Fantasia*. Then try watching a non-musical sequence from just about any Warner Bros. short or Disney feature and see if you can spot the same rhythmic principles at work, not only in the movement but in the editing, camera moves and sound as well. To facilitate this, try tapping your finger or using the metronome while watching.

Here the camera pans at a steady pace for the whole 5 beats.
At the same time, the character whips around the scene with each key pose landing squarely on the beat.

ADVANCED

Once your foundation rhythm structure has been established, a variety of useful effects can be created by playing with the relationship between the various elements of your animation and the beat. For example, placing key actions on the strongest part of a beat can make them more emphatic, while placing them on the off beat can make them seem off center or out of control. Keep in mind that this holds true both with a music track and without.

Example: In *The Sorcerer's Apprentice* from *Fantasia*, command of the primary beat changes ownership throughout the duration of the piece in direct relationship to the power struggle which lies at the heart of this musical story.

Right off the top, the sorcerer commands the strongest beats while Mickey's entrance (in the role of the apprentice) appears distinctly off beat. When the sorcerer retires for the night, Mickey briefly gains control of the beat only to thoroughly lose it to an enchanted broom and its many offspring run amok. In the end, only the sorcerer, disturbed from his rest, can take back the beat (and therefore the power) and bring the situation under control.

See also: *The Role of Music*

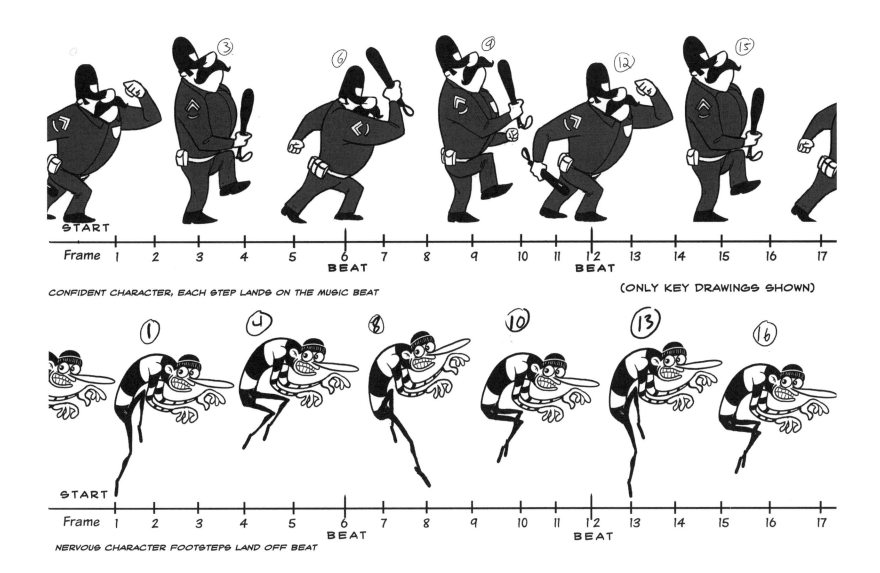

START

Frame 1 2 3 4 5 6 7 8 9 10 11 12 13 14 15 16 17

BEAT BEAT

CONFIDENT CHARACTER, EACH STEP LANDS ON THE MUSIC BEAT (ONLY KEY DRAWINGS SHOWN)

START

Frame 1 2 3 4 5 6 7 8 9 10 11 12 13 14 15 16 17

BEAT BEAT

NERVOUS CHARACTER FOOTSTEPS LAND OFF BEAT

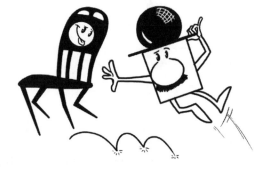

CHAPTER 8: BACKGROUNDS
INTRODUCTION

Location, location, location! No, we're not talking about real estate here but rather imaginary places, the ones you invent for your own animated projects. More than just neutral spaces in which action is played out, settings actually play a key role in setting up animated action and can affect everything from mood to plot. Here we'll explore how location really does matter.

Note that for simplicity's sake, we will primarily be using the term "background" in regard to location, background and setting.

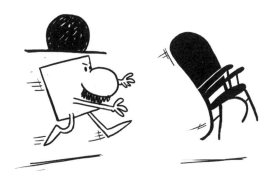

BACKGROUNDS AND MEANING

BACKGROUNDS PLAY A DISTINCT AND ACTIVE ROLE IN COMMUNICATION.

BASIC

Along with such elements as action and dialogue, backgrounds have their own role to play in communication. Let's say you have a scene in which a dog is chasing a cat down a long, twisty alleyway. The cat pulls ahead; it looks like he is going to escape. Then he turns a corner and suddenly finds himself in a small, barren courtyard, enclosed on three sides by high brick walls. We hear the dog gaining from behind and see the cat's face fall as he realizes that he is trapped.

The key here lies in realizing that it is the background itself which says, "No escape." The sound of the advancing dog and the look on the cat's face are only confirmations of what the background has already shown us. Even if the cat is looking over his shoulder to keep an eye on the dog and so fails to see the courtyard himself, the audience already knows from the details of the setting that he is now in serious trouble.

Example: In *101 Dalmatians*, as Pongo drags Roger to the park in search of Anita and Perdita, we quickly learn that the search will not be an easy one. We know this primarily because the background panning behind the characters shows us that the park is large and full of sight obscuring hills, trees and bushes.

ADVANCED

Backgrounds can also communicate on their own, without any action or dialogue whatsoever. One way they can achieve this is by showing the aftermath of action, whether human activity or a force of nature: the wreckage of a house after a party or tornado, for example.

Backgrounds can even express the personality of a character. In *The Tell Tale Heart*, the backgrounds are seen largely from the hero/narrator's POV. Their wonky quality helps to undermine the hero's attempts to convince us, through the narration, that he is sane by revealing his obviously off balance view of the world.

Backgrounds can communicate on their own by showing the aftermath of action. In this case, we see the aftermath of two very different kinds of destruction- a party and a tornado- each with its own story to tell.

BACKGROUNDS AND MOOD

BACKGROUNDS PLAY AN ESSENTIAL ROLE IN ESTABLISHING MOOD.

BASIC

When it comes to setting mood, backgrounds have an important role to play. Here style is a key factor. Cool formality, romantic elegance, edgy terror, homey warmth, etc. each have their own special characteristics which can be further modified by references to the styles of different cultures, eras and so on.

For example, the backgrounds for the dwarves' homey cottage in *Snow White* incorporate details from carvings, artifacts and architectural elements traditionally found in actual German peasant cottages. These elements enhance the European fairy tale flavor of the story. Within this general context, the specific use of curved lines, wood textures, warm colors and friendly clutter combined with a scale which keeps everything small and low to the ground make the cottage seem safe and cozy once Snow White has cleaned it up.

ADVANCED

To demonstrate style's ability to alter mood, try taking a given location and rendering it in different ways. For example, with harsh, angular lines, drab colors, and dramatic shadows, the cozy peasant cottage above could be filled with dread.

In the same way, a forest could be the scary jungle which Snow White experiences or the ethereal grove which appears in *Fantasia's* "Ave Maria" segment. Here, much of the atmosphere comes from the way the trees are handled. Snow White's nightmare forest is full of gnarled, broken trees with downward reaching branches. By contrast, the trees in *Fantasia* are extra tall with gracefully curved, upward reaching branches.

Two underlying strategies are used to create these stylized forest effects. One is the exaggeration of the real attributes of trees, towards opposite effects. The other is analogy. For example, in their exaggeration, the trees in *Fantasia* begin to look like the arches of a grand church: a perfect analogy for the uplifting tone of this sequence. Ultimately, the visual analogy is extended until the whole forest resembles a cathedral made by nature.

Factors which help backgrounds establish mood include such details as line quality and lighting, as well as overall style, whether contemporary or retro; ultra sophisticated or rustic.

BACKGROUNDS AND CHARACTER DESIGN

BACKGROUND DESIGN AND CHARACTER DESIGN NEED A LOGICAL RELATIONSHIP.

BASIC

One of the most basic rules of background design is that it mustn't overwhelm or obscure the characters. At the same time, it must feel related to the characters in some way such that we believe that both elements could exist in the same world.

So what is needed here is a balance between how background and character design differ and how they are the same. Color palette, line quality, degree of detail, degree of realism versus stylization, etc. can all be used to create both similarities and differences. The key then is to arrive at a consistent strategy for a given production in which some of these characteristics will be shared and others contrasted.

For example, in *The Grinch Who Stole Christmas*, finely detailed characters are contrasted against highly simplified backgrounds but both elements share a similar use of bold, flat color. On the other hand, in *Sleeping Beauty* it is the characters who are simplified while the backgrounds are highly detailed. But here backgrounds and characters share key characteristics such as the use of flattened, angular, elongated forms inspired by late medieval illuminations.

ADVANCED

How far can the contrasts between background and character design be pushed? Can you put a realistic character in an abstract setting or vice versa? Of course, you *can* do such things, but how can you make them work? Even here, the key lies in creating the right balance between contrast and similarity.

Of course, in these circumstances the contrasts are not only a given, they may be essential to your concept, so the trick lies in finding similarities which are strong enough to tie background and character together without making themselves too obvious.

Yellow Submarine plays mix and match with character and background design, successfully placing the cartoony submarine, for example, in a photo collage setting. This is made possible with an overall graphic approach which joins these two foreign elements by softening their contrasts, rendering the photos in hi con, for instance, to marry them more closely with the submarine's black outline and bright, flat colors.

**VERSION 1
SIMPLE CHARACTER
ON DETAILED
BACKGROUND**

**VERSION 2
DETAILED
CHARACTER ON
SIMPLE BACKGROUND**

Look for ways to create a balance between how backgrounds and character design differ and how they are the same.

BACKGROUNDS AND PERFORMANCE

**THE PROPERTIES OF BACKGROUNDS SHOULD BE
DESIGNED TO SUPPORT PERFORMANCE.**

BASIC

If a background is getting in the way of your action, always remember that you can change it.

More than just a decorative backdrop, backgrounds actually create a platform on which action is carried out and within this role have tremendous potential to influence performance. So how can we harness this potential so that its effect is positive?

We can begin by remembering that the properties of all the elements within a given background can be customized towards enhancing performance. Let's say we have a sequence in which a character is driving recklessly down a road. In live action, the setting would probably be limited to existing roads, but in animation the possibilities are limitless. We could simply use a straight road (probably our first idea) but we could also choose to add a curve for the character to veer around without braking. For even more excitement, we could make this a mountain road with a hairpin turn at the edge of a cliff.

The key lies in considering the details which have potential to affect the action: single lane country road or multilane highway, pavement or gravel, smooth topped or full of ruts. This kind of thinking, applied to every aspect of your settings, opens up options for performance.

Examples: The curved road in front of Roger and Anita's home in *101 Dalmatians* helps to establish Cruella as a dangerous character, even before we see her, by giving her the opportunity to demonstrate her reckless approach to driving.

In other circumstances it's the straight road which creates more tension, as in *Toy Story*. Here the long, straight but car-filled road feeds Woody's anxieties by keeping his goal (the family's moving van) in sight but almost out of reach.

Even a straight road has potential to support performance. Here the long, straight, tedious trip up the hill builds tension which is released...

ADVANCED

We can create even more performance options by moving beyond the boundaries of the real world. A road with potholes so deep that vehicles can disappear into them or surfaces so rough, the tires get shaved down to nothing: these are examples of how you can exaggerate the real properties of roads to create new action. You can connect your road to related forms of transportation and have a trip down a mountain turn into a literal roller coaster ride, which not only creates a wilder performance but also becomes a way to show just how out of control the driver feels. Or the road could become a conveyor belt to an unknown destination demonstrating a different kind of loss of control.

Example: The climax of *The Triplets of Belleville* includes a road so steep that the villains' cars actually flip over as they try to climb it, an exaggeration which makes this sequence both more dramatic and more visually exciting.

See also: *Creating a Universe*

...in the wild ride down. Notice here how the thrills are enhanced in ways both real and not so real.

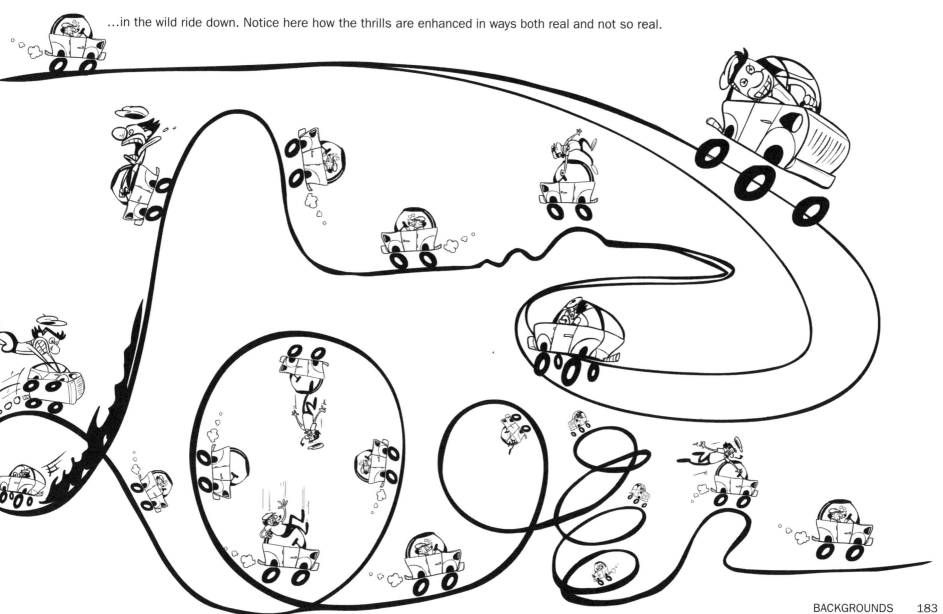

PLACEMENT OF ELEMENTS

PLACEMENT OF ELEMENTS WITHIN A BACKGROUND AFFECTS COMMUNICATION.

BASIC

It's not just what elements you put in your backgrounds that matters but also where they are placed.

Where you place the various elements in your settings might appear to be a simple matter of aesthetics, but in fact, the specific floor plan you create has a direct impact on how the action plays out and that, in turn, affects communication. For example, elements can be placed to create a diversion, allowing one character to slip past another unseen or to create obstacles which force characters to make a choice.

ADVANCED

Used well, the placement of elements can even turn backgrounds into supporting characters with surprisingly important roles to play.

In *Spirited Away*, when the young heroine emerges reluctantly from the entry building into the abandoned amusement park, the building intrudes deep into the frame, blocking the way back, leaving her only one choice — to move forward. In fact, the looming building almost pushes her off the screen. As she moves deeper into the park, the objects in the backgrounds, such as a tempting set of stepping stones, continue to lead her in the needed direction.

What we are seeing here, played out symbolically, is a girl on the cusp of adolescence, a force which will take her into adulthood no matter how much she may wish to remain a child. Through the techniques above, the settings take the role of that force, pushing and guiding her forward towards a destiny which cannot be avoided.

Pleasant as this background of a hillside path seems at first glance, notice how, rather than offering choices, placement of the surrounding cliff and trees block other options, effectively making this a path of destiny.

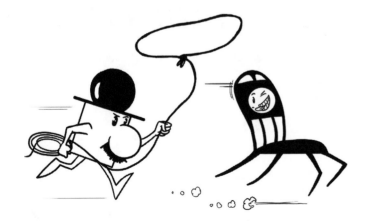

CHAPTER 9: SPECIAL EFFECTS
INTRODUCTION

Hurricanes! Tsunami! Explosions! Special effects are surely one of the most exciting aspects of animation. But keep in mind that effects are also about the subtle interplay of shadows and the mood-lifting promise of a spring rain. Also remember that there is more than one kind of rain, more than one kind of shadow, and so on. And that each specific variation has its own potential not only to create mood but to play other roles as well.

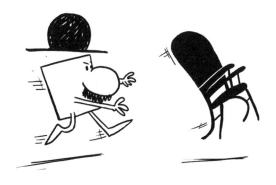

SPECIAL EFFECTS: REALISTIC VS. STYLIZED

ALL SPECIAL EFFECTS NEED A DEGREE OF STYLIZATION.

BASIC

Special effects can range from realistic to abstract. But whether realistic or not, all animated effects need some stylization. Highly stylized approaches often simplify shapes and textures while exaggerating or abstracting movement. In *Yellow Submarine*, for example, Glovey's smoke trail is stylized into a flat, opaque, scallop-edged puff which disperses into patterns more psychedelic than real.

By contrast, realistic approaches tend to follow nature more closely in terms of design and movement. But even here there is a need for stylization in such aspects as the choreography. In *The Sorcerer's Apprentice* from *Fantasia*, the water looks realistic but when Mickey Mouse orders it to leap around him, it does so in perfect synch with both the music and his commands. Even when the broom pours water into the overflowing bucket, the pouring and overflowing movements are in perfect, if less obvious, synch. This same kind of careful stylization can be brought to every aspect of even the most realistic effect. With water, for example, this could also affect such things as the size and frequency of waves and splashes.

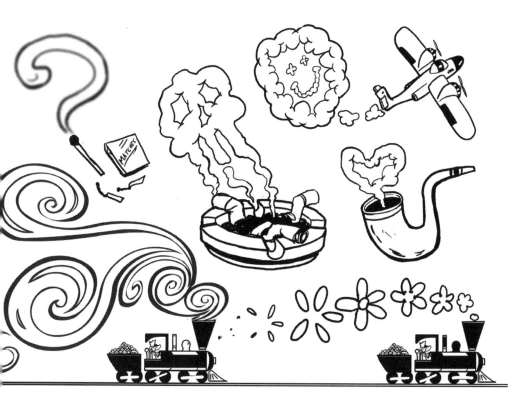

Even seemingly simple special effects such as smoke can be handled in a variety of styles, from high realism to fanciful exaggeration.

Value-Added Points: It's usually better to match the style of effects to the overall style of the project. This is especially true in CG which has a capacity for realism in effects not yet reached in character work, a potential mismatch which can undermine overall integrity.

Also beware of making your effects (especially realistic ones) too uniform: real waves, clouds, etc. are always responding to factors in their environment which prevent absolute consistency. On the other hand, deliberate uniformity can enhance a stylized approach.

ADVANCED

Realistic effects can also be stylized by exaggerating their real properties. Cigarette smoke, for example, can be blown into different shapes. In real life this may be restricted to circles and plumes, but in animation this one trait can be extended without losing the sense that the smoke is still real. Hearts, squares, etc. all become possibilities, making the smoke effect more interesting while also allowing it to become a vehicle for an extra layer of meaning.

Example: In *101 Dalmatians*, Cruella blows an exaggerated smoke frame around a picture of the dogs, hinting at her wish to take over their fates.

HOW SPECIAL EFFECTS AND CHARACTERS INTERACT

SPECIAL EFFECTS HAVE MANY POTENTIAL ROLES BEYOND JUST CREATING MOOD.

BASIC

How do characters and special effects interact? Sunsets and dramatic shadows obviously help set the mood for performance. And when characters are pitted against forces of nature, a tornado or tsunami can even function as a kind of villain. But there are other character-effects interactions which, though less obvious, are equally important.

One worth considering is how effects help connect your characters to their environment. For example, a character walking down a dirt road on a hot, sunny day would not only cast a shadow but also raise a cloud of dust with every step. Showing these cause and effect relationships makes the character feel more real because we understand that if she can cast a shadow and raise dust, she must have substance and weight. At the same time, these effects also make the environment feel more real. The end result is a greater belief that this is an actual being living within an actual world.

Attention to such detail is especially useful when working in a more realistic style, and essential when adding animation to live action, particularly when the animated elements are highly fantastical and everything else is grounded in reality.

Example: When the giant bird in Ray Harryhausen's *The 7th Voyage of Sinbad* swoops down to attack the sailors, the dust raised by the draft of its wings helps persuade the audience that this is really happening. Harryhausen was a pioneer of this kind of detailed environmental effect.

ADVANCED

Effects can also be used as an extension of a particular character. Notice here how this use of effects not only connects character and environment but actually blurs the line which divides one from the other. In *101 Dalmatians*, the smoke from Cruella's cigarette extends her domination of the other characters. Her bulky coat and wide gestures already take over the screen whenever she is on camera. But even when she is off camera, her smoke fills the upper half of the screen with a noxious curtain which forces Anita and Pongo to stoop down low to catch a breath of air. And with its thick presence, we can easily imagine the smoke lingering in the room long after Cruella's departure, a noisome souvenir of her visit.

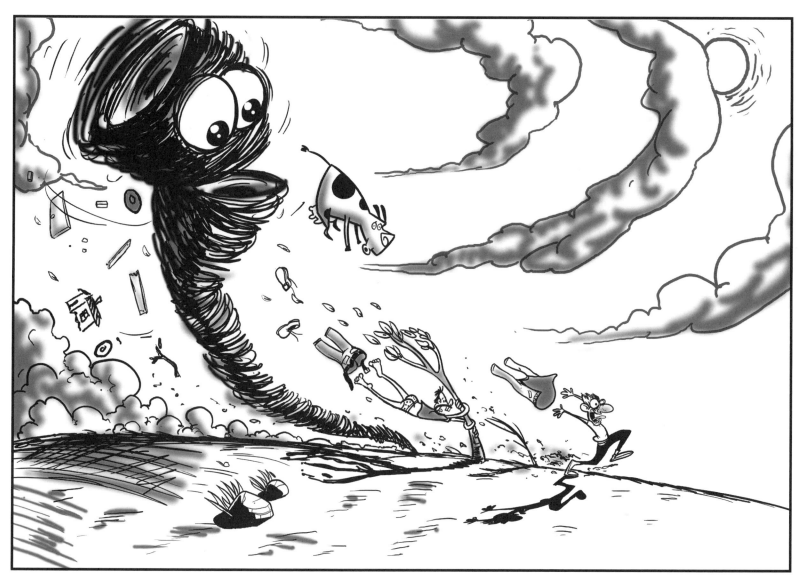

Big special effects, such as tornadoes, can play the role of villain. But even here, the more subtle role effects play in tying characters to their environment remains key.

FIRE

THE QUALITIES OF FIRE ARE AFFECTED BY CIRCUMSTANCE.

BASIC

How fire should be handled depends on what is being burned, how much is being burned, and under what conditions.

At its most basic, fire can be represented with simple flickering flames, an effect created by having each flame shift back and forth. This approach works equally well for a single candle flame or a modest camp fire.

For more realism or drama, such as with a large bonfire or burning building, there are several options. For example, you can have the tips of the flames occasionally break off and float upwards before disappearing. Real fires also cast off sparks and produce extra flames that shoot up from the source and just as suddenly disappear. And of course, you can make the flames bigger and the basic flicker bolder.

For simplicity's sake, any or all of these movements can be repeated over and over again in a straightforward cycle, but an even more realistic and dramatic effect will be achieved if they are used in random order, which creates a variety of movement instead of an obvious pattern.

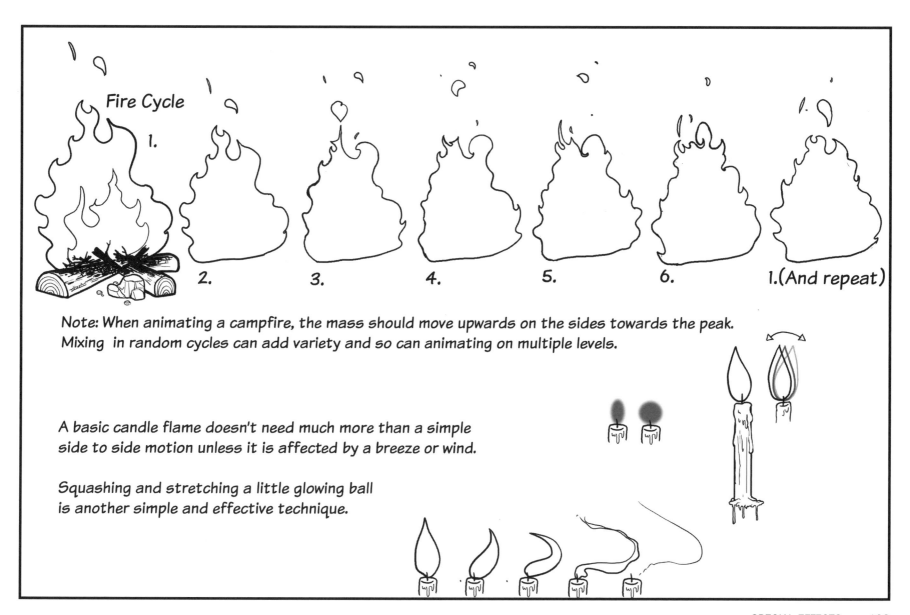

Fire Cycle

1.

2. 3. 4. 5. 6. 1.(And repeat)

Note: When animating a campfire, the mass should move upwards on the sides towards the peak.
Mixing in random cycles can add variety and so can animating on multiple levels.

A basic candle flame doesn't need much more than a simple
side to side motion unless it is affected by a breeze or wind.

Squashing and stretching a little glowing ball
is another simple and effective technique.

ADVANCED

Other factors to keep in mind when animating fire include the color of the flames, the height and quantity of the flames, and the speed at which they burn. All of these properties are affected by circumstances. Fires also have rhythm created by the movement of all their elements, with bigger fires burning at a faster pace with more complexity of rhythm than tiny ones.

And don't forget that a real fire will reflect off the surfaces around it. Flickering, flame-colored highlights appearing randomly on nearby surfaces create a warm ambiance if this is a friendly fire. For a raging inferno, brighter highlights help confirm the extreme heat. Here highlights also raise the stakes by implying that any surface close enough to reflect the fire may soon burst into flames itself.

In either case, reflections will make your fire more believable by anchoring it more thoroughly to its environment.

See also: *Special Effects: Realistic vs. Stylized*

FRIENDLY LITTLE FIRE

REMEMBER THAT REAL FIRE
WILL REFLECT OFF THE
SURFACES AROUND IT

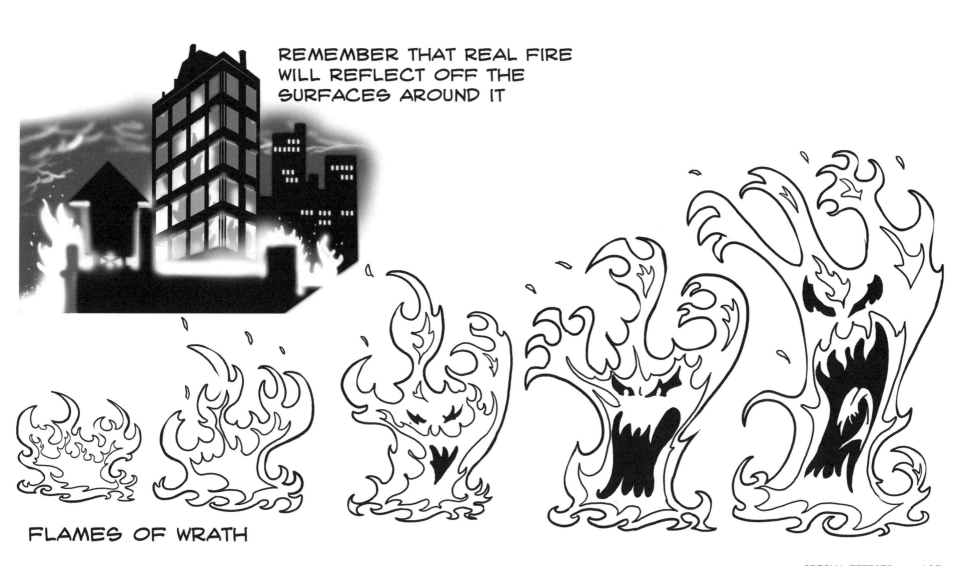

FLAMES OF WRATH

EXPLOSIONS

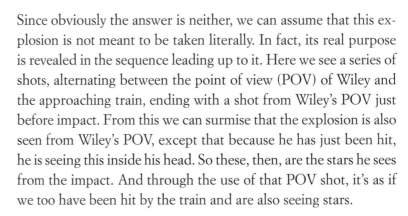

EXPLOSIONS START BIG.

BASIC

Who doesn't like to watch things blow up?

However and wherever they are used, explosions are visually exciting. To create that big visual impact, explosions of all types and sizes tend to follow the same basic pattern: they start at their biggest and then clear from the source outward. So when a bomb hits the ground, we might first see a big fan-shaped sunburst which then dissipates from the ground up. When a firecracker bursts in the air, we might first see a big round sunburst which then dissipates from the center out.

ADVANCED

The most exciting explosions are those which fill the entire screen. Here that first sunburst becomes a flash frame — a sudden filling of the screen with light — because the size of the sunburst is so large, its edges actually exceed the screen's boundaries.

Along with literal uses such as the bombs and fireworks shown above, full-screen explosions also have impressionistic applications. For example, when Wiley Coyote has a head-on collision with a fast-moving train in *Zoom and Bored*, the climatic result is a full-screen explosion. But who or what exactly is blowing up here? Wiley? The train?

Since obviously the answer is neither, we can assume that this explosion is not meant to be taken literally. In fact, its real purpose is revealed in the sequence leading up to it. Here we see a series of shots, alternating between the point of view (POV) of Wiley and the approaching train, ending with a shot from Wiley's POV just before impact. From this we can surmise that the explosion is also seen from Wiley's POV, except that because he has just been hit, he is seeing this inside his head. So these, then, are the stars he sees from the impact. And through the use of that POV shot, it's as if we too have been hit by the train and are also seeing stars.

In other words, this truly subjective way of presenting the effects of a violent collision (especially compared to the cartoon standard of showing stars swirling around the character's head) not only let's us see the impact but helps us feel it as well.

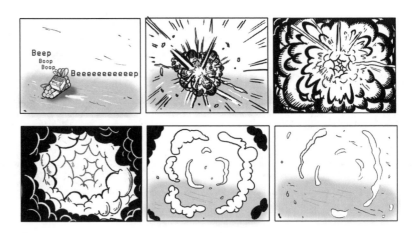

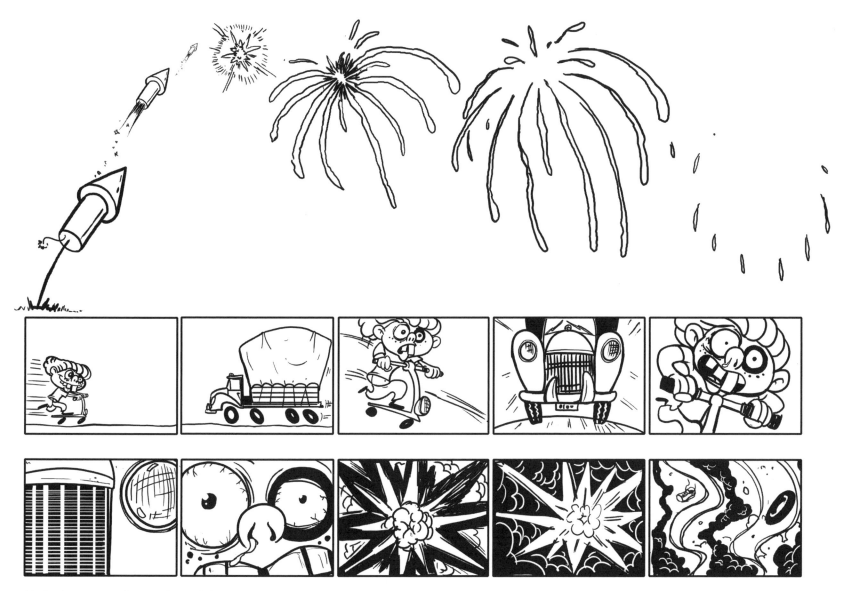

Explosions come in a variety of shapes and sizes.

WIND AND TORNADOES

WIND CANNOT BE SEEN. RATHER WE SEE THE EFFECT OF WIND ON OTHER THINGS.

How can you animate something which can't be seen? In the case of wind, the solution lies less in the action of this invisible force and more in its visible effect on other things. And this means that in our planning, we have to consider not only the nature of the wind we need but also the elements with which it will interact.

Different kinds of winds produce different kinds of interactions. For example, a light breeze will rustle leaves, curtains or other lightweight elements while a stiff breeze will rattle windows, flap a flag or sway tree branches. And a big wind will sway whole trees, knock over lawn furniture or tear laundry right off the line.

A really big wind can also pick up elements such as sand or dry snow which then gives the wind itself a kind of visual form consisting of blurred images zipping by — in essence, a big mass of free-moving speed lines. This is the real property out of which, perhaps, comes the fairy tale convention of showing wind as a visible being with both body and face.

This brings us to the heavy hitters: wind storms such as hurricanes and tornadoes. These giants each have special characteristics. Hurricanes have extreme wind and torrential rain. Along with flying debris and silhouetted elements such as trees being blown about, it is rain which makes this wind visible in all its fury. A big enough storm will actually blow the rain sideways. Filling the screen with these various elements gives a hurricane its characteristic sense of being all encompassing.

A hurricane takes over an entire landscape. By contrast, a tornado is a distinct element which passes through a landscape, destroying some things and sparing others. The ultimate vacuum cleaner, what makes a tornado visible is the dust and debris it sucks up as it as it spins through at great speed.

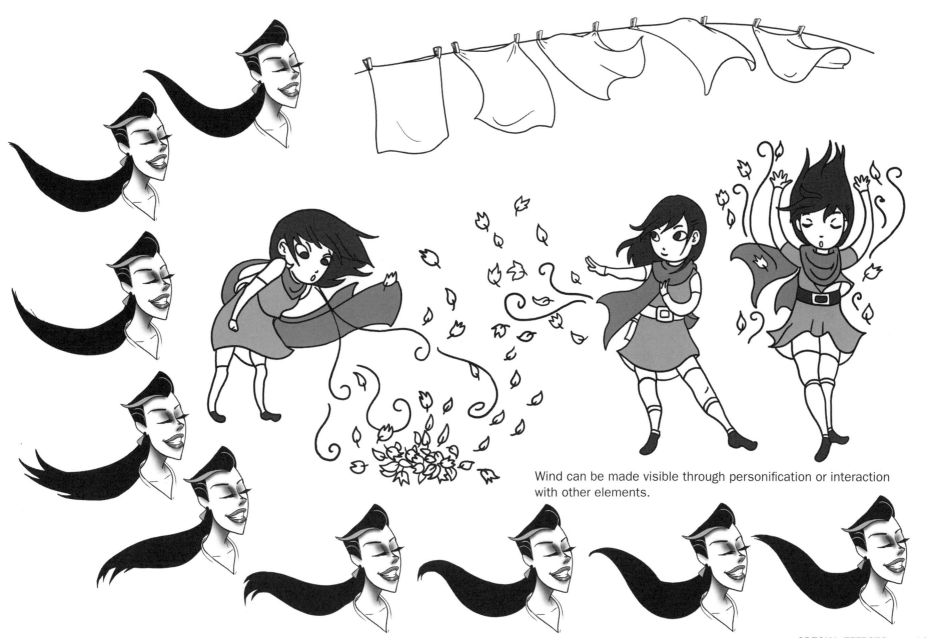

Wind can be made visible through personification or interaction with other elements.

Tornados actually have several key movements: they spin, they wobble, and they travel. The spinning can be accomplished with a cycle of speed lines moving around the core funnel shape. To this you can also add blurred debris. A tornado travels as it spins, but the movement of top and bottom tends to vary in speed, creating a slow wobble. And while cartoon tornadoes favor a standard shape, real tornadoes come in a variety of shapes and sizes.

Whatever the size or type of wind you are planning, remember that you have the option to build into your scenario elements with which the wind can interact, not just for visibility but also for meaning and entertainment: a child trying to build a pile of leaves which a playful wind keeps whirling away; drying clothes dancing on the line as the wind picks up; a sudden gust blowing out the last match before the fire can be lit at the campsite; a twister picking up a hitchhiker and unexpectedly dropping him right at his destination.

Examples: Watch for the cartoony tornado in *The Band Concert* and the classically realistic storm in *The Old Mill*. And for an inventive variation on the use of wind, take a look at *Avatar the Last Airbender*.

See also: *Speed Lines; Rain*

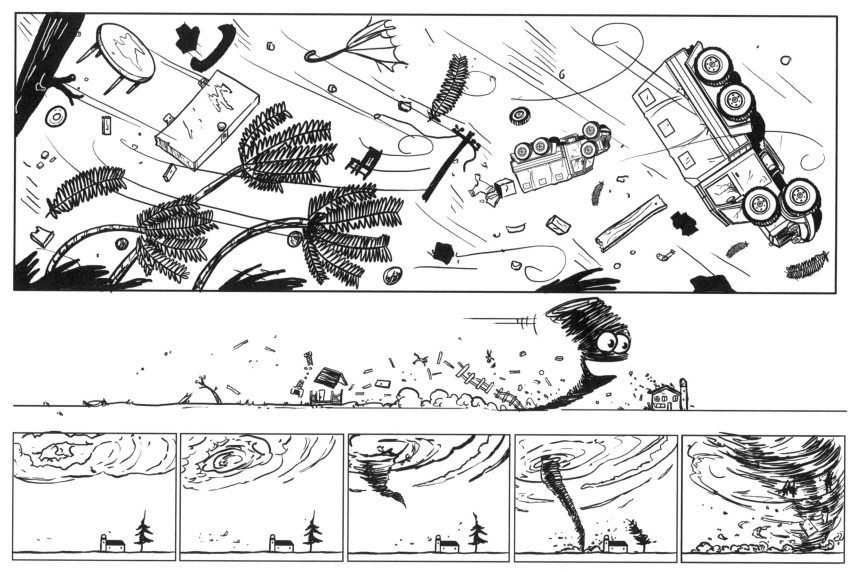

Bigger winds create bigger interactions.

WATER AND TIDAL WAVES

THE KEY QUALITIES OF WATER ARE FLUIDITY AND WEIGHT.

BASIC

Making water read as water has more to do with fluidity and weight than with the more obvious quality of transparency.

For example, waves can be as simple as a line of softly pointed peaks, with or without whitecaps, tipped gently in the direction the waves are traveling. Here the softness of the peaks hints at fluidity and the angle at which they are tipped gives the sense of weight, adding up to a feeling of water even when rendered with solid color.

This basic approach can be used for waves of all sizes, from tiny chop to huge tsunami.

ADVANCED

Whether creating water which is realistic or stylized, fluidity and weight are still key factors.

In realistic waves, the peak continuously pushes out over the front of the wave until gravity takes over and pulls it down. The falling peak breaks up into the foam we call a white cap and then plunges into the water below.

Splashes are created by a similar process, with spumes which rise and then break up as they fall back into the water. In both waves and splashes, weight helps cause the break up and fluidity defines the characteristic shapes at each stage.

When you carry this over to the advanced tidal wave, remember that it means more of everything: more height, more weight, more speed. And, of course, a lot more water. The drama of a tsunami can also be enhanced by the amount of water it sucks back from the shore as it approaches land, leaving a huge expanse of bare sand which only moments before was covered by ocean.

Keep in mind that fluidity and weight allow water to be readily choreographed. Watch in *The Little Mermaid* how splashes nicely frame the main action of a musical number while moving in perfect synch with the music. Fluidity and weight also allow a stylized wave to morph into a watery hand which can literally pick up characters and bat them around.

Value-Added Point: Don't forget that wave action affects characters (and objects) as they move around in water and that as they move around, they inevitably create splashes. Such interactions help connect characters to this specialized environment.

See also: *Special Effects: Realistic vs. Stylized; How Special Effects and Characters Interact*

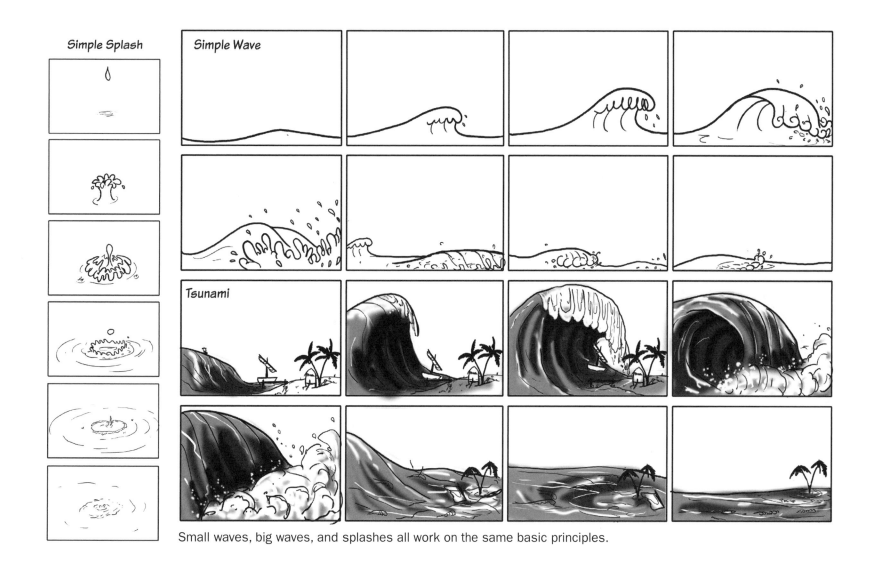

Small waves, big waves, and splashes all work on the same basic principles.

RAIN

RAIN IS MORE ABOUT THE MOVEMENT OF QUANTITIES OF RAINDROPS AND LESS ABOUT THE INDIVIDUAL RAINDROPS THEMSELVES.

BASIC

What do you see when you watch falling rain? You may notice that you don't see individual drops so much as a mass of silver-gray streaks. This effect can be produced with random cycles of grayish diagonal lines against a soft-focus background. Adding more levels of lines will create a heavier rainfall. And varying the direction of the lines from straight up and down to almost sideways communicates whether conditions are calm or windy. With these simple tools, just about any kind of rain can be created.

ADVANCED

There are, in fact, many kinds of rain. And despite the apparent simplicity of this effect, different kinds of rain can produce distinctly different moods. Factors that alter the mood of rain include steadiness, direction, density, and strength of the downpour, all of which can be controlled within the approach given above.

For example, a dense, wind-driven rain which occasionally lightens up only to begin pouring down again, has a built-in sense of drama. Big weather like this reminds us of how powerless we really are against the forces of nature. And as in any good drama, the occasional lightening of the downpour raises our hopes only to dash them when the torrent returns. Such rainstorms can therefore be used to bring out the heroism in a character who must carry on in the face of the storm. Or they can be used to reflect the power of the mob, another force of nature, as in *Snow White*, where heavy rain accompanies the angered dwarves as they chase the evil Queen up the cliff to her death.

By contrast, a steady, perfectly vertical, moderate rain falling from a dull, gray, completely overcast sky generates a sense of dreariness by its very monotony and by failing to offer any clue of when, if ever, it might end.

See also: *Wind and Tornadoes*

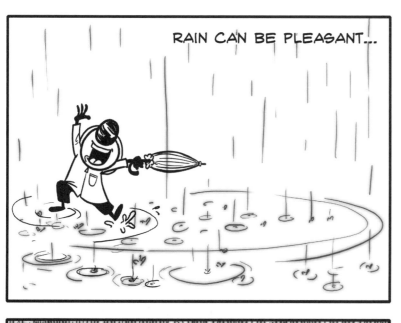

RAIN CAN BE PLEASANT...

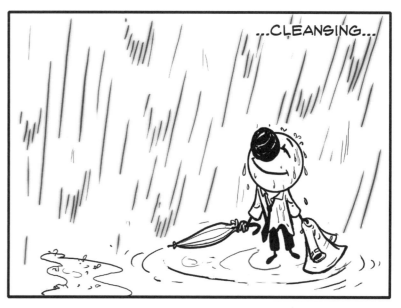

...CLEANSING...

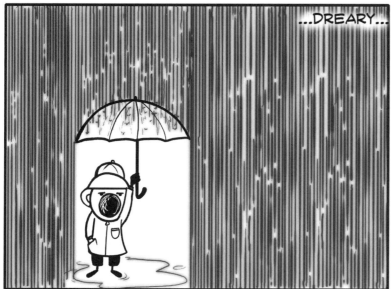

...DREARY...

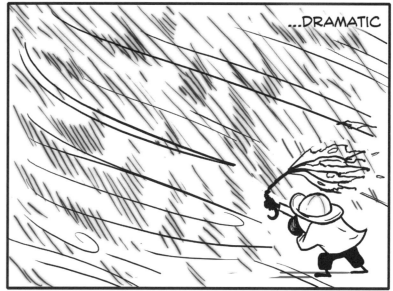

...DRAMATIC

Rain has many moods, created by such factors as steadiness, direction and density.

SHADOWS

SHADOWS ARE THE MOST VERSATILE EFFECT WITH THE WIDEST RANGE OF APPLICATIONS.

BASIC

Shadows can be used for many complex applications, yet they can also be as simple as a patch of solid black beneath your characters' feet. While not an absolute necessity, this most basic shadow does give characters a defined point of contact with their setting. Without such visual grounding, characters may seem to float even if given weight in the animation.

As you move beyond basics, it becomes important to give shadows some transparency. This makes them both more real and more useful. For example, a transparent shadow falling over a portion of the screen will darken that area, producing additional colors which still match the overall palette. As well, changing the degree of transparency can alter the mood of shadows, shifting them, perhaps, from inviting to threatening.

Value-Added Point: Transparency can be created in a number of ways. Digital animation applications feature controls which dictate transparency. And in analogue animation, transparency can be created with a second pass of the camera using a partial exposure.

ADVANCED

Beyond grounding characters and setting mood, shadows can also play an active role in communication. But how can this potential be unlocked?

One key lies in connecting shadows to a specific light source. Basic shadows often imply a generalized source of light without actually identifying it. But once a specific source is identified, a new world of possibilities opens up.

For example, shadows created by the sun can establish the time of day and consequent passing of time or reveal changing weather conditions such as an off-screen shift from a cloudy day to a sunny one. And shadows cast by a light shining from a hallway into a darkened bedroom can show the movement of off-screen characters without revealing their identities or conceal the unexpected presence of something within the room.

Keep in mind that shadows cast by such artificial sources can not only be used at any time of day or night but can also be fully controlled by your characters: with a flick of a switch that concealing shadow can be created or taken away.

And of course, a shadow can also take on a life of its own — reflecting a character's dark side, perhaps or personifying his fears.

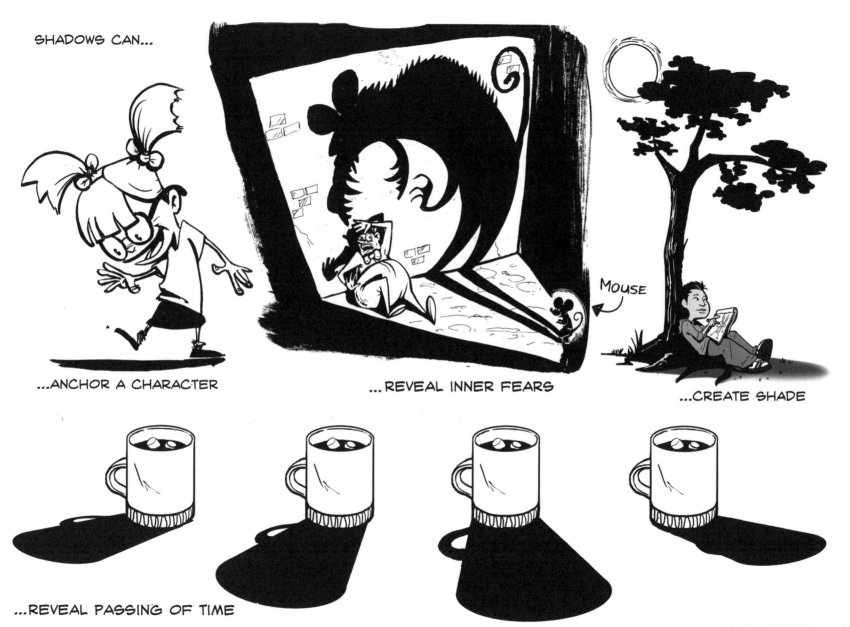

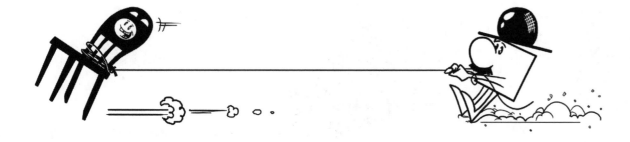

CHAPTER 10: ABSTRACT AND NON-NARRATIVE ANIMATION

INTRODUCTION

It's a mark of animation's diversity that it can go from full-blown narrative to conceptual non-narrative all the way to complete abstraction.

The visuals of an abstract animation may consist entirely of color patterns created digitally or perhaps by manipulating 35mm film stock. The content of a non-narrative piece might involve the visualization of a poem or the study of light as it moves across a room. Yet as different as abstract and non-narrative animation can be from narrative, they still share many key elements, including the same primary principles. In this section we will examine some of these shared elements and how they can be adapted to fit the needs of these alternative approaches.

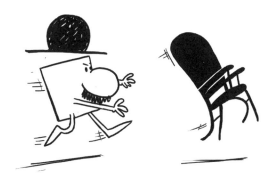

ABSTRACT AND NON-NARRATIVE ANIMATION AND ANALOGY

JUST AS IN NARRATIVE WORK, ANALOGY CAN PLAY A KEY ROLE IN NON-NARRATIVE AND ABSTRACT ANIMATION.

BASIC

What is the role of analogy in abstract and non-narrative animation?

Looking at an abstract animation composed, let's say, of rapidly moving dots and lines, one might ask if analogy has any role to play here. But actually, analogy can play many roles here, generating themes and imagery just as it does for narrative animation, while also supporting internal logic.

However, to be effective in this case, analogy must be expressed in new terms, ones which reflect the specific context. This means, for example, that abstract animation needs abstracted analogy.

Analogy can be abstracted by stripping it down to its most essential elements. So if the theme were nonconformity, rather than delving into the psychology of a winter-loving butterfly which refuses to migrate with the flock as you might with narrative analogy, the abstract analogy could simply be "many similar elements plus one which is different."

Once reduced to the basics, specific details can be plugged in. A single slow-moving dot in the midst of many wildly gyrating ones expresses nonconformity in abstract terms. And shifting into the territory of figurative non-narrative, so does a static character in a leisure suit contrasted against a line of uniformed factory hands marching endlessly to work.

Notice how in both these examples, movement helps to express the theme, taking advantage of animation's strength in this area. Notice also how in this context, iconic elements become the primary carriers of information. It is wholly such factors as design and patterns of movement which communicate the idea of nonconformity here, without the need for such devices as character or plot.

ADVANCED

As we have already seen, patterns of movement are a key factor in how stripped-down analogy communicates. In order to communicate, though, these patterns must be recognizable. This can be achieved by grounding analogy in the phenomena of the natural world — the life cycles of plants and animals, the phases of the moon, etc. — or in patterns of human behavior, as above.

Such patterns are so familiar and meaningful that even when stripped of narrative context or figurative imagery, they still speak to the audience. But, interestingly, so do patterns which seem even more abstract, such as ones which simply contrast qualities of shapes and movements. With this approach, surprisingly complex statements can be made.

In abstract analogy, ideas are communicated wholly through such factors as design and movement patterns.

For example, rounded shapes and flowing movements could be contrasted with angular shapes and stiff movements, creating an abstracted statement about flexibility versus rigidity or, perhaps, an organic world versus a manufactured one.

Even patterns based in rhythm and time can be used to generate analogy: an even rhythm contrasted against an erratic one speaks to the idea of order and chaos, regardless of the specific imagery which is used.

See also: *Analogy as Foundation; Animation and Movement-Based Communication*

ABSTRACT AND NON-NARRATIVE CONTINUITY

ABSTRACT AND NON-NARRATIVE ANIMATION NEEDS A SPECIAL APPROACH TO CONTINUITY.

Just like narrative animation, abstract and non-narrative animated projects need a motivated and coherent means of moving from shot to shot.

Let's first clarify that we are not talking only about mechanical motivations for shifting camera angles but also about strategies which connect the contents of one shot to the next, creating an ongoing sense of continuity and helping all the parts add up to a greater whole. In narrative work, this can be as simple as having a character look off screen before cutting to see what she sees, a strategy which links the two shots while also effectively putting us inside the character's mind. There are many such motivating narrative strategies, often derived from elements like plot and character performance.

But many, if not most, abstract and non-narrative animations have neither plot nor character performance. Nor are they necessarily constructed as a series of linked shots. Many, in fact, may be more accurately described as a progression of linked ideas. Consequently a different kind of motivating strategy is often required.

You could, for example, look for poetic structuring devices rather than narrative ones. This might involve using a recurring visual element as the common link — an attribute such as roundness, perhaps, or a distinctive use of light — which appears in a series of consecutive shots.

Disparate images can also be linked with repeating camera movements. Here you could cut together a series of pans shot at exactly the same speed and angle, each pan traveling past dramatically different images. With this approach, it is the momentum of the movement carried over from one shot to the next which creates an unexpected sense of continuity.

See also: *Alternative Structure*

Abstract and non narrative continuity can be created through various means including a continuous line of action which passes through many scenes.

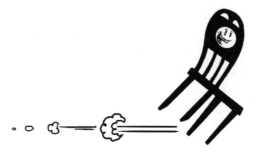

CHAPTER 11: TITLES AND CREDITS
INTRODUCTION

Titles and credits can be as basic as white lettering on a plain black background. But they can also be so much more. Welcome to the wonderful world of animated title and credit sequences where, in ways both simple and complex, the otherwise boring act of rolling credits is brought to life.

CREDIT SEQUENCES AS PART OF YOUR FILM

OPENING TITLES AND END CREDITS SHOULD BE CONNECTED TO THE CONTENT.

BASIC

Titles and credits offer the opportunity to draw your audience in from the first frame of your production and keep them watching right through to the very end. This neat trick can be accomplished by treating titles and credits as part of the content, instead of something which is merely stuck on in an arbitrary fashion. In animation, we are already dealing with a graphic world, so this is really just a matter of extending the boundaries of that world to incorporate the credits in a meaningful way.

This can be as simple as choosing fonts, color schemes, and music which match the mood of your production. For example, *Illuminated Lives* extends its medieval theme into the design of the opening and closing credits, an approach also seen in such Warner Bros. shorts as *The Scarlet Pumpernickel*.

ADVANCED

To get even more out of titles and credits, try using them as part of the set up for your story or perhaps as a commentary. This can be accomplished by reconsidering the main content of your project from a new vantage point, such as that of a poet, artist or stand up comic rather than as a narrative storyteller.

For example, try looking for a visual element which is emblematic of your project. This could be an object, a kind of movement or a defining pattern. The opening title sequence of *101 Dalmatians* effectively uses Dalmatian spots as its graphic theme. Not only visually clever, this approach also serves as unexpected foreshadowing, revealed when we discover that the plot hinges on Cruella de Vil's obsession with those very spots.

Value-Added Point: For sheer entertainment value, watch for some of the great animated title sequences created for such live action feature films as *The Pink Panther* series.

See also: *Abstract and Non-Narrative Continuity*

COMING SOON...

Titles and credits can be tied to content by incorporating design elements which reference the mood or theme of your production.

MAKING CREDITS READABLE

CREDITS AND TITLES MUST BE READABLE ON SCREEN.

BASIC

The primary purpose of titles and credits, whether basic white credits on a black background or something more elaborate, is to showcase information. But this most important function can't be achieved unless the information is easy to read on screen.

So how can this be accomplished?

First, be sure to choose a clear, readable font. Then make sure your background is neither overwhelming nor distracting. And of course, be careful to leave the information on the screen long enough to be comfortably read but not so long as to bore your audience — long enough to be said out loud twice, at a normal speaking rate, is a good rule of thumb here.

If you plan to use animation or fancier graphics, be careful that these don't split the audience's attention, making them miss one element while taking in the other. For example, instead of having potentially distracting animation running alongside the credits, let the animation lead in to each credit slate and then stop while the written information is actually being read. Or use a repeating action (called a "cycle") placed off to the side while the credits occupy center screen.

Finally, don't forget to think about screen size. Sure, smaller fonts with lots of details look good on the big screen. But even films which start with a theatrical release are inevitably going to end up on someone's TV screen, computer monitor or cell phone, so aim for maximum readability under a variety of circumstances.

Example: The credit sequence of the TV series, *Mystery*, uses animation based on the work of Edward Gorey to lead in to each credit slate.

Though interesting, this font is unreadable.

To make credits readable, first choose a clear, legible font. Then consider other techniques such as using animation to lead into the credit or....

ADVANCED

There are other ways to make credit sequences engaging without creating distractions. For example, instead of supplementing the written credits with moving graphics, try adding movement to the credits themselves.

This approach can take many forms. For example, all the letters on the first credit slate could fade on and then be scattered like autumn leaves by a gush of wind, clearing the screen before the next credit appears. Or the letters could be treated like characters with distinctive personalities causing them, perhaps, to behave like impatient schoolchildren waiting in line for a treat.

Notice how, with this approach, the animation not only creates little risk of distracting the audience from reading the credits, it actually ensures they will be focused directly on that information. Just don't get too fancy with the choreography and remember to put in some pauses, if need be, to allow the audience to comfortably take in the words.

...adding movement to the credits themselves.

6 UGLY MUGS ...BUT ONLY ONE IS GUILTY

PART III ETCETERA, **ETCETERA**

INTRODUCTION

IN ANIMATION, THERE IS ALWAYS SOMETHING MORE TO LEARN.

Welcome to the end of the book! We don't get many visitors back here. But just the way some film directors reward viewers who stick around to the very end of the last credit with a little surprise*, so here, along with the usual back end reading and film lists, I'm pleased to offer some last thoughts. You'll find them in the Summary.

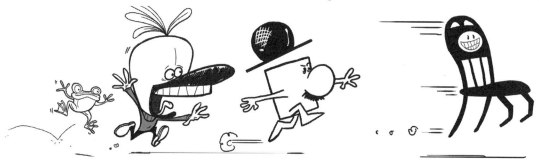

* Remember the "outtakes" at the end of *Bug's Life*? They were hugely enjoyed by all three people left in the theater when I first went to see it.

SUMMARY

YOUR ANIMATION ISN'T FINISHED UNTIL IT'S BEEN VIEWED.

Rather than using this space to simply repeat in short form what has already been said, let's consider one last important point.

And that is that no matter how much effort you put into making your animations, your work isn't really finished until it has been viewed by an audience. There is, in fact, something essential which happens in that process which helps a piece gel into its final form.

A key factor here is that you as animator cannot fully know what you have created until your work has been viewed, preferably in a situation where you are present for the screening. In fact, the process of watching an audience watch your work is so important that it really should be regarded as part of the production process — a kind of post-postproduction.

No where else but in front of an audience will you learn as quickly what you have communicated through your work: whether your jokes are getting laughs; whether a particular character is engaging the viewers or repelling them; whether the audience is silent during the screening because they are so involved that they are forgetting to breathe….

It is my hope that this book will help you make animation which not only satisfies your personal creative aspirations but also holds your audience in its sway, whether you hope to move them or lull them or knock their socks off with laughter. Here's to more better animation.

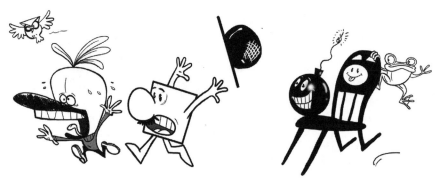

ABOUT THE AUTHOR AND THE ILLUSTRATOR

ELLEN BESEN

A former faculty member of Sheridan College's School of Animation (1987-2002) and infamous workaholic, Ellen Besen studied animation at Sheridan and has been working in the field for over 35 years. (35 years! Even she can hardly believe this.) Highlights of her career include directing award-winning films for the National Film Board of Canada, broadcast work on the topic of animation for CBC Radio, and film curating for such organizations as the Art Gallery of Ontario. Her films have been shown in multiple international festivals and at such institutions as MOMA, and her film analysis workshops are featured regularly at the Ottawa International Animation Festival. She has written popular series for Animation World Network on such topics as animation and analogy, is currently creative director of The Kalamazoo Animation Festival International, and continues to teach the principles of animation filmmaking on an intensive one-on-one basis. This latest project, *Animation Unleashed*, is a book of applied theory which encapsulates over 20 years of dissecting how animation communicates.

Ellen can be reached online at: *bisonx2.blogspot.com*

BRYCE HALLETT

Bryce Hallett is a ridiculously successful, award winning[*] independent animator/cartoonist who has been toiling away in obscurity since graduating from Classical Animation at Sheridan College (Oakville, On.) in 1999 and Graphic Communications at Canadore College (North Bay, On.) before that. His cartoons have been seen by some across Canada and the USA, in TV shows such as *The Red Green Show* (CBC/PBS), *History Bites* (History Television/Comedy Network), advertisements, and music videos. Occasionally he can be found teaching workshops on various animation techniques with Teletoon or the Toronto Animated Image Society, where he also serves on the board of directors. Bryce has hand crafted each illustration in this book with blood, sweat, and tears (of joy). He even has a website: *www.frogfeet.ca*

[*] The award he won was for "best supporting actor, Theatre Ontario Festival 1995" but it's still a nice trophy.

GLOSSARY

Anthropomorphization: The humanizing of animal or object characters through the addition of human body parts, human thinking processes and therefore human behaviors.

Click Track: A rough sound track consisting of a simple continuous beat used to plan and coordinate the timing of various elements — such as action, cuts, camera moves, and music — within an animation production.

Continuity: See Abstract and Non-Narrative Continuity.

Cut: The most basic and versatile edit which moves the viewpoint from one camera angle to the next with no intervening frames. Can be used to put together a sequence of continuous narrative action but also to move from one location to another or backwards and forwards in time, etc.

Cycle: Continuous action created by repeating a set sequence of drawings or images. Can be used for any repeating action including walks, flapping flags, rain, waves, windshield wipers, etc.

Graphic Medium: Any medium which tends to strip down and then enhance its visual elements. Think here of taking a black and white photograph and rendering it in hi con and notice how all the nuance of gray tone would thus be eliminated and the remaining solid black and white elements amplified.

Intonation: The various tonal qualities of voice used in language to express emphasis, contrast, emotion, etc.

POV (Point of View): A camera angle set up from the vantage point of a particular character. At its most extreme, a POV makes us feel as if we were literally looking through the character's eyes.

Rotoscoping: The process of tracing movement frame by frame from live action film onto paper. The resulting trace offs can then serve as a guide for matching animation to live action film or as a guide for creating an animated performance or even as a rough first draft of the animation.

Shot, Scene, Sequence: Animation has traditionally been made up of scenes and sequences. In general, a scene consists of action within one location with either a static camera position (or camera angle) or a change of angle within the scene created by a camera move. And a sequence consists of a series of related scenes. In recent practice, animators have begun to borrow terminology from live action, so now you will also hear a scene referred to as a shot.

Staging: The setting up of action within a particular shot and/or sequence towards achieving the clearest, most accurate communication possible.

Zoom In and Out: Traditionally animation has called the movement of the camera in towards the action or out away from it a truck in and truck out. In recent terminology, these camera movements are now also called zooms (another term borrowed from live action though the meaning has somewhat altered).

ANIMATION TECHNIQUES

Hand-Drawn Animation: 2D animation created with a series of drawings on paper which are then rendered in a variety of ways.

Classical Animation: Traditionally, a form of hand-drawn animation which is grounded in real movement and behavior.

Under the Camera Animation: Animation created directly on an animation stand with the camera mounted directly above. Includes animation created with cut outs, sand, finger paint, etc.

Cameraless Animation: Animation which is created directly on film stock, often by drawing, painting, or scratching directly into the film's emulsion.

Stop Motion: 3D animation created with real objects which are shot a frame at a time and then moved between frames to their next position. Includes pixilation, puppet animation, and claymation.

CG: 3D animation created entirely with digital technology.

2D Digital: 2D animation created entirely with digital technology (as opposed to hand-drawn 2D animation which has been rendered digitally).

FILM REFERENCES USED IN THIS BOOK

A Chairy Tale – Norman McLaren, Claude Jutra, NFB, 1957.

A Charlie Brown Christmas (Peanuts) – Bill Melendez Production, 1965.

Anastasia – Fox, 1997.

Aqua Teen Hungerforce – Matt Maillaro, Dave Willis, Cartoon Network, 2000.

Avatar the Last Airbender – Nickelodeon Animation, 2005.

Beauty and the Beast – Disney, 1991.

Bug's Life – Pixar, 1998.

Charade – John Minnis, Sheridan College, 1984.

Cinderella – Disney, 1950.

Cinderella Swing Shift – Tex Avery, MGM, 1945.

Creature Comforts – Nick Park, Aardman Animations, 1989.

Duck Amuck – Chuck Jones, Warner Bros., 1953.

Dumbo – Disney, 1941.

Every Child – Eugene Fedorenko, NFB, 1979.

Fantasia – Disney, 1940.

Feed the Kitty – Chuck Jones, Warner Bros., 1952.

Finding Nemo – Pixar, 2003.

Futurama – Matt Groening, 1999.

Gerald McBoing Boing – Robert Cannon, UPA, 1951.

Harvey Birdman – Michael Ouweleen, Erik Richter, Turner Studios, 2000.

How to Kiss – Bill Plympton, 1989.

Illuminated Lives – Ellen Besen, NFB, 1989.

King of the Hill – Mike Judge, Greg Daniels, Deedle-Dee Productions, 1997.

King Size Canary – Tex Avery, MGM, 1947.

Lady and the Tramp – Disney, 1955.

Little Bear – Nelvana, 1995.

Luxo Jr. – John Lasseter, Pixar, 1986.

Monsters, Inc. – Pixar, 2001.

Mystery (Credit sequence for TV series) – Derek Lamb, Eugene Fedorenko, 1980.

One Hundred and One Dalmatians (aka *101 Dalmatians*) – Disney, 1961.

Pink Panther – Blake Edwards, Geoffrey Productions Inc., 1963.

Pinocchio – Disney, 1940.

Rabbit Seasoning – Chuck Jones, Warner Bros., 1952.

Red Hot Riding Hood – Tex Avery, MGM, 1943.

Rocket Robin Hood – Krantz Films Inc., 1966.

Rocks (Das Rad) – Chris Stenner, Arvid Uibel, Filmakademie Baden-Württemberg. 2003.

Rocky and Bullwinkle and Friends – Jay Ward Productions, 1959.

Ryan – Chris Landreth, NFB, 2004.

Scarlet Pumpernickel – Chuck Jones, Warner Bros., 1950.

Sea Dream – Ellen Besen, NFB, 1979.

Sleeping Beauty – Disney, 1959.

Snow White and the Seven Dwarfs – Disney, 1937.

South Park – Trey Parker, Matt Stone, Comedy Central, 1997.

Special Delivery – John Weldon, Eunice Macaulay, NFB, 1978.

Spirited Away – Hiyao Miyazaki, Studio Ghibli, 2001.

Sponge Bob Square Pants – Stephen Hillenburg, Nicktoons, 1999.

Superman (Theatrical Series) – Fleischer Studios, 1941.

Thanksgiving – Independent film, 1970s.

The 7th Voyage of Sinbad – Ray Harryhausen, 1958.

The Band Concert – Disney, 1935.

The Big Snit — Richard Condie, NFB, 1985.

The Fairly Odd Parents – Butch Hartman, Frederator Incorporated, 2001.

The Fly – Ferenc Rufusz, MAFILM Pannonia Filmstudio, 1980.

The Great Toy Robbery – Jeff Hale, NFB, 1963.

The Grinch Who Stole Christmas – Chuck Jones, MGM, 1966.

The Hand – Jiri Trinka, 1965.

The Jungle Book – Disney, 1967.

The Little Mermaid – Disney, 1989.

The Old Mill – Disney, 1935.

The Simpsons – Matt Groening, 20th Century Fox, 1989.

The Street – Caroline Leaf, NFB, 1976.

The Tell Tale Heart – Ted Parmelee, UPA, 1953.

The Tortoise and the Hare – Disney, 1935.

The Triplets of Belleville – Sylvain Chomet, 2003.

Toy Story – Disney/Pixar, 1995.

What's Opera Doc – Chuck Jones, Warner Bros., 1957.

Why Me – Janet Perlman, Derek Lamb NFB, 1978.

Yellow Submarine – George Dunning, 1968.

Zoom and Bored – Chuck Jones, Warner Bros., 1957.

RECOMMENDED READING

Animation and America
by Paul Wells (2002, Rutgers University Press)

Animation from Pencils to Pixels: Classical Techniques for the Digital Animator by Tony White (2006, Focal Press)

Animation Techniques by Roger Noake (1989, Chartwell)

Animation Writing and Development: From Script Development to Pitch by Jean Ann Wright (2005, Focal Press)

Basics Animation: Scriptwriting (Basics Animation) by Paul Wells (2007, AVA Publishing)

Cartoons: One Hundred Years of Cinema Animation by Giannalberto Bendazzi (1994, John Libbey Cinema and Animation)

Encyclopedia of Animation Techniques by Richard Taylor (2004, Book Sales)

Gardner's Guide to Animation Scriptwriting: The Writer's Road Map by Marilyn Webber (2000, GGC)

Hollywood Flatlands: Animation, Critical Theory and the Avant-Garde by Esther Leslie (2004, Verso Books)

How to Write for Animation by Jeffrey Scott (2003, The Overlook Press/Peter Mayer Publishers)

Masters of Animation by John Grant (2001, Watson-Guptil Publications)

Storytelling in Animation: The Art of the Animated Image by John Canemaker (1988, Samuel French Trade)

Storytelling through Animation by Mike Wellins (2005, Charles River Media)

The Animation Book: A Complete Guide to Animated Filmmaking–From Flip-Books to Sound Cartoons to 3-D Animation by Kit Laybourne and John Canemaker (1998, Random House)

The Animator's Workbook: Step-by-Step Techniques of Drawn Animation by Tony White (1988, Watson-Guptil Publications)

Understanding Animation by Paul Wells (1998, Routledge)

Writing for Animation, Comics, and Games by Christy Marx (2006, Focal Press)

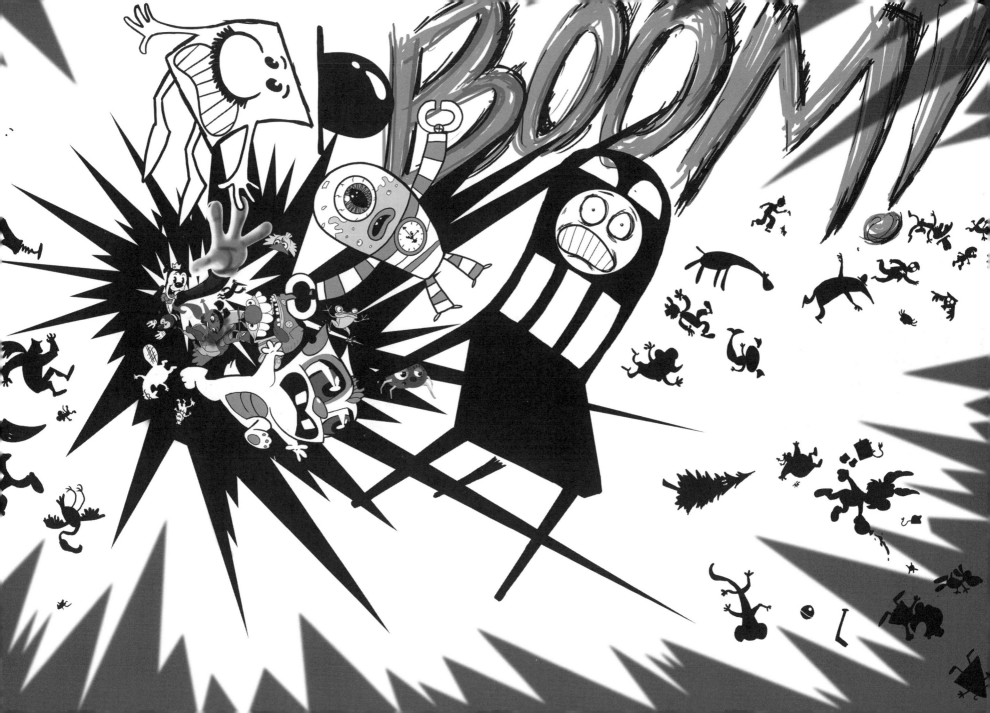

INDEX

SETTING UP YOUR SHOTS SECOND EDITION

GREAT CAMERA MOVES EVERY FILMMAKER SHOULD KNOW

JEREMY VINEYARD

This is the 2nd edition of one of the most successful filmmaking books in history, with sales of over 50,000 copies. Using examples from over 300 popular films, Vineyard provides detailed examples of more than 150 camera setups, angles, and moves which every filmmaker must know — presented in an easy-to-use "wide screen format." This book is the "Swiss Army Knife" that belongs in every filmmakers tool kit.

This new and revised 2nd edition of *Setting Up Your Shots* references over 200 new films and 25 additional filmmaking techniques.

This book gives the filmmaker a quick and easy "shot list" that he or she can use on the set to communicate with their crew.

The Shot List includes: Whip Pan, Reverse, Tilt, Helicopter Shot, Rack Focus, and much more.

"This is a film school in its own right and a valuable and worthy contribution to every filmmaker's shelf. Well done, Vineyard and Cruz!"

> – Darrelyn Gunzburg, "For The Love Of It" Panel, www.ForTheLoveOfIt.com

"Perfect for any film enthusiast looking for the secrets behind creating film... It is a great addition to any collection for students and film pros alike....." Because of its simplicity of design and straight forward storyboards, this book is destined to be mandatory reading at films schools throughout the world."

> – Ross Otterman, *Directed By* Magazine

"Setting Up Your Shots is a great book for defining the shots of today. The storyboard examples on every page make it an valuable reference book for directors and DP's alike! Great learning tool. Should be a boon for writers who want to choose the most effective shot and clearly show it in their boards for the maximum impact."

> – Paul Clatworthy, Creator, StoryBoard Artist and StoryBoard Quick Software

JEREMY VINEYARD is currently developing an independent feature entitled "Concrete Road" with Keith David (*The Thing, Platoon*) and is working on his first novel, a modern epic.

$22.95 | 160 PAGES
ORDER # 84RLS | ISBN: 1932907424

FILM DIRECTING: CINEMATIC MOTION 2ND EDITION

STEVEN D. KATZ

BEST SELLER
OVER 40,000 COPIES SOLD!

Cinematic Motion has helped directors create a personal camera style and master complex staging challenges for over a decade. In response to the opportunities offered by digital technology, this second edition adds essential chapters on digital visualization and script breakdown.

S. D. Katz uses extensive illustrations to explain how to create extended sequence shots, elaborate moving camera choreography, and tracking shots with multiple story points. Interviews with top Hollywood craftspeople demonstrate how to bring sophisticated ideas to life.

Readers will be able to follow links to the MWP website and interact with the author's original storyboards, built in 3-D with the latest storyboard software.

"There are a precious few ways to learn the subtleties of filmmaking and challenges of cinematography: Watch great movies repeatedly; go to a great film school; read Steven D. Katz's Film Directing: Shot by Shot *and* Cinematic Motion. *The practical and pragmatic information is balanced by the insights of great filmmakers, Allen Daviau, Ralph Singleton and John Sayles.* Cinematic Motion *is the definitive workbook for both the aspiring as well as the accomplished filmmaker."*

> – John McIntosh, Chair, Computer Art,
> School of Visual Arts, NYC

"There are few authors or books that reach 'must-read' status. The works of Steven Katz have achieved this appellation. Cinematic Motion *is a remarkable tutorial for any aspiring or working director. Clear, practical, and wise, the book is an essential guide to understanding and implementing staging for the motion picture medium."*

> – Sam L Grogg, Ph.D., Dean,
> AFI Conservatory

"In Cinematic Motion, *Katz succeeds in breaking down the daunting tasks that a director faces when choreographing actors and the camera on set."*

> – Dan Ochiva, *Millimeter* Magazine

STEVEN D. KATZ is an award-winning filmmaker and writer, and the author of *Shot by Shot*, the now classic text on cinematic style and technique.

$27.95 | 362 PAGES
ORDER # 121RLS | ISBN: 0941188906

SETTING UP YOUR SCENES
THE INNER WORKINGS OF GREAT FILMS

RICHARD D. PEPPERMAN

Every great filmmaker has films which inspired him or her to greater and greater heights. Here, for the first time, is an awe-inspiring guide that takes you into the inner workings of classic scenes, revealing the aspects that make them great and the reasons they have served as inspirations.

An invaluable resource for screenwriter, cinematographer, actor, director, and editor, Pepperman's book uses examples from six decades of international films to illustrate what happens when story, character, dialogue, text, subtext, and set-ups come together to create cinematic magic.

With over 400 photos of selected movie clips laid out beautifully in a widescreen format, this book shows you how to emulate the masters and achieve your dreams.

"Setting Up Your Scenes *is both visually stunning and very useful for students of cinema. Its design, layout, and content make the book unique and irresistible.*"
— Amresh Sinha, New York University/The School of Visual Arts

"*Pepperman has written a book which should form the basis for an intelligent discussion about the basic building blocks of great scenes across a wide variety of films. Armed with the information in this book, teachers, students, filmmakers, and film lovers can begin to understand how good editing and scene construction can bring out the best storytelling to create a better film.*"
— Norman Hollyn, Associate Professor and Editing Track Head, School of Cinema-Television at the University of Southern California

"*Pepperman dissects some very infamous scenes from some very famous movies — providing us with the most breathtaking black and white stills — in order to highlight the importance of the interplay between dialogue, subtext, and shot selection in great filmmaking.*"
— Lily Sadri, Writer, Screenwriter (*Fixing Fairchild*), Contributor to *www.absolutewrite.com*

RICHARD D. PEPPERMAN has been a film editor for more than 40 years and a teacher for more than 30. He is also the author of *The Eye Is Quicker* and *Film School*.

$24.95 | 245 PAGES
ORDER # 42RLS | ISBN: 1932907084

FROM WORD TO IMAGE
STORYBOARDING AND THE FILMMAKING PROCESS

MARCIE BEGLEITER

BEST SELLER

For over a decade, Marcie Begleiter's acclaimed seminars and workshops have made visual communication accessible to filmmakers and all artists involved in visual storytelling. Whether you're a director, screenwriter, producer, editor, or storyboard artist, the ability to tell stories with images is essential to your craft. In this comprehensive book, Begleiter offers the tools to help both word- and image-oriented artists learn how to develop and sharpen their visual storytelling skills via storyboarding.

Readers are taken on a step-by-step journey into the pre-visualization process, including breaking down the script, using overhead diagrams to block out shots, and creating usable drawings for film frames that collaborators can easily understand. The book also includes discussions of compositional strategies, perspective, and figure notation as well as practical information on getting gigs, working on location, collaborating with other crew members, and much more.

"From Word to Image *examines the how-to's of storyboard art, and is full of rich film history. It demystifies an aspect of filmmaking that benefits everyone involved — from directors, to cinematographers, to production designers.*"

— Joe Petricca, Vice Dean,
American Film Institute

"*Begleiter's process is a visual and organizational assist to any filmmaker trying to shift from story in words to story in moving image.*"

— Joan Tewkesbury, Screenwriter, Nashville;
Director, *Felicity*

"From Word to Image *delivers a clear explanation of the tools available to help a director tell his story visually, effectively, and efficiently — it could be subtitled 'A Director Prepares.'*"

— Bruce Bilson, Emmy® Award-Winning
Director of over 350 television episodes

MARCIE BEGLEITER is a filmmaker and educator who specializes in pre-visualization. She is the owner of Filmboards, whose clients include Paramount, New Line, HBO, ABC, and Lightspan Interactive.

$26.95 | 224 PAGES
ORDER # 45RLS | ISBN: 0941188280

{ **THE MYTH OF MWP** }

In a dark time, a light bringer came along, leading the curious and the frustrated to clarity and empowerment. It took the well-guarded secrets out of the hands of the few and made them available to all. It spread a spirit of openness and creative freedom, and built a storehouse of knowledge dedicated to the betterment of the arts.

The essence of the Michael Wiese Productions (MWP) is empowering people who have the burning desire to express themselves creatively. We help them realize their dreams by putting the tools in their hands. We demystify the sometimes secretive worlds of screenwriting, directing, acting, producing, film financing, and other media crafts.

By doing so, we hope to bring forth a realization of 'conscious media' which we define as being positively charged, emphasizing hope and affirming positive values like trust, cooperation, self-empowerment, freedom, and love. Grounded in the deep roots of myth, it aims to be healing both for those who make the art and those who encounter it. It hopes to be transformative for people, opening doors to new possibilities and pulling back veils to reveal hidden worlds.

MWP has built a storehouse of knowledge unequaled in the world, for no other publisher has so many titles on the media arts. Please visit www.mwp.com where you will find many free resources and a 25% discount on our books. Sign up and become part of the wider creative community!

Onward and upward,

Michael Wiese
Publisher/Filmmaker

FILM & VIDEO BOOKS

TO RECEIVE A FREE MWP NEWSLETTER, CLICK ON WWW.MWP.COM TO REGISTER

SCREENWRITING | WRITING

And the Best Screenplay Goes to... | Dr. Linda Seger | $26.95
Archetypes for Writers | Jennifer Van Bergen | $22.95
Bali Brothers | Lacy Waltzman, Matthew Bishop, Michael Wiese | $12.95
Cinematic Storytelling | Jennifer Van Sijll | $24.95
Could It Be a Movie? | Christina Hamlett | $26.95
Creating Characters | Marisa D'Vari | $26.95
Crime Writer's Reference Guide, The | Martin Roth | $20.95
Deep Cinema | Mary Trainor-Brigham | $19.95
Elephant Bucks | Sheldon Bull | $24.95
Fast, Cheap & Written That Way | John Gaspard | $26.95
Hollywood Standard, The, 2nd Edition | Christopher Riley | $18.95
Horror Screenwriting | Devin Watson | $24.95
I Could've Written a Better Movie than That! | Derek Rydall | $26.95
Inner Drives | Pamela Jaye Smith | $26.95
Moral Premise, The | Stanley D. Williams, Ph.D. | $24.95
Myth and the Movies | Stuart Voytilla | $26.95
Power of the Dark Side, The | Pamela Jaye Smith | $22.95
Psychology for Screenwriters | William Indick, Ph.D. | $26.95
Reflections of the Shadow | Jeffrey Hirschberg | $26.95
Rewrite | Paul Chitlik | $16.95
Romancing the A-List | Christopher Keane | $18.95
Save the Cat! | Blake Snyder | $19.95
Save the Cat! Goes to the Movies | Blake Snyder | $24.95
Screenwriting 101 | Neill D. Hicks | $16.95
Screenwriting for Teens | Christina Hamlett | $18.95
Script-Selling Game, The | Kathie Fong Yoneda | $16.95
Stealing Fire From the Gods, 2nd Edition | James Bonnet | $26.95
Talk the Talk | Penny Penniston | $24.95
Way of Story, The | Catherine Ann Jones | $22.95
What Are You Laughing At? | Brad Schreiber | $19.95
Writer's Journey, – 3rd Edition, The | Christopher Vogler | $26.95
Writer's Partner, The | Martin Roth | $24.95
Writing the Action Adventure Film | Neill D. Hicks | $14.95
Writing the Comedy Film | Stuart Voytilla & Scott Petri | $14.95
Writing the Killer Treatment | Michael Halperin | $14.95
Writing the Second Act | Michael Halperin | $19.95
Writing the Thriller Film | Neill D. Hicks | $14.95

Writing the TV Drama Series – 2nd Edition | Pamela Douglas | $26.95
Your Screenplay Sucks! | William M. Akers | $19.95

FILMMAKING

Film School | Richard D. Pepperman | $24.95
Power of Film, The | Howard Suber | $27.95

PITCHING

Perfect Pitch – 2nd Edition, The | Ken Rotcop | $19.95
Selling Your Story in 60 Seconds | Michael Hauge | $12.95

SHORTS

Filmmaking for Teens, 2nd Edition | Troy Lanier & Clay Nichols | $24.95
Making It Big in Shorts | Kim Adelman | $22.95

BUDGET | PRODUCTION MANAGEMENT

Film & Video Budgets, 5th Updated Edition | Deke Simon | $26.95
Film Production Management 101 | Deborah S. Patz | $39.95

DIRECTING | VISUALIZATION

Animation Unleashed | Ellen Besen | $26.95
Cinematography for Directors | Jacqueline Frost | $29.95
Citizen Kane Crash Course in Cinematography | David Worth | $19.95
Directing Actors | Judith Weston | $26.95
Directing Feature Films | Mark Travis | $26.95
Fast, Cheap & Under Control | John Gaspard | $26.95
Film Directing: Cinematic Motion, 2nd Edition | Steven D. Katz | $27.95
Film Directing: Shot by Shot | Steven D. Katz | $27.95
Film Director's Intuition, The | Judith Weston | $26.95
First Time Director | Gil Bettman | $27.95
From Word to Image, 2nd Edition | Marcie Begleiter | $26.95
I'll Be in My Trailer! | John Badham & Craig Modderno | $26.95
Master Shots | Christopher Kenworthy | $24.95
Setting Up Your Scenes | Richard D. Pepperman | $24.95
Setting Up Your Shots, 2nd Edition | Jeremy Vineyard | $22.95
Working Director, The | Charles Wilkinson | $22.95

DIGITAL | DOCUMENTARY | SPECIAL

Digital Filmmaking 101, 2nd Edition | Dale Newton & John Gaspard | $26.95
Digital Moviemaking 3.0 | Scott Billups | $24.95

Digital Video Secrets | Tony Levelle | $26.95
Greenscreen Made Easy | Jeremy Hanke & Michele Yamazaki | $19.95
Producing with Passion | Dorothy Fadiman & Tony Levelle | $22.95
Special Effects | Michael Slone | $31.95

EDITING

Cut by Cut | Gael Chandler | $35.95
Cut to the Chase | Bobbie O'Steen | $24.95
Eye is Quicker, The | Richard D. Pepperman | $27.95
Film Editing | Gael Chandler | $34.95
Invisible Cut, The | Bobbie O'Steen | $28.95

SOUND | DVD | CAREER

Complete DVD Book, The | Chris Gore & Paul J. Salamoff | $26.95
Costume Design 101, 2nd Edition | Richard La Motte | $24.95
Hitting Your Mark, 2nd Edition | Steve Carlson | $22.95
Sound Design | David Sonnenschein | $19.95
Sound Effects Bible, The | Ric Viers | $26.95
Storyboarding 101 | James Fraioli | $19.95
There's No Business Like Soul Business | Derek Rydall | $22.95
You Can Act! | D.W. Brown | $24.95

FINANCE | MARKETING | FUNDING

Art of Film Funding, The | Carole Lee Dean | $26.95
Bankroll | Tom Malloy | $26.95
Complete Independent Movie Marketing Handbook, The | Mark Steven Bosko | $39.95
Getting the Money | Jeremy Jusso | $26.95
Independent Film and Videomakers Guide – 2nd Edition, The | Michael Wiese | $29.95
Independent Film Distribution | Phil Hall | $26.95
Shaking the Money Tree, 3rd Edition | Morrie Warshawski | $26.95

MEDITATION | ART

Mandalas of Bali | Dewa Nyoman Batuan | $39.95

OUR FILMS

Dolphin Adventures: DVD | Michael Wiese and Hardy Jones | $24.95
Hardware Wars: DVD | Written and Directed by Ernie Fosselius | $14.95
On the Edge of a Dream | Michael Wiese | $16.95
Sacred Sites of the Dalai Lamas– DVD, The | Documentary by Michael Wiese | $24.95